# TOM LEA
*An Oral History*

# TOM LEA
*An Oral History*

Edited by Rebecca Craver and Adair Margo

Texas Western Press • The University of Texas at El Paso • 1995

©1995

Texas Western Press

The University of Texas at El Paso

El Paso, Texas 79968-0633

First Edition

Library of Congress Catalog No. 94-61797

ISBN 0-87404-234-8

Printed in Korea.

∞ All Texas Western Press books are printed on acid-free paper, meeting the guidelines for permanence and durability of the Committee on Production Guidelines for Book Longevity of the Council on Library Resources.

# CONTENTS

# *Preface*

During the spring of 1993, while evaluating the collection of the Institute of Oral History at The University of Texas at El Paso, I discovered a serious void. In more than 850 interviews conducted with border residents over a twenty-year period, the Institute lacked an extensive biographical interview with the celebrated artist-author Tom Lea.

A few days after this discovery, at an event honoring local authors, I met Becky Duval Reese, director of the El Paso Museum of Art. I mentioned my desire to record Lea's memories, and she told me the museum was planning a retrospective exhibit of his art. We discussed how the interviews and exhibit might be combined, and when I sought her advice about a person to conduct the interviews, she suggested Adair Margo, owner of a local art gallery, a woman who had just completed a two-year term as chair of the Texas Commission on the Arts and who was serving as Lea's exclusive agent.

Adair responded affirmatively to my request to interview Lea. After some training in oral history techniques, she began her interview sessions. The series of interviews stretched out over six months and resulted in fifteen hours of tape recordings, nearly five hundred pages of transcript.

The oral history interviews established connections between UTEP, the El Paso Museum of Art, and the Adair Margo Gallery, all of which came together in a collaborative project to celebrate the life and work of Tom Lea. Originally the plan was to include excerpts of Lea's taped commentary in an exhibit catalog, but we soon realized that the quality of the material captured on tape should not be condensed and that we should not hurry the editing process in order to finish in time for the opening. Instead, it was decided that Adair and I would produce a full-length book from the interviews.

In the fall of 1993, Adair and I embarked on our adventure together, and by the time the retrospective exhibit opened in February 1994, we were well on our way. For more than a year she and I met weekly to edit the transcript of the interviews. Through the study of his words, Adair and I became emotionally bound up in Lea's life. We marveled at the scope of his experience, the spectrum of notable persons who crossed his path. We rejoiced in his triumphs and success, wept with the tragedy, and laughed as we enjoyed his

humor. We wondered if other people would find it as engaging as we did. It is our sincere hope that they do.

Many helped us through the process from interview to book. First, we thank Tom Lea, whose willingness to be interviewed allowed this all to happen, and Sarah Lea, always the gracious lady. They kindly shared their scrapbooks, personal papers, and family photographs with us.

Adair and I want to express our appreciation to the Robert J. Kleberg, Jr. and Helen C. Kleberg Foundation and to William Kiely for generously funding production of the book. We also thank Jan Cavin, director of UTEP's Development Office, for her assistance in obtaining funding for the project. Kevin Rowan did most of the transcribing, and Nancy Hamilton used her extensive knowledge of local and regional history to help keep us accurate. We are grateful to Cheryl Adams and Isaac Lopez, the staff of the Adair Margo Gallery, and Michelle G. Benavides, assistant coordinator of the Institute, for relaying countless messages. For their support, we thank Jack Bristol, who at the time was UTEP's vice-president for External Relations, and Marcia Daudistel, associate director of Texas Western Press. They saw the possibilities from the beginning and always believed in the project.

We thank all who assisted us by providing and reproducing the illustrations: photographers David Flores, Joel Salcido, and Dave Shindo; librarians Wayne Daniel of the El Paso Public Library and Claudia Rivers, head of Special Collections, UTEP Library; Bruce Cheeseman of the King Ranch Archives; Mary Lou Gjernas of the U.S. Army Center of Military History; Barbara Wolanin, curator, Architect of the Capitol; Tom Evans of the National Graphics Center; and Florence Schwein and Scott Cutler of UTEP's Centennial Museum. We acknowledge the production assistance of Lisa Miller of Texas Western Press and book designer John Downey. Thanks also to Cynthia Farah who shared her photographic talent with us and donated the portrait of Lea featured on the cover.

Rebecca Craver
January 1995

# *Introduction*

Tom Lea and his work have always been a part of my life, from the time I was a youngster growing up in the city we share as our home, El Paso, Texas. His murals graced the library and other buildings I spent time in as a child and his paintings and books were found in the homes of friends as well as my own. My grandmother related with pride the fact that my great-grandfather baptized Tom in the First Baptist Church when he was eight years old.

As I grew older, my parents considered Tom and his wife, Sarah, examples to follow. They were contributing citizens of integrity and compassion who lived modestly and without pretense. During an unattractive display of teen-age immaturity, I recall my father admonishing me, "Sarah Lea wouldn't act that way."

Although our personal interaction was infrequent and generally brief, I felt compelled to visit Tom Lea when opening an art gallery in 1985. I know now that because of my respect for him, I was seeking his blessing. With initial notions of exhibiting what was "innovative" and "new," I vividly remember his discomfort with my words. "Artistic vision" and "contemporary expression" meant nothing to him, but a belief in knowledge, diligence, and skill most certainly did. His honesty gave me a perspective I did not have before and the beginnings of a much stronger footing.

Never did I suspect that eight years later, in 1993, I would be given the opportunity to gain a deeper understanding of this man and his beliefs. When Becky Craver asked me to record Tom's oral history, I spent two hours a week over a six-month period listening to his recollections and personal musings. There was no need to jog his memory. He recounted a perfect and chronological account of his life as well as the smells, sounds, textures, and colors that have surrounded him. He converses, not from the superior perspective of an "artist" whose calling is to share his personal "vision" for posterity, but as an honest craftsman whose passion is to observe and describe. His focus is external—he has described himself as an "avowed painter of the Almighty's own outward and visible handiwork" —and he speaks as a man who feels privileged to live each day, meet good people, encounter opportunities, and apply his skills to the tasks at hand.

Those tasks varied greatly over eight decades as Tom's life has evolved, taking him far beyond El Paso and back again. He has worked as a muralist, illustrator, World War II correspondent, novelist, historian, and studio painter. His path has crossed some of history's most noted individuals, many of whom he has captured in portraits.

This amazing and productive life is recounted in the following pages, proving the view that one anecdote of a man is worth a volume of biography. Tom's story relates both the people and events of his life, but extends much further. It gives us an appreciation of the convictions which guide his life.

Goethe wrote that "talents are best formed in solitude; character is best formed in the stormy billows of the world." This book tells the story of a man who, with genuine humility, proves Goethe's point.

Adair Margo
January 1995

## Chapter One

### *Growing Up on the Border, 1907 – 1924*

I was born on the 11th of July, 1907, here in El Paso. It was a very hot night in summertime. And I was born, my father said, at 4:44 in the morning on the seventh month and the eleventh day of the seventh year, and making up the 7-11-07, 4:44, I should be lucky as hell at craps. They lived in a little house on they used to call it "Rye-oh Grand" [Rio Grande] Street, right across from the not-so-old Hotel Dieu, that had been built a few years before. And so mother didn't have a very long journey to get to the hospital when she felt that I was going to arrive. And, it was sort of funny because her doctor, Dr. [J.A.] Rawlings, was up in his summer home in High Rolls, New Mexico, and when Mother and Dad came walking into the hospital after midnight, why, there was no one there except the sisters [Daughters of Charity] and so they frantically called the doctor and the only doctor available was Dr. [John W.] Cathcart who was a radiologist. But he came through, I guess, in a pretty good fashion because I arrived safely and everything was fine.

At the time, Dad was the Police Court judge; I think they call it Corporation Court now. There was just one. And my dad was pretty pepped up about this having a son and so he went on down to the court, and of course, in those days, mostly it was bums and drunks and things like that. Anyway, he had all the prisoners brought in and announced the birth of his first son and said, "You're all turned loose. Beat it!" So, the cops had a hard time, rounding them all up the next day. But anyway, they celebrated my birth.

Dad had met Mother, I believe, in 1901 when he had first arrived in El Paso. How he arrived is kind of interesting. He had some cousins that he thought a great deal of that had a big ranch – in those days it was a big ranch – and actually it adjoined what later became Fall's, Albert Fall's [Three Rivers] Ranch. This one was called the I-Bar X. And Dad came out. He had gotten his license to practice law in Missouri. Let's see, it was the Kansas City School of Law. It's still in operation.

Anyway, Dad came out and stayed on the ranch awhile. After he'd hunted and played like he was a cowboy and all of that, time came for him to go, I guess.

He took the stage then from Carrizozo down to Alamogordo; that was before there was a railroad working. And on the way on the stage they made a little stop for the passengers to get out and kind of stretch themselves and everything before they got to Alamogordo. And Dad excused himself and got behind a bush and got back in the stage and they went on in to Alamogordo, and Dad reached in his pocket and his wallet was gone. He had lost it apparently when he had gotten out at the rest stop. So he had two or three silver dollars in his pocket and he got a horse at the livery stable and rode back up there. And he couldn't find the bush or anything. So he came back, owed the man at the livery stable for the rental of the horse, and in pretty bad shape. He had, I think, one dollar, one silver dollar, left in his pocket. He was on his own. A freight train came through, stopped in the yards there at Alamogordo and he wanted on. He talked to the engineer and he [the engineer] said, "Well, go on back and see the brakeman or the conductor." And Dad went back and got in the caboose. And the old guy was a pretty good fellow; he said, "I'll share it. I'll give you a ride. The next stop we're going to is El Paso." Dad said, "Oh, that's fine."

He got to El Paso then and he had one dollar and he didn't know a soul or anything. It was a little bitty town in those days. So he went around and he saw this sign "Eats," a restaurant. And he went in and he said, "You sell meal tickets?" [They] said, "Yes." He said, "Well, I have a dollar and I'd like to buy a dollar's worth of meal tickets." And this owner and cook was Al Uhlig's dad. And when Dad's meal ticket ran out, why, he came back in and said, "I'll wash dishes for you." And Mr. [Oscar] Uhlig said, "No, you don't have to do that. I'll stake you until you get a job." So Dad found a job at the [Stackhouse Fuel and Lumber Co]. It was where the drive-in bank of the State National Bank is now [Campbell and Mills streets]. And Dad's job was to ride a horse and go around collecting for deliveries of wood and coal, as a bill collector.

Anyway, [one day] Dad saw this girl go by on Kansas Street apparently on her way home, and he said he remembered she had on a little red jacket with gold buttons. And he thought she was very nice. And as she went by, he tipped his hat, and she very, very coldly acknowledged. Dad went in to Mr. [Powell] Stackhouse, [Jr.] and said, "Who is that young lady that just went by from school?" And I think Mother was a freshman in high school. He said, "Oh, that's Zola Utt. Her dad has just built a house up on El Paso Street." And Dad said, "Well, how would I meet her?" And Mr. Stackhouse looked at Dad and said, "Well, I suggest the best way to do it is to go and see if you can meet her at the Sunday school class at the First Baptist Church." So Dad went and he met Mother. And, I think, you know, he kind of courted her. And old Clarence North, many years later, [told me], "You know your dad ran me off. I was wanting to go see Zola Utt, and he came up on horseback one day when I had come

2

up to see her, and he said, "'Look. That's my girl. Get the hell out of here!'" And he said, "Your dad was kind of a tough young fellow. So I left."

Dad [always] wanted to find a mine. And his idea in going West was to find a great discovery mine. Well, he heard about all the things that were happening in Mexico. He made friends with the son of one of the *rurales* captains. By that time, why, the Mexican Central Railroad was running, and Dad went down on the railroad to Chihuahua with his friend. And then they went to the Babícora Ranch, and from there they got on horseback and they rode from Babícora all the way down to Colima, looking for mines and having a good time. I know they got thrown in jail for some kind of, I don't know what, in Guadalajara. Dad said, "Guadalajara is the most beautiful place I ever saw. Most beautiful girls, too." Anyway, they had quite a time in Mexico [but] they never found a mine.

And Dad had given Mother an engagement ring before he left, and Mother very patiently waited for him. She had graduated from high school, and after graduation she taught piano lessons. I don't think she was a very good musician but she would play the piano for the Sunday school and things like that. I think that's how she kept busy while Dad was prowling around for three years in Mexico. Dad got back from Mexico and the courtship was reestablished, and they were married in June 1906. So that's how I happened to come into this world.

I loved my mother very much, but I sort of worshipped Dad, always did. That's one of the reasons I have never wanted to write too much about him. There was one time when I came back from one of my trips during the war [World War II], Dad was sitting on the front porch, reminiscing about his youth, and he got to telling me [about his life]. He had great adventures. For instance, in that trip to Mexico when he was a young man, he found a hacienda down in one of the *barrancas* and he really loved the life. And there was some haunting question in his mind whether he should go back and marry the girl he was engaged to or whether he should stay in Mexico. He told me that about two years before he died.

We lived in a little house around the corner from the house where Dad and Mother started their married life. I think it was around the corner on Kansas Street. And my first memory is the horses from that old fire station clattering down Rio Grande Street and my being in the front yard. There was a picket fence and I was looking through the picket fence and here came the fire wagon, and the fire engine they had to fire up with wood. You see, the horses were black, and the smoke was all coming out of the fire wagon, you know. And the firemen had on these big hats. It was something that a little, tiny child could remember.

3

I can't remember when I didn't like to draw pictures. Dad [kept] a letter in his office where my mother guided my hand to write Dad back in Kansas City when he was seeing his dad. It said, "Dear Daddy, I miss you" and something or other. "Love you, Tom." And then Mother let me draw a picture of a little man down on the side with a suitcase, and that was Dad, see? I had that thing; I don't know what happened to it. I was about four years old, I guess. There's a photograph of me with one of Dad's neckties on and it came clear down to below my knees, and one of his hats and his suitcase. I was trying to imitate him and his travels in those days.

Little brother Joe was born at our house at 1316 Nevada. And I remember I stayed next door during all the excitement. I spent the night at the McBrooms'. You know, Margie McBroom was a little girl about my age and it was a great thing to stay at the McBrooms' overnight. And when I came home, they let me go and see my new brother. Then my other brother wasn't born until twenty years later. In 1915 [Mother and Dad] started building that house a half a block away on the corner of Newman and Nevada [1400 Nevada], which was the house that I remember most in my boyhood. My stepsister [Bertha Schaer] still owns the house. It was finished in time for us to move in at Christmas time in 1915. And Dad was already mayor.

Mount Franklin was right out our front window and at the foot of it was a big quarry. The walls and foundations of El Paso at that time were mostly made from the stone from that quarry. As the rock wagons came down from the mountain it was great fun to go and jump and get a ride on down to what was Boulevard. Yandell was called Boulevard Street. And the other thing that we tried to hop on was the horse-drawn ice wagon, and steal a little piece of ice. This was always in the summertime.

We played shinny on roller skates with a sawed-off broomstick. It was like hockey only the puck was a small Carnation milk can. We always played on Nevada Street because there was practically no traffic ever there. It was a dead end, but the pavement went in front of our house and all the kids would come and play shinny there everyday after school.

Lamar School was eight blocks from our house, and we'd walk to school and come home for lunch and walk back, so we made four trips [each day]. It kept kids in shape a lot better than they do now where they just climb on a bus. Anyway, I remember that there was a shortcut which Mother was very much against. There was a stone wall about twenty-five feet high that they built to retain the slide from Golden Hill, and kids had dug out the mortar between the rocks so that you could climb all the way up this wall and take a shortcut right over Golden Hill to our house. When you felt pretty ambitious that was the way you'd go.

4

By the time I went to high school, why, I had a red Indian bicycle. On the northeast part of the stadium in front of El Paso High, there was a long, long line of bicycle racks where you locked your bicycle in. You had to pump like heck to get up the hill from our house to the high school but going home was real nice.

I never had on long pants until I went to high school. We had knickerbockers with old black stockings and high top shoes, usually laced right down to the toe. Some of them had brass or copper toes in them so that you wouldn't wear out your shoes so fast, kicking stuff around. We always had our shoes half-soled.

We all had slingshots. You'd find a pair of shoes that had been discarded and we'd make the pocket of the slingshot out of an old piece of shoe leather, not the sole but the leather. And the best cords were from Swift's Premium Hams, which always came wrapped in blue cords that were thick and strong. When our mother would buy a ham, we'd always want the [cord] because [even] if we weren't going to use it, why, we could do some pretty good trading. Once I had built a neat slingshot and I wanted to see how far I could get the stone up into the vacant lot over the backyards of the Roaches' house and the Pipers' house, so I up and gave it a wham and the damn thing took a wrong turn and broke Mrs. Baker's bedroom window about a half a block away. Well, I heard the crash and I knew Mrs. Baker would be after me so I ran around the driveway. Our driveway was made of some kind of real rough concrete and my feet slipped and I hit the side of my head and knocked myself out and scraped all the skin off and felt terrible. Came in the house and Mother called Dr. Rawlings and he put me to bed. I had a slight concussion and the whole side of my face was a scab while it was getting well. When Mrs. Baker found out who did it, she came down to see me and said that it was all right. She was sorry I got hurt. There was some lesson taught there: if you do something bad, you get hurt, which I kind of believe. It did hurt.

Our house had a basement, a full basement all underneath. A big front room extended across the whole front of the house and there was a laundry room and a servant's place, all in the basement. My brother Joe was more of the gregarious type than I was, and he had a club called the Trojan Club and they would meet down there and the whole house would reverberate with these kids, and my mother would cook a great big pot of *frijoles* and cornbread and they'd have a big feast down there. I sort of took over the little room from the servants and I made it into a studio. It just had one little window, [actually] a half window because it was underground, but I remember I painted I guess it was one of my first murals there. It was the picture of a flapper. I did it in showcard color

5

on this plaster wall and it kind of oozed out at the edges. It was a flapper. The skirt came up almost to the knees and my mother didn't approve at all.

Dad never went to church much. He said he was afraid the steeple would fall! But Mother taught Sunday school for many years at the [First] Baptist Church on the corner of Virginia and Magoffin. I had to go [to church] every Sunday, lots of times twice and some Wednesdays. When I could beg off for to do my lessons, why, Mother wouldn't make us go. But I had to go to the BYPU [Baptist Young People's Union] a lot and all of that.

The Lord gave us a very close call one time. Joe and I were coming out of the basement where the Sunday school meetings were, and it was raining like the dickens. We were standing in front of the church steps and the bolt of lightning struck about twenty-five feet from where we were standing and scared the living heck out of us. They used to have they called them mushrooms in the center of intersections so that people wouldn't cut corners, and this bolt of lightning hit that metal mushroom. We thought the Lord had really got us. Nearly knocked us down. It was a real blast. And, boy, were we glad when Mother came by with the car and took us home.

My first grade teacher was Miss [Lillian] Cole. She was real tall, real skinny, very cool and gracious, and she taught us the alphabet. She had a big mason jar full of lentils and we each got a watercolor pan full of lentils and she would come with chalk and on top of our desk she would write an "A" and we had to put lentils all around the "A." Then we had to put the lentils back off the desk into the little pan and rub the "A" out and then we had to make the "A." We did so much work on this letter that we could remember what we did. Then a "B." That's the way we learned the alphabet.

I remember that there was a teacher in the fifth grade named Eula Strain. Miss Strain was a Baptist and knew Mother at the Baptist church, and she had told Mother that I really showed some interest and maybe talent. Of course I could draw pictures, and she said, "It's funny to watch that little left hand." I don't know, but that always burned me up. Mother had gone to the principal of Lamar School and said, "This boy is left-handed and I want him to stay left-handed. Don't try to teach him [otherwise]; I want him to stay left-handed so that there won't be any nervous thing." And in those days they kind of thought that was a way to make a child get nervous and unbalanced a little bit. I stayed real left-handed. To this day, I couldn't ever square dance because they say, you know, "Go to the right," and I'd go to the left.

Dad was elected mayor of the town in the spring of 1915. He was mayor from 1915 into [19]17 and he never ran again. I remember very distinctly the night that the election returns came in. Joe was very small and I was pretty small, too. Joe and I were in our pajamas, but I think Mother was staying

dressed and was terribly nervous trying to find out if her husband was defeated or had won the election. In those days, you know, the only communication would be on the telephone to find out how the election was going. And I remember how a man came and knocked on the door and said that Dad had won. All the precincts were in and Dad had won. Pretty soon Dad came in a Buick. And that's the time Joe and I were allowed to get dressed. Very shortly after, the man who had the *típica* orchestra of the town in those days came. I think his name was Rayo Reyes. This was in the days before they called them *mariachis*. They had a flat-bed truck with a piano and a bass violin, and they gave the *mañanitas* to Dad, just about dawn. And it was the most thrilling thing for little kids. So that was how Dad became mayor.

Then we moved into the house at 1400 Nevada. Joe was in kindergarten and I was in the third grade or something like that. The Mexican Revolution was in full swing and Dad, he sort of had to keep the peace on the El Paso side of the river. It was tough times down in Mexico. Dad and Pancho Villa had some words when Villa crossed over into El Paso one time. Dad had his chief of police and a couple of officers with him when he told Villa to get back across the river. Villa never forgave him and then Dad put [his wife] Luz Corral Villa and Villa's brother Hipólito in jail when they came over. They apparently were helping Villa get some arms and ammunition from sources on this side of the river.

Anyway, Villa didn't like the *presidente municipal de El Paso* worth a damn. He put out a public notice in Mexico offering $1,000 in gold for Dad, dead or alive, and he sent a threat to kidnap Joe and me. He didn't sign it but one of his *dorados* [did]. So for about six months Joe and I went to school with a police escort and came home with a police escort. And there was always a policeman stationed all night at our house. And, of course, this was big adventure stuff, sure. It was a little bit tough for a little guy, because, "Nya-nya, the mayor's son," you know, "you're getting special treatment," and everything. There had to be a few fights; the mayor's son had to show that he was okay. Joe was too little, really, to get into that.

While Dad was mayor, there were literally thousands of refugees from Mexico pouring into El Paso. And there was a typhus epidemic, you know, and the health officer of El Paso, I think his name was Dr. [Charles T.] Race, died of typhus. Of course, they were trying to do all things possible to keep from catching the typhus, and one of the things they told Dad was that the typhus louse didn't like silk, that cotton and linen is where they'd lodge, and the doctor suggested that it would be helpful if he had silk underwear. Well, this really did it. Dad came home and said, "Zola, can you make me some silk underwear?" And Mother made him silk BVD's and I mean he was really talking about his silk underwear for some time. He never caught typhus.

7

They had a big refugee camp out in Fort Bliss. Some of the people that had come over were smugglers. They were caught and put in jail, and they all were unwashed and in pretty poor shape from the troubles they had had in Mexico. They were lousy and full of fleas, and they were trying to keep [the typhus epidemic] from crossing the river. The police were using gasoline to delouse some of the prisoners in one of the cells down at the police station. It wasn't done by force or anything. The prisoners were quite willing to get something [done] about it. And somebody [with] a spark from a cigar or a cigarette or lighting a match to a pipe lit the gasoline. It was terrible. They burned to death. [Twenty-five men died in the March 1916 incident.] It really devastated my father and he thought about it an awful lot. Somehow or other he took the blame for it, you know, as he would. I remember that vividly.

Another time he came home very excited after having been away all night. It was at the time of that Santa Ysabel Massacre, [January 10, 1916] when the American mining men were on a train in Chihuahua and Villa's henchmen stopped the train and took the Americans off and shot them all, killed them. And this caused feeling so hot in El Paso that a mob formed. And they formed the night that the bodies were brought back to El Paso, as I understand it. Somewhere on Overland Street this big crowd collected and they had guns and they were going down to the Segundo Barrio [Second Ward] and clean out the Mexicans for what they'd done to American mining men. Well, Dad, the fire chief [John W.] Wray, and a policeman named Joe Stowe stood down there on the other side of Overland Street and faced the mob. Wray had the firehose trained on the crowd and [when] they started to advance and started waving their guns, Wray let them have it, and it stopped the riot.

And the feeling was really that we should go in, intervene in Mexico. At that time, why, Sen. Albert Fall was in Congress, and he was publicly advocating the desirability of intervention into Mexico, just go down and stop all this stuff, which Woodrow Wilson paid no attention to. I think Fall was very sympathetic to the old regime and very unsympathetic with the *revolucionarios*. While Fall and his family were all in Washington, he rented his house up there on [1725] Arizona Street to old man [Luis] Terrazas. I guess he was one of the richest men in Mexico. He had come out of Mexico from Chihuahua City with all his relations and servants. They'd come by buggy and wagon, and that's quite a little trip from Chihuahua City, especially when Villa is chasing you.

People like Terrazas lived entirely different from those sad, forlorn refugees out there living in tents at Fort Bliss, you know, on government rations. They had nothing, just stuff they carried on their backs. There was a great feeling of sympathy for them. [The negative feeling] was against the people that were

causing all the suffering. And they were seen as the *revolucionarios*, the people that were causing this terrible trouble in Mexico.

Anyway, the feeling at that time was intense and hot. I don't suppose it was any hotter anywhere along the border. No place felt it as strongly as this. In those days it wasn't so much Villistas or Carranzistas or what-not. It was the *revolucionarios*; they were all the same as far as the people on this side were concerned, and all raising cain. They forgot their large revolutionary dream of making Mexico a better place by having a better government and they all got to fighting amongst themselves as to who was the one that was going to reap the reward. It became a kind of duel between various leaders.

I know that people like my father finally came to prefer [Venustiano] Carranza because he was a little more for the idea of law and order in Mexico and had set himself up in Mexico City as president after the terrible assassination of [Francisco] Madero. And they were running [Victoriano] Huerta out of Mexico; he went to Europe and then he came back and was in El Paso with Pascual Orozco – I think I'm right on that. And they were planning some kind of a reentry into Mexico against Villa and I believe against Carranza, too, when Huerta fell ill. He died in a rather short time of cancer. And he rented a house up by Maj. [Richard F.] Burges' house on West Yandell. And I remember that Dad was gone the night Huerta died. Dad then was asked by the family to be the executor of what small things Huerta had on this side. So Dad [served] as attorney for Huerta, who was probably the most despised man in Mexico at that time.

Gen. Felipe Angeles lived in El Paso for a while. And of course, in 1918 or [19]19 he went down into Mexico to join Villa against the Carranzistas. [They] caught him and executed him. He was the greatest soldier that Mexico has ever produced. He was the director of the Chapultepec Academy, corresponding to our West Point. And he also was a fine mathematician and he had been sent by the Porfirista government to Saint Cyr, the French academy. And Dad always said that Felipe Angeles was [one of the] designers of the French 75 millimeter light artillery piece. He was a fine technical man, a very brave and very admirable man. Dad admired him very much. And he also had the duty of telling Angeles that because he was plotting to capture Juárez and have another battle that he was causing troubles in El Paso and that he should leave.

I got a lot of perks from Dad being the mayor. Like I once rode in a fire wagon. I spent the night with the firemen and slid down the pole and rode on the fire wagon. My mother was very much against it, but, boy, that was great! There were thousands of troops, you know, at Fort Bliss, and they had a thing called Camp Cotton. It was somewhere down there near the railroad yards. And I remember that Lt. [O.E.] Michaelis was one of the general's aides and he had a

tent down at Camp Cotton and Dad got into letting me spend the night with the soldiers down there. I was nine [years old] and oh, man, that was fantastic!

We'd play up there on Golden Hill, what's now Pill Hill. Mr. Park Pitman had a son who was kind of a tough guy and was a little older than we. And we never did get along too well, but his daddy was always nice. He had a little telescope that he'd look at the moon and see Saturn's rings and all that kind of stuff. And he let us look through the telescope at part of one of the battles for Juárez. And I saw for the first time a guy get shot and drop over and another fellow ran out and grabbed his gun and took off with it. I'll never forget that first [encounter with] war.

I remember one night the [artillery] men came up on Golden Hill Terrace right in front of old Park Pitman's house. And they were shooting a French 75 caliber over the town into Juárez. It was real exciting stuff, you know, and the windows all rattled. Dad always had to be in the middle of things. One of the commander's staff got a motorcycle with a sidecar and came by the house. And Dad got his rifle and a whole belt of ammunition and he went down and enjoyed the shooting with the Army.

I had a letter – I don't know what has happened to it – that he wrote [Gen. John J.] Pershing when Pershing was in the expeditionary force in France, telling him how he wanted to get into the army, and he got in too late in 1918, so he didn't get [to go] overseas. He was in the Spanish-American War, too [but] never saw any action. So that really irritated him that he never had seen any angry shooting except across the river. That's why he was so interested in what I was doing during the war [World War II]. He lived until three days before they let loose the big bomb. So he lived through the whole war. And when I'd get back from one of these trips, why, he'd just, you know, listen, listen . . . . He had a stroke while I was away one year and he was sort of laid up, but, God, he was all ears about it, wanted to know all about it and how I felt. He was very proud.

Dad's den was full of all kinds of Indian ceramics, and bows and arrows, and a big buffalo head, and books, and quite a gun collection of old pieces and some good modern rifles and small arms. [Another] sort of an icon in Dad's den was this picture of Homer Lea in a Chinese robe. Dad told a good deal about Homer. He was my dad's first cousin, Uncle Alfred's son, and he had been born as a fine, lusty, young boy. They lived in Denver, and they had a male Indian as a nurse. I don't know who [actually] dropped the infant Homer on the flagstone fireplace hearth. It injured his back to where he was a hunchback the rest of his life. That's how it happened. He was apparently a brilliant mind and a real soldier at heart. He went to Stanford and learned Chinese there from Chinese friends and then went to China. The Chinese tong in San Francisco paid his way to go over to China to help, [as] Dad used to say, "knock the Manchu emperors

10

off the throne." Homer was pretty successful. He had an army that had been organized, and with his military studies and everything he began to put them in practice and he actually did some good work in that rebellion. But they cornered him. By this time he had met a young fellow named Sun Yat-Sen who really was a promising revolutionary. And he and Dr. Sun went to Japan to escape the Chinese that were after them. And they were in Japan a little while and when Homer came back, he wrote a novel called *The Vermilion Pencil*, which has got a lot of information in it, but it's kind of a crummy, romantic thing. It wasn't Homer's métier.

When Dad and Mother were married in 1906, Homer was back in California, entertaining various Chinese visitors, et cetera. Homer's dad and mother lived in Los Angeles, and Dad and Mother had their honeymoon in Long Beach and they went by, of course, to see Uncle Alf and his wife. Anyway, old Homer was there and Dad said, "Homer had absolutely no time for me." But years later, you know, Dad always made Homer as a hero, because he finally went back, became Sun Yat-Sen's chief of staff, and had the rank of lieutenant general in the Chinese army that actually made Sun Yat-Sen the president, you know.

While Homer was in Japan, he saw what Japan's plan was and he wrote *The Valor of Ignorance*, which pretty accurately foretold what the Japs were going to do in World War II. After it all had happened early in 1942, why, the people in charge began to read it and see how close Homer had come to what the Japanese were going to do. After *The Valor of Ignorance* – I believe this is chronologically right – he wrote a book called *The Day of the Saxon*, in which he prophesied that Russia was going to take over and it was going to come through a conquering of England's Indian Empire. Karachi was one of the strategic points in his thought. Well, the Kaiser Wilhelm of Germany invited him to come as his guest, see their spring military maneuvers, and discuss military matters as a sort of an advisory expert. This was about 1912. And the marshal of the British army at Sandhurst or wherever, I guess it was in London, then heard about this and he asked Homer to come over and see him, which Homer did. And when Dad was old and I had been around some, I remember he told me, he said, "Well, son," he said, "Homer was a genius, but I never met a man that was more conceited and that had less time for his kinfolks than Homer Lea."

The only thing I can remember about Uncle Cal, Dad's brother Calvin Lea, was he came to visit us one time. We still lived at 1316 Nevada and it must have been when I was only seven years old. And I remember he was so delightful to me and to my brother Joe who was a little tiny boy then. He had some clay and he carried it in his suitcase. This [clay] was kind of dry, and he wet it and left it overnight. I remember he could model a little horse and an Indian and all kinds

11

of things with just his hands. And he wanted to be a sculptor but he never became one. But he was very strong on having a little *copita* and, of course, my mother was a very strong temperance lady and Cal would go across the river for his little daily drink. He came home one night, must have been very, very plastered, and the folks were in bed and Cal came in and wanted something to eat. He opened the icebox door, and he pulled too hard on the handle and the whole damn icebox came over. Dad and Mother got up, they got the icebox back and it didn't hurt Cal. Dad said, "It never hurt a drunk ever." But my mother thought it was time for Uncle Cal to go back to Missouri. And I think the bacon was burnt shortly after that. So he left. They told me years later that my grandfather, who was the surveyor in Jackson County, Missouri, often left very nice little topographical drawings of trees and the hills on the edges of his survey papers. And there was some feeling that [the talent] was transmitted to Cal, and one of the reasons that I think I had it so easy about getting to go to art school was that Dad had seen his brother completely frustrated by orders not to leave the farm. He didn't want to see that happen to anybody. He was always very fond of saying that he'd rather have his son be a good blacksmith than a poor preacher. I think he said that several times.

El Paso was an entirely different kind of city [then]. So many people knew each other, and everything was so much quieter and slower because there weren't as many automobiles and the streetcars were the main way that most people got around. We'd take the streetcar and we'd get off at the plaza and walk a block down to Dad's offices. He was in the First National Bank Building. I think it was a five-story building, and the roof was a great vantage point for people with binoculars to watch the [Mexican] revolution. There was always a bunch up there whenever there was any trouble. And they'd take their armchairs and watch the revolution.

And Mother didn't like for us to be on El Paso Street or San Antonio Street because of all the saloons. And I can remember vividly the smell on San Antonio Street was a kind of a mixture of wet sawdust and beer. It must have been the smell of raw bourbon that would come out of these swinging doors. It suggested sin. It really did. And also during the time when there were so many soldiers here, there was a vaudeville house a little further down almost to San Antonio Street. It was a real rough joint. And sometimes they'd leave the door open, and when we'd go to the Unique Theatre across the street, we could look in there and, boy, you'd see these girls kicking high and. . . . It smelled like hamburgers. Now, why is that? I can still smell the hamburgers. Maybe it was because there was a restaurant around the corner.

We learned to swim at the YMCA on Oregon Street [at Missouri]. Twice a week after school and on Saturday if you wanted to, why there was a Pee Wee

class and you learned gymnastics and all that kind of stuff. The Arizona street-car that stopped half a block from our house went right down and turned the corner at Oregon and you could go to the Y and go to the library [across the street]. That was always a pretty good thing to do after you were through with your class or your swim over at the Y. And Mrs. Maud Sullivan [the librarian] would let me browse in all the art books, and I'd look at all the pictures. That gave me a background that I later found most of the students at the [Chicago] Art Institute didn't have.

When I was a kid, right after Dad was mayor, we always had to go on a Sunday afternoon drive. We had a Buick, a seven-passenger Buick. My brother Joe and I had to sit in the jump seat. We often took my grandmother and my grandfather on these Sunday drives. The only thing that made it bearable for kids like Joe and me was that Dad would usually take us by the Elite [Confectionery] and we could get either a "baseball" which was vanilla ice cream covered with chocolate or we could have a chocolate soda. The Elite, let's see now, was on the corner of Mesa and Texas, on the northwest corner.

In 1915 they built a road all the way to Fort Bliss. They called it Pershing Drive, and every Sunday afternoon the 82d Field Artillery Band gave a concert and an awful lot of people would drive out to the Fort and [park] around this bandstand which was built by the polo field. And when the piece was through, why, if you liked it, you honked the horn. I can remember as a kid how when they played John Philip Sousa, everybody would honk the horn a long time.

Mother and Dad and Joe and I made a trip in our Buick [seven-passenger touring car] one time up to the Grand Canyon. I guess I was about twelve or thirteen. On the south rim of the Grand Canyon there was a thing called Hopi House. They were selling Indian curios and every afternoon at four o'clock, why, these Hopis would put on a little dance, kind of an eagle dance and beat the tom-tom. And inside the Hopi House were all of these beautiful Hopi ceramics on an altar they had created. I don't know how it ever got to the Grand Canyon, but it was there. And, you know, that fascinated me more than the Grand Canyon. I was prepared for it a little bit because Dad had begun to collect Casas Grandes pottery, bowls and vases and also Mimbres stuff. We'd go to Mimbres Hot Springs every summer for a little while, our family would. So that interest in ceramic designs, I think, gave me a tendency to think in terms of geometric design. I really think it was a basis for my work.

While I was in high school I'd go up in the summertime to Santa Fe. I made three trips. I'd go on the Santa Fe Railroad, you know, and then a tourist bus that left from Lamy took you up to the town of Santa Fe. Judge Colin Neblett, the federal judge up there in Santa Fe, was a great friend of Dad's and he was an old bachelor and he had this big house up on Palace Avenue. He'd let me stay there

and he had a housekeeper that would make my meals, and I just had a great time. My folks would let me stay up there a week or ten days. And I'd go from Palace Avenue, oh, into the museum every day, and then I'd walk up Canyon Road to where the Camino [del] Monte Sol turned off to the right. Fremont Ellis' house was the last one up there, and next to him was, I believe, Will Schuster's, then Joe Bakos, and then Walter Mruk. Who else was there? Willard Nash. Willard Nash was kind of snooty. He was pretty artistic and I never did get to meet him.

Fremont Ellis was the only guy that really took my work seriously in Santa Fe and almost made me feel like an adult. He was a young painter, one of the Cinco Pintores. And he didn't have anything at all except the desire to paint. And I never knew a man that had such a love for just pigment. He had a reverence for what he spread out on his pallet. He loved it and he tried to use it with a kind of almost reverence, you know. I never knew any painter like him. He was good to me.

One summer Willa Cather was up there, staying with Alice Corbin Henderson. But I never got to meet her. I'd see her and Mrs. Henderson walking. They would walk up to the top of the Camino [del] Monte Sol and back every evening. It was kind of a sight, you know, to see Willa Cather. I wrote a letter to her when I lived in Chicago, when I was very young, and she answered it. I wrote it in care of her publisher, Knopf, and she answered it from New Brunswick. It's a very nice letter. It's in my copy of *Death Comes for the Archbishop*.

Santa Fe had the first museum I was ever in in my life, the Museum of Fine Arts. I loved Santa Fe and it meant a great deal to me. I guess I'm really not a Texan. I'm a New Mexican because of my youth, the ranches and Santa Fe and our summer vacations and the Mimbres Hot Springs and all of those things in New Mexico. I was only on one Texas ranch as a boy. I spent six weeks on the George Evans ranch down near Valentine.

I started taking art the first time that I could and that was when I was a sophomore in high school. I was exceedingly fortunate to have the art teacher there. Miss Gertrude Evans was originally from Madison, Wisconsin, and she was very well-educated, gracious, and she was a fair artist. Several summers she went [to Santa Fe] to study with Fremont Ellis and she could paint in oils. She taught nothing but art, and she really encouraged me, gave me a great deal of background about painting. I truly owe lots to her. And one of her good friends was Maud Durlin Sullivan, who was the librarian [at the El Paso Public Library]. She was also from Wisconsin and they had known each other for years.

When I was a senior, I didn't have many classes left to take to graduate, so I took double periods of art and they let me take a class in English at the junior

14

college, which was in the same building [El Paso High School]. Jeannie M. Frank and Fanny Foster were the two English teachers [who] taught me everything that I tried to use later as a writer. They were wonderful. I think I was extremely fortunate to have people like Miss Evans and those two English teachers and then to meet Maud Sullivan, the librarian downtown. I was just lucky.

Miss Evans, of course, was instrumental in choosing people that would do the art work for the school annuals, and she suggested that I try making a cover for *The Spur*. So I got one of Dad's old Spanish spurs and made a drawing of it. Did it in ink, like a cartoonist, and it was printed in gold on black paper for the cover. The fourth year [of high school] I was elected editor-in-chief of *The Spur* and Billy Coles, who was a real nifty guy, was business manager. And we had a printer there in the high school, Mr. [Harry] Blumenthal who was a good friend of both Billy and mine. The main thing was to go to all the merchants in town and have them buy ads; that was where the money was. Anyway, Billy and I got together and said, "How are we going to do this?" And we shook hands and said, "We'll see how much we can make and we'll give it to the school." So *The Spur* came out, and Billy got more ads than anybody had ever gotten and just before graduation day, we went in to see Dr. Frank H. H. Roberts, the principal, and Billy gave him a check for $2,800. And we said, "We would like to have the Class of 1924 buy a new curtain for the auditorium," which they did a few years later when Billy and I were away from El Paso. So the graduation night, while they were passing out the diplomas, they called Billy and me up on the stage, and Dr. Roberts presented each one of us with a beautiful traveling case with tortoise shell comb and brush for our travels when we went away to college. So it was very nice. I went to the [Chicago] Art Institute, and Billy went to Swarthmore and Dartmouth to prepare for Harvard Law School. We had quite an experience together.

There was this little club in high school, just kids there in high school that were interested in art. Two of them wanted to be cartoonists, and the others were just sort of there for the ride and enjoying. We'd have meetings and show these drawings we made. The club was on the top of [some] apartments. I forget the name of it. It's where the John Williams Insurance Company is now [400 block of East Yandell] and this was on the top. Frankie Hadlock's dad owned the building and he let us have a kind of a little penthouse on the roof, which we fixed up. And we had a little sort of a bum carving of the Aztec god Chacmool and so he became our sort of logo and symbol. And I think that Chacmool Society lasted for, oh, a couple of years. We had fun. I enjoyed doing likenesses of my friends, and I did several up there. And when I would try to spark some girl like Ethel Irene Howe, why, I'd invite her up there and her mother didn't quite know if that was the right thing to do, to go to the Chacmool studio.

15

But I did some real bum drawings of these girls. Then, I remember I did a good one of [Delphin] Tuffy Von Briesen, my pal, and one of Ed Ware and one of, what was his name, Preston Oliver and Speedy Adams . . . all these guys. They're all dead now, every one.

At that time the only real biography of an artist that I thought was great was that Pennel biography of James Abbott McNeill Whistler. Also, even at that time I was very, very fascinated with the work of Rockwell Kent, his black-and-white stuff. You see, there was that kind of Indian design in the background.

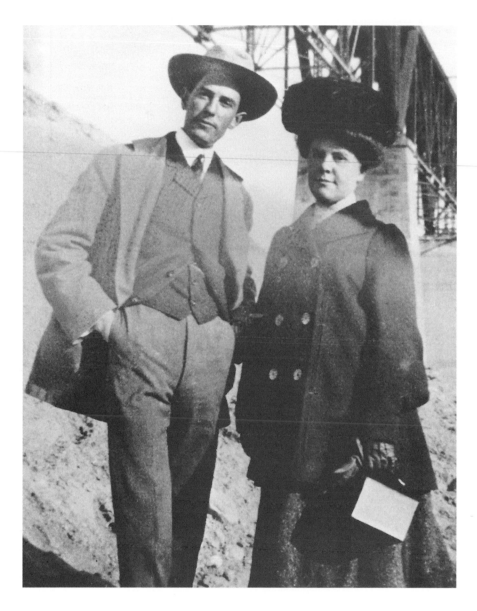

*Lea's parents during a Sunday buggy ride near the Rio Grande several months before their June 1906 marriage. (Courtesy Harry Ransom Humanities Research Center, The University of Texas at Austin)*

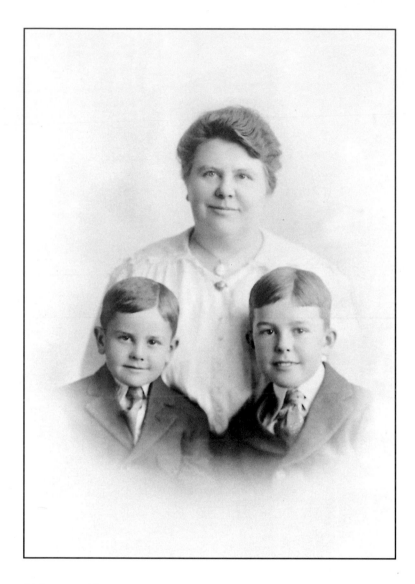

*Eight year-old Tom Lea, (right) with brother Joe and mother.*

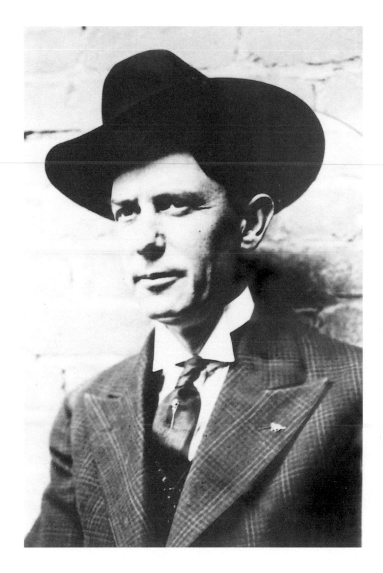

*Tom Lea, Sr., a frontier lawyer and the mayor of El Paso, 1915-1917.*

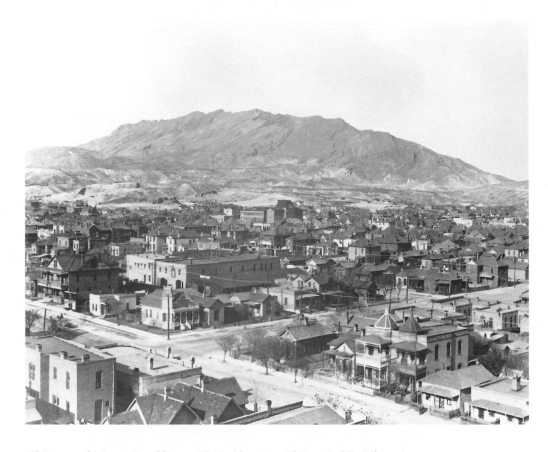

*El Paso and Mount Franklin, c. 1915. (Courtesy El Paso Public Library)*

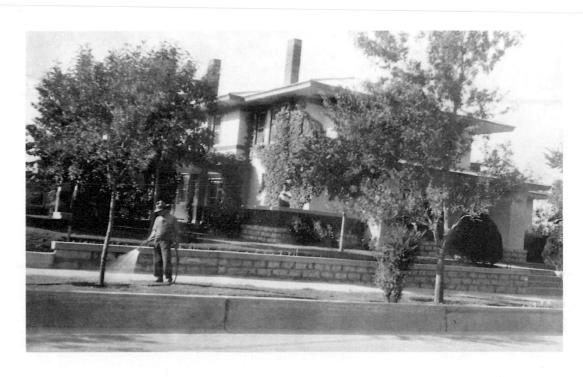

*Lea family home at 1400 Nevada, El Paso, 1924.*

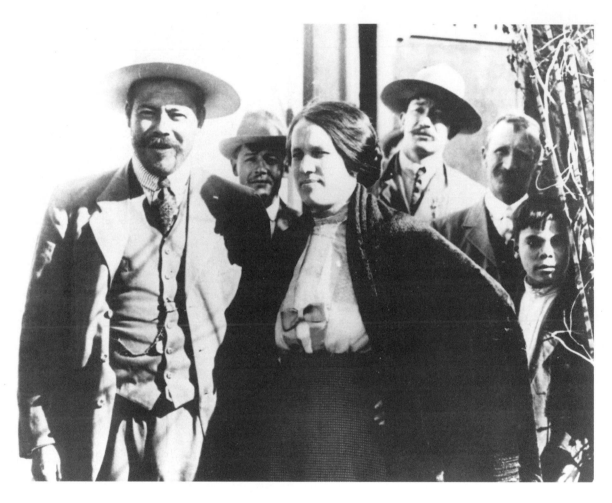

*Pancho Villa and his wife, Luz Corral Villa. Mayor Tom Lea arrested her for arms smuggling during the Mexican Revolution.  (Courtesy El Paso Public Library)*

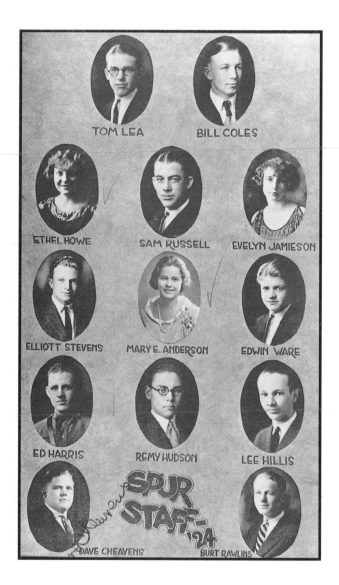

*A page from El Paso High School's yearbook, The Spur. Tom Lea was editor-in-chief during his senior year.*

# Chapter Two

# *Early Career, 1924 – 1936*

How I happened to go to Chicago was very interesting. Gertrude Evans had a beautiful sister, Alice Fields, whose husband's business brought them [to El Paso]. Alice had a friend named Norma van Swearingen, who was an illustrator. She had done illustrations for some of the magazines of that time, *Cosmopolitan* and *Saturday Evening Post*, I believe. Norma van Swearingen came to visit her friend Alice Fields and Alice told her about me. And she wanted to see what I was doing. I had just done a drawing of Wally Lowenfield's mother, Helen Moore. I remember I did her in charcoal, and Mrs. Swearingen liked it. And she said, "I think you ought to go to the Chicago Art Institute [The Art Institute of Chicago], and if you can, get into a class of John Norton." And that's kind of how I got the idea that I would go to Chicago.

Norma van Swearingen said that John Norton was the most vigorous Western type that was teaching at the Art Institute, that he had been a Rough Rider in the Spanish-American War and when Dad heard that he said, "Well, that's pretty good. I want to see my son study with a man like that." So the only real definite thing that was said about the Chicago Art Institute was that there was a man there whose name was John Norton, and that I would like him and that he would like me. I never saw Mrs. van Swearingen but that one time, that day she had me come over and bring some drawings that I'd made. Just that one meeting, that one meeting changed [my life].

And, of course, she was a friend not only of my art teacher in high school, Gertrude Evans, but a friend of her sister's, and they were very well-respected people. And my mother thought that if they would endorse such a thing, then the Chicago Art Institute would be pretty good. And so I wrote and got the information about going. And then there was a question about where I would live. There wasn't any kind of a campus or any control whatsoever on anybody that went to the Art Institute. It was a place where you went to learn to paint. And I think a few people went there to learn to be teachers, you know. After you'd been there a few years, you got a diploma or something. But us guys that really wanted to be artists looked down on these people that got diplomas, you know.

The hell with a diploma. What you want to do is learn. So this was a pretty tough thing about what I was going to do. Mother didn't want me to just go up there and not have any friends and Dad was feeling the same way. And Mother happened to think of her friend, Mrs. Nita Carpenter, whose father was Dr. Clegg, a physician living on the North Side in Chicago. And Mrs. Carpenter wrote her father and he said that he and his wife would be delighted to help me and find a place for me to live that would be, as Mother said, "all right."

First time I'd ever been anywhere by myself except to Santa Fe, you know. I went to Chicago on the Golden State Limited. And Dr. Clegg met me at the La Salle Street Station. In those days, you know, you traveled with a trunk and the express company delivered the trunk to your address, and he said, "I've gotten a room for you at the YMCA on Wilson Avenue." This is quite a ways, about forty minutes from the Loop by elevated train. So we went up there and there was a very nice set-up. Nobody bothered me. I could swim and I could use the gymnasium, which I did, you know, to sort of keep in shape and all that. And I lived there at the Wilson Avenue YMCA for the first year I was in Chicago.

When I lived in Chicago, I couldn't get my home country out of my mind. For instance, I made a map of every one of the towns that were mentioned in Castañeda's account of Coronado's expedition. And I made a star map, thinking the way the stars were at home. And I got to thinking so much about the summers in Santa Fe and about the corn dance at Santo Domingo and the Hopi pueblo over at Walpi in Arizona. I'd go over to the Newberry Library and study the Bureau of Ethnology reports, the Smithsonian reports, you know those big old green volumes? And there was one that had a wonderful collection of Hopi kachina doll drawings, and an article by J. Walter Fewkes called "The Influence of Environment on Aboriginal Cults." And I was fascinated. I thought, gee, if I could only get those books for myself. And Dad's law partner, Ewing Thomason, had just been elected to Congress and was in Washington. I wondered if Mr. Thomason could get them for me in Washington. So I wrote Dad and Dad wrote Ewing and first thing you know, here came these volumes.

I would take the elevated, the "El," at Wilson Avenue and go to the Loop every day. That included Saturdays, when there weren't regular classes at the Institute, and on Sunday, why, I would go and meet my friend Enrique Alférez, who had come to Chicago to study with the sculptor Lorado Taft. I think the El Paso Kiwanis Club paid his fare to Chicago. There were eight young men that were studying [with Taft] and lived in the barn in back of the big studio he had down at 60th and Ellis Avenue, and they were allowed to watch him and hear him and sometimes help him a little bit with some of the sort of peon work there in this great big studio.

26

Enrique was a refugee from the [Mexican] revolution. He came up to El Paso with a painter named Arévalo. And Enrique could speak no English at all. And a man named Harry Waggoner, who had the Fine Arts Shop in the Roberts-Banner Building downtown, sort of took him on. And Dad bought a Audley Dean Nicols [painting] from Harry Waggoner and they became friends, and that's where I met Enrique. Enrique lived in a little tiny room up on the third floor of one of those hotels on El Paso Street. He was very, very poor and a wonderful guy. I think the Kiwanians gave him a little extra money besides buying him a ticket up there, but no return ticket or anything like that. They just sent him up there and he had to make his way. And he did, you know.

He [washed dishes at the Glen Inn Cafeteria on Wabash Avenue], and he got a job at the Art Institute. He borrowed a big Mexican sombrero that Dad had given me and I took up there as a kind of stunt [since] it was still kind of revolutionary times, 1924. Anyway, Enrique got a job posing as a Mexican *caballero* with the hat. Dad had Victoriano Huerta's beautiful silk sash that he wore and I had that and that big hat. And Enrique found a short *chaqueta* and he sewed some coins on it. I think they were Chinese coins or something, and he would pose with his serape, which I had there at the Art Institute. You know, models in those days got a dollar an hour, and they worked damned hard for their money. Twenty-five minutes and then five-minute rest, then twenty-five minutes and they did that for three hours at a stretch.

The first year I never even got to meet John Norton. I had to do all of these things that I thought were kind of ridiculous, like we had to go over to the Field Museum once a week and look at various periods of artifacts made by the Maoris and the Vikings and I don't know what all. And I had to take some things like Perspective for a half a day a week and Design two mornings a week. That was just my dish because I'd use Indian ceramic designs that I knew. Had lots of fun with that. And what else? Oh, the Life [Drawing] class was utterly miserable. It was a system invented by the guy there named Mr. Forsberg. He was a big, fat, blond guy. And the nude model. . . why, you'd make ovals and ovals and finally if you made enough ovals, why, it would kind of make the figure. Jesus! So I didn't do that. I'd draw the figure, you know? I never got a grade at all. And I saw some of the work that Norton's people were doing, but his class wouldn't allow any first-year students. So second year, anyway, was a lot better.

You know, I never did get over being homesick, and Dad sent me the extra money to come home during the summer semester of the Art Institute in 1926. I spent I guess two months at home, and my friend Oscar – he later used Eric – Mose came down [to El Paso]. He's a Chicago boy.  Mother was up, I think, at Mimbres Hot Springs, so Oscar and I did a nude in the shower in the bathroom, and the nude had red hair and had red hair everywhere that girls have hair and

27

gee, my mother said, "You get that right off that wall." That was really something. We painted over it.

Dad let us take his [car] and Oscar and I went to Santa Fe together and had a hell of a good time. Camped out. Never went to a hotel. Just had a tarpaulin. When we got back from these trips, why, some very good friends of mine in high school who were both going to the School of Mines [now UTEP] were very interested in getting out a *Flowsheet* that was comparable to *The Spur* that El Paso High had. So they asked me if I would do the art work. They couldn't find anybody up there at the Mines that could do art work. I did all the drawings that they required.

Second year there at the Art Institute, Enrique [Alférez] said, "If you don't mind, you can come and live in my place. Mr. Taft won't care." So Enrique and I shared a room in the barn across the alley from the Taft studio for my second year. And during that time I got to take a painting class. And uh, in the evenings, I would take classes in life drawing from a man there who was the illustrator of all the early Tarzan books. His name was Allan Saint John. He was a pretty dadgum good draftsman and he taught me a lot about how to draw the human figure. We worked in charcoal; each pose lasted a week. And we worked from 6:30 to 9:30 five days a week. And I got a lot from that. And the second year I was allowed to compete with a painting for the European Traveling Scholarship.

I remember then when John Norton came by from his painting class and saw what I was doing, which was pretty modern I guess you'd call it, he stopped and said, "That's very interesting." He went on and I said, "Who is that?" And the man said, "That's John Norton." Not long after that, why, I introduced myself and he said, "Well, you come and study in my class next fall," which I did. I was only in his class three months when I quit in order to do a mural. I had a chance to do a mural for a decorating firm that was doing this big old mansion out in River Forest. What I did was design decoration for the four walls of kind of an indoor swimming pool. I took designs from the *Egyptian Book of the Dead*. I made a regular one-inch scale drawing on brown paper of lotus and figures of Egyptian men and women all the way around. And all the figures were six feet high. I either painted it directly on the plaster or put muslin on the walls in preparation so that it wouldn't crack. I don't [remember]. I don't know how it lasted. That was way out on the West Side of Chicago, out past Oak Park. And so I quit Norton's class.

Then I [began] supporting myself with doing little odd jobs. For instance, every Saturday I'd do a portrait for the Jewish Relief Fund. They had a meeting every Saturday noon in the Strauss Tower. And they always had a drawing of the speaker, a drawing rather than a photograph, which was interesting, in a week-

ly publication giving news of the Relief Fund. So, I made drawings for these guys and that was one of my sources of income.

The other thing I did . . . there was a drug store down near Taft's studio and I went in and said I thought I could letter their window cards. And so I did a sample and the guy gave me this job. Every week, why, he'd put different stuff in the drugstore window, you know, and I'd write "Talcum Powder at 59 Cents" or whatever, and I got pretty good at that because I was taking a course in lettering. Oh, this was interesting and had a real effect on me: Eugene Detter. All these calligraphers know about him; he was a great guy there in Chicago. And he had just returned from Europe, where he had taken rubbings of the Trajan column lettering, the beautiful, classical Roman uppercase letters. And he had a disciple named Mr. Cowen, who was very close to Detter, and I got to take a lettering class with him. And sometimes Detter would come in and give us encouragement. And I always had trouble because I was so very left-handed. I had to learn to cut my pens, we used quills then to . . . because they insisted on you knowing how to do everything and not use a speedball. And I had trouble there just like I did later in China, being left-handed.

I saw Norton in the Art Institute hallway about three months after I had quit his class and the [mural] was done. It was at noon and I was waiting for Nancy [Taylor] to finish her classwork and I was going to take her to lunch. And Norton came in and said, "Where the hell have you been?" And I said, "Well, I had a job. I've done a mural." And he says, "Where is it?" And I told him, "River Forest." And he said, "Can I see it?" So on the way back he just abruptly asked me if I'd like to work for him. He said he had a new commission and it was for a decorative sort of landscape in this library. And I remember one of the things that really did get John. When we got all through – I wasn't there – Norton went to get his pay and this old bird that had wanted the work done, he said, "Well, I can't pay you what you asked because I've counted the leaves on that oak tree and you haven't got as many as you had in your sketch." That was the kind of thing you had to deal with.

Then, not too long later, Norton got another studio. It was an old loft, a terribly gloomy place, right over the "El" on Lake Street, fourth floor, and it was about 150 feet long and 50 feet wide. A huge old place. And that's where we did the ceiling for the *Daily News* concourse that was being built. And when we had just gotten started, there was a very loud knock on the door and a fellow came in carrying a violin case and with another man with him. And the other man said, "Are you Professor Norton?" And he said, "Yes," and he said, "You know what you're doing here? You're doing scab work." He said, "You got to join up." [He was] just as rough as hell. So he said, "We can call everybody off that whole damn construction if you don't go along with us." John looked at

the violin case. He said, "Well, I'll let you know tomorrow." He said, "You be sure and do that."

Well, John, of course, went down to Holabird and Root, Architects, who had given him the job, and they had a discussion in there. And so the next day when the man came back, why, Norton took out a membership in the, let's see, it was Scenic Artists Local Union 350, 14th District Council, [Painters, Decorators and Paperhangers of America]. And it cost a hundred dollars a quarter to belong. And he took a membership for me and for himself. And Norton had two of the gals from the Art Institute helping him, too. They were temporary, you might say, and so John [asked the union representative], "Well, now this entitles me [to know] what is a journeyman? And what is this thing about an apprentice?" And this old boy from the union, he said, "See that girl over there in the corner? You're going to lunch, see? And you say, 'Sis, paint up to that line. Here's the color.' That's an apprentice." And the guy pointed at me and he said, "See that kid over there? Well, if you're going out to lunch and you say, 'Son, throw a little warmth in them greens.' That's a journeyman." So Professor Norton learned a lot from the labor union. He paid his dues for the rest of his life.

When he had his studio, the Tree Studio, right close to the Loop, he bought a lithograph press. George Bellows sold him on the idea of making lithographs. Bellows had been out there to Chicago the year before, as a visiting artist. Anyway, we made a lithograph together and then we'd go out and get a sandwich or something. Those were in prohibition days and sometimes Norton would have a pint bottle of gin and we'd have a gin and water and have a sandwich. And we got to talking about our early life and everything. He always treated me like I was a contemporary and it was really wonderful. We got to be very, very good friends.

The most important thing in John's life was his family, to take care of them and do the best he could. He was having a hard time at it, trying to make a living as a teacher. And when he started getting these commissions as a muralist, things got better and it made a lot of difference in his attitude toward life and also the comfort of his family. He had this fine wife named Madge and then he had a son, who was called Bud, and he was a great big old boy. And he had a stunning daughter named Margaret who first married a Chicago theater critic named Ashton Stevens. He was a much older man and that didn't work. Then she married a great guy named Jack Guion who was absolutely no good as a husband but the most entertaining guy. He was one of the first real radio men in Chicago. And of course that [marriage] didn't last and so then Marge married a man named Garrett who was a stock broker and very solid. That helped a lot. She never married again. Norton's youngest daughter was named Nancy. All of

them were delightful. Incidentally, one summer I spent some time over in Saugatuck [Michigan] with the family. That was where they went every summer, across the lake. I did a drawing over in Saugatuck of Margaret's son, a little guy on the beach, with a sand pail and a little spade and a black woman, who was a nursemaid. It's in *The Art of Tom Lea*.

The first work I did for [Norton] was in the spring of 1927. And let's see, we worked in three studios. No, four. The Tree Studio building was first, where the lithograph press was, and then the big old loft on Lake Street, and then somebody left and went to Europe for a while and we had a studio up on Carl Street. It was a kind of an artist's roost up there on the near North Side. And then we got the studio that really was the great stuff on North Clark Street. That was huge. The ceiling was forty feet high, and it was, oh, one hundred feet long, and darned near as wide. It was supposed to have been an early movie studio, where they did two reelers. Somebody said that it was where Gloria Swanson got her start, but I doubt that. It was depression time, and right around the corner from this place on Clark Street was one of the county buildings and a [charity] soup kitchen. And sometimes you'd see three abreast, two blocks long of those poor bums. It would just, you know, tear your heart out.

Norton was so good to me that he would pay me a hundred dollars a week. It was depression times, and in those days a hundred dollars a week was pretty good. And then he got me this mural job of my own down at the Sherman Hotel. One of John Norton's friends was a man named Ernie Byfield and he was the manager and I think owned a great amount of the stock of Chicago's Hotel Sherman, which at that time was one of the good hotels. And there was a night-club in the basement of Hotel Sherman called College Inn. Ben Bernie, quite a jazz man in those days, played every night in College Inn and it was the old pocket-flask set-up deal. And Ruth Etting, who was a great torch singer, was the star there. Anyway, Ernie thought that when the lights went off and there was dancing in the moonlight in the basement that there should be some kind of murals that would give his people some kind of *ambiente*. And he asked John Norton about it. And John said, "Well, no, I don't want to do that. I don't give anything about a nightclub." I think John felt that that was a little beneath him. But he says, "I've got a young man that can probably do it all right for you. I'll oversee the work." So Byfield and I got together and what Byfield wanted: some fellow had just come in and sold him the idea of phosphorescent paint. And you could put it on a brush and paint contours with it and you could fill in the contours. There wasn't any question about modeling or anything of that kind, but it was shape and it was luminous; it would absorb light when the lights were on and then you'd turn the lights off and it would glow in the dark. And so I said, "Sure, I'll take a whack at that."

31

And I did a thing as if the walls of the cabaret were an aquarium and painted these fish with the luminescent paint as shapes, different shapes of fish. Lots of fun with the tropical colors. And then [I painted] a few figures of gawking people looking through the glass at the aquarium. I remember that I got a Mexican fellow who belonged to the Scenic Artists Union that I belonged to, to help. And as I recall it, I worked about three weeks on the thing and it was well enough done. And for my designing and overseeing the job I think I was paid nine hundred dollars. I'm not sure. It was either nine hundred or eleven hundred, something like that. A fortune! I got it all in one check. So I did that and [it] gave us enough money for Nancy and me to go to Europe. That's how I got to Europe.

Nancy was a beautiful girl. I saw her the first year I was there. [She] had spent one year at the University of Indiana and had dates with Hoagy Carmichael. And she came to the Art Institute at the same time that I did but she was in a different set of classes. So I never did have an opportunity to [meet her], you know. I had admired lots of pretty girls and that was it. But the second year we were in a class together. I've forgotten what it was. I think it was Still Life Painting or something like that. And I was very much impressed with her and let's see, she knew a lot of poetry and I thought I did. I was reading Shelley and Keats, you know, kind of romantic stuff, but . . . . Anyway, I invited her out to one of the [Sunday afternoon] teas at Lorado Taft's, clear out on the South Side. And we had a very pleasant time. I took her to dinner, then, down on Cottage Grove Avenue after the tea. And, I don't know, we really got interested in each other, but we didn't get married until February of 1927. We went up to Waukegan and, I guess you'd call it, eloped. Her mother didn't like it worth a damn and her father didn't care.

So it wasn't too bad [because] I had my work for John Norton and everything. We had a room in a rooming house over on Cass Street, and we lived there [awhile] and then I had a chance to get into an apartment house up on Fullerton Parkway, which is right by Lincoln Park, a beautiful place. We got a one-room apartment on the tenth floor. It was kind of cramped. We lived there for two or three years. After we were married, [when] I had a little extra money and Dad and Mother sent some money to help out for our fare, I brought Nancy down to El Paso. [It was] late in 1927, I think. That was Nancy's first introduction to the West. She was from Terre Haute, Indiana. And my uncle Dale, my mother's brother, got us a rented car; it was a little Ford roadster, Model T. And we had a suitcase between us and we rode up to Santa Fe. You know that was a great deal in those days. It took us three days to get there.

Another thing that I remember about the Art Institute was the director, a man named Robert B. Harshe, a wonderful man. And it was against the law for

a student to smoke out there by those lions out on the steps in front of the Art Institute. And I came out of the Art Institute one time with a cigarette in my mouth and this rather, I would say, sturdy looking man, burly almost, said, "You want a light?" and pulled a lighter out. And I [later] asked who it was and found out it was Harshe. And John [Norton] said, "Well, I think you ought to know him better." And he took me in the office one day and they had planned it. Harshe said, "Would you like to do some murals for the South Park Commission in one of the south parks," and I said, "I'd sure like to do murals anywhere, sir." And so I did murals for what they called field houses in these public parks way down on the South Side. And it was a way to make some money.

[In Chicago] there were two people . . . no, more than that, two *influences* that gave me lots of pleasure and some direction. There was a fellow student older than I was, named Wallace Purcell, at the Art Institute. Wally was a very good sculptor, and he had just done a portrait of a child of some friends of his that lived up in Kenilworth. And he said, "I think you ought to meet them. They're just great people." So I went up there with Wally one Saturday afternoon. And I met Fergus and Josephine Mead.

And of course, my friendship with Fergus [Bill] Mead was one of the great friendships of my life. And he was very much like this Hemingway "lost generation" thing. When he went off to war, he volunteered in a Wisconsin outfit. I forget the name of the division, but he fought all through the World War I in France and Bill was a veteran of the Meuse-Argonne offensive. He had had people fire at him in a serious manner. And all this time he was engaged to a girl named Josephine Parker. Her family owned the fountain pen company. [They met] at the University of Wisconsin.

Well, he came back from the war and was discharged. He didn't ever even get a scratch on him. He was a very lucky guy. And they married and Bill wanted to go to Paris to write. So they went. And they were there for two years. Their first child was born there in Paris. And they lived that life around Montparnasse and all that stuff that you read about. He did not ever meet Ernest Hemingway or any of the Gertrude Stein group or any of that. And Bill was an honest, wonderful man and a most informed man. He told me, "One day I was sitting there in this little rented apartment in the midst of all this happy life in Paris. I was looking at this play that I had written, and I knew it was never going to work and I knew I had no business fooling around." And he said, "That day I made arrangements for us to get little Bill and Josephine back to Chicago, where I thought I could get a job." And so he got a job. He became one of the managing vice-presidents of an advertising firm called the Buchen Company. Anyway, Bill and I hit it off just perfectly. And after I married Nancy, I took Nancy up there and she hit it off perfectly with Josephine. So almost every weekend, why,

33

we would be up there. Bill had a boat. It wasn't Star Class; it was a more of a lit-tle family sailboat for having fun rather than racing. I remember the name was the *Aeduna*; that was an obscure goddess that Fergus picked up somewhere and named his boat for. Anyway, we learned to sail on Lake Michigan and had won-derful weekends up there with them.

And Bill had a wonderful library, which he made available to me, anything I wanted to borrow. And I became aware of people like Hemingway and Gertrude Stein and the guy that didn't ever use capital letters, the poet e.e. cummings. I knew something about Scott Fitzgerald because he had done so many things in *The Saturday Evening Post*. And through Bill I made the acquain-tance of the books of Aldous Huxley. The first thing I read of Aldous Huxley's was *Point Counter Point*. And I went from there to sort of collecting Aldous Huxley's books as they came out. His essays on the various things in Europe that he liked made a great impression on me. Later, when I went to Europe I tried to see a lot of the things that he talked about.

The other influence [in Chicago] was a gal that Nancy had met somewhere and her name was Edna Mandel and she was married to Leon Mandel II, who owned the Mandel's big department store on State Street. They were very wealthy people. And Edna had ideas of being an artist but not serious enough to do anything about [it]. But she commissioned me to do her portrait, which was a lousy thing and which I was able to destroy before she got too mad at me. On Saturday nights they used to have parties at their big apartment, about two blocks from where we lived overlooking Lincoln Park. And they'd have people like Earl "Fatha" Hines and Tiny Parham come up and play the piano in their apartment. It was the days of Al Capone's gin and it was quite an interesting thing. And [it] gave me, a country boy, kind of an idea about how some other types of people lived. . . with a lot of dough, just to do anything. So Bill and Leon and Edna were people that were a different kind of influence on me than the great influence of John Norton. But I thought I'd mention it because it was a part of our life. Every weekend we had lots of fun and fun that we could not possibly have afforded.

I made a living. I was very proud of that, and I think my folks were very proud of that. I did some advertisements for the Reading Pipe Company, I remember, that even [appeared] in *The Saturday Evening Post*. I had a portfolio and used to haul it around under my arm to go to these various advertising agencies. This was between murals, you know.

And one day – this was in 1930 – John [Norton] said, "You know what you ought to do? You ought to go to Europe. It's time for you to see some of that stuff over there." So we [Nancy and I] went to Europe on the *Ile de France*, third class. This was in steerage, and we were the only people that spoke any English

at all. They were Poles and Italians and all kinds of people going back to see their people, but apparently they hadn't had much success in the U.S. because they were not going back in any style. And we got to Le Havre and took the train up to Paris. And John Norton said that there was a little hotel there that he thought was pretty good and that it was reasonable and it would be a good place for us to get started in Paris. And it was called the Hotel Paris-New York. And I remember the address because the taxicab drivers looked at me with such disdain when I tried to say *"Cent quarante-huit Rue de Vaugirard."* "You mean 148 Rue de Vaugirard?" Anyway, the side street of this hotel – and I remember this almost better than the hotel – was named *L'Impasse de l'Enfant Jesú*, the Alley of the Infant Christ. This was over in Montparnasse on the Left Bank.

And we saw the Rotonde and the Selecte and sat there very uncomfortably, not knowing a soul. And we were there maybe four or five days of just prowling around the city [because] we were too proud to ask for any kind of directions. There wasn't much organized tourism. Oh, this was the end of the season, August of 1930, when everybody stayed home. There was no money, you see? And so we almost had tourism to ourselves. I found out that there was going to be a great exhibition in the Louvre, and it was featuring Eugène Delacroix's great, wonderful works.

Well, all the time that I was a student at the Art Institute I was crazy about reading in the Ryerson Library there under the roof of the Institute. There were three volumes, all in French, so I didn't get the text, but wonderful pictures of Delacroix's work. And for some reason Delacroix was my favorite, so Nancy and I spent two or three days in the Louvre, being absolutely awed by the wonderful paint quality this man had. This was years before I ever understood that the paint quality that I admired had come from a fellow over in England named John Constable. Then I found out that the Church of St. Sulpice was still open and there were two great murals by Delacroix, and one of them was Jacob wrestling an angel. I had studied that in the Ryerson Library! And we took a taxi to get there. And we spent the day in the sacristy. There were a few people in there praying, the doors were open. But there was this great tree over Jacob wrestling with the angel and it was the most magnificent painting . . . . It thrilled, thrilled me. And that was [a greater] highlight than the exhibition in the Louvre.

And we went to other places in Paris where there were great things going on, but we weren't bohemian enough to enjoy it and we didn't have much money and so mostly Paris to us was walking with a map. And it was completely [beyond our budget] to get across the Seine and go to the [Hôtel de] Crillon or any of those places, but we walked and we walked all through Paris.

35

And I bought a book on Delacroix and one on Piero [della Francesca] and I said, "Let's get out of this town. Let's go to Italy." That's what we really wanted to do.

So we took the train south. We had one big suitcase, Nancy and I did, and we learned our first Italian in these third class carriages: *"Non sputare nella carrozza!"* "Don't spit in the carriage!" But everybody did! We arrived in Florence in early September, and God, Florence was a wonderful place. We went to a hotel there and it cost the equivalent of ten dollars a night and we were just burning our money up. So we asked about *pensiones* and there was the Pensione Picciolli, I remember, and it was right on the Arno. We were on the fourth floor, and we could look down and it was supposed to be the exact spot where Dante had encountered Beatrice. And we looked out across the river and there was a spire of Santa Trinità and God, it was glorious! Another thing about Florence that we loved so much was the little Church of the Carmine where Masaccio's murals are. That was the one I made drawings of. Then also the Church of Santa Croce, which is a big church, had all the Ghirlandaio mural portraits over the choir stalls: all of the historians and some of the great ladies beautifully done in this marvelous mural. Well, we stayed [in Florence] 'til I said, "Well, we've got to go to Arezzo, and we got to go to Orvieto." When we were trying to make arrangements to go, we found out we'd have to travel third class with all the chickens.

One of the things that I'll never forget was on our way over to Arezzo. In the railroad stations, they had little box lunches called *cestini*. It had a piece of bread and it had some cheese and it had a piece of bologna and then it had a little bottle of red wine. Good. Well, we were sitting there having our *cestini* and a great big, fat priest came in and sat down on the opposite bench where we were. Our baggage was all overhead and I was sitting there, and he finished his *cestini* and he had a pocket in this long gown that he was wearing and he pulled out I guess it was his prayer book and a pocketknife. He opened the pocketknife and proceeded to pick his teeth with a pocketknife, and I've never forgotten that.

We went down to Arezzo and I remember we felt like we were such holiday people. We hired a *carrozza* drawn by two mules and the harness had red yarn on it, little yarn tassels, red tassels and jingle bells on the shaft. And we went up to the Church of San Francesco before we even went to the hotel. And, God darn, there it was. Well, we got a room in the hotel, which cost more than we felt it should have, but we stayed in Arezzo a few days. And I found that I could buy 8x10 black-and-white prints called *Alinari*. All the masterpieces in Europe were done in Alinari prints. So we bought a whole set of these there in the Church of San Francesco that Piero had done. And we didn't have to sketch because we had the photographs and they were good photographs. The second

day I was there, we gave the old *sacristano* a tip, and he let me climb up on the choir stalls so I could touch the bottom of Piero's work, and it was lovely.

Anyway, then we went on to Orvieto. I think the reason we went there was because we were so anxious to see what Luca Signorelli, one of Piero's best students, could do. So we went over there and there's this great transept. On one side are people rising into heaven with the angels carrying them and on the other side, why, the devil's carrying people to hell. But the main thing was the first splendid Renaissance anatomical display. Signorelli really had studied human anatomy, you know. Nobody could imitate him. But we loved the plain austerity of Signorelli's mural just as much as we did the serenity of Piero in the Church of San Francesco.

At Orvieto, I remember, we had lots of fun. We discovered the *"Est-Est-Est"* wine. It was a red wine. I don't think it was ever a specially good one, but there was a wonderful tale about it. This guy at the hotel could speak a little English, and he told us about this old priest, a bishop, in the Middle Ages that had gotten word that the pope wanted to see him. And he made this trip, riding his mule all the way down from northern Europe and he got to Orvieto and was very thirsty and ordered up a great cask of wine. And he tasted it and he said, "I think I'll stay here a while." And he never showed up in Rome and the pope sent word, "Why aren't you here?" He was still in Orvieto. And he was so far gone that all he ever got to really answer the pope was *"Vino Orvietani est, est, est . . ."* and expired. Anyway, that was the kind of stuff that we loved.

We went on south to Rome and, of course, Rome was a whole new world, too. We were in Rome a month. And in those days I think we paid five lire and that was twenty-five cents or something to get in [the] Sistine Chapel. And you could rent a mirror for ten lire from the old *sacristano*, who was a kind of gatekeeper, and there wouldn't be anybody in there but you. Then maybe five or ten tourists would come in and gawk a while. But you could sit on the pews and with the Alinari prints and with the mirror you could study the Delphic Oracle or see how Eve was beseeching Adam and how the Lord was in the whirlwind creating Adam and all these things. And you could look and not kill your neck. It was . . . quiet, nice. Then you'd look up over the altar and it was all blackened with candle smoke. I never understood why Michelangelo made that figure of Christ so fat and so wide. It's a very strange figure of a male. It may have something to do with Michelangelo being old, or I don't know what.

And then in Rome after seeing so much, we were suddenly up to here with art. So, I said, "Let's go to Naples." And we got to Naples and we found out that we could get a ticket on the boat that went to Capri for twenty lire, a dollar or something. We went over there and found a *pensione* and it was called the Hotel Eden Paradiso. They named it twice. It was clear up on Monte Solaro, the

highest part, and it was like being in paradise for kids. We had our feet washed with lye soap and a scrub brush and then we helped to trample out the grapes of the 1930 harvest at Capri. And we'd see old Norman Douglas, [who wrote *Southwind*], and Dr. Axel Munthe, the guy that wrote the [*Story of*] *San Michele*, and their little boyfriends walking in the vineyards. And we would go down some days and rent a funny old cotton bathing suit and sit on this little beach, Marina Piccola, and spend the day down there with a little *cestini*.

And one thing [that happened in Capri], I don't know how to explain it. I was by myself up on the path that led to the top of Monte Solaro, where there was a little shrine. And this old woman appeared out of nowhere and she had a stick that helped her walk, a crooked stick, and she held out her hand and mumbled something in Italian, which I did not understand. She was asking me for alms, and I didn't pay her any. It frankly frightened me. I didn't . . . I couldn't acknowledge her. I was very emotionally impressed by this old beggar woman. I came back to the *pensione* and I told Nancy about it [and said], "I'm going to make a drawing of it." And I made the drawing and it has the little background of the different kinds of pine trees that grew there on the island and this steep hillside. And many years later, I found the picture in a portfolio that had survived Santa Fe and everywhere, and I gave it to Jim Lea in Houston. Then I [realized] what it was, what I had seen. And this probably is very sentimental, but it seemed to do something for me. I was this kid, an ignorant youth from a new world, encountering the past and the past was asking for something. So I wrote it on the back of this [drawing] that Jim has.

We had a wonderful time in Capri. We'd go down to the ruins of Tiberius' palace down there, and look out over the Mediterranean. At night we could just see a faint glimmer of the fire from Vesuvius. It never erupted or anything but there'd be a little smoke, like a kind of shadowy light.

Anyway, the money ran out. We figured we had enough to get back to Le Havre, and we had a round-trip passage, third-class again, on the *Ile de France*; it was making a return [trip]. This was in December. We were only there from August until mid-December. So we came back to Paris and guess what we found at the American Express? A check from Dad! So we could go back second-class instead of steerage, and there was something left over.

So I asked the clerk at the Hotel Paris-New York how we could get to the flea market. He said, "I'll take you. You can't speak French and I'll help you." He was a very nice young man. So the three of us went to the flea market in Clignancourt and there was exactly the kind of Arab/Moorish musket, an old flintlock, that looked like it was right out of one of Delacroix's pictures of the wars. The whole barrel was wrapped with this beautiful brass wire, and it had

38

pieces of ivory and some kind of a vermilion thing embedded in the stock and design. It was kind of dirty and had been thrown around some, [but] it was quite a nice piece. I forget exactly [what the price was], but it was very reasonable and I could afford it. So I bought the darn thing and we got back to the hotel and the clerk helped me wrap it in *Le Matin* or some newspaper from Paris.

I carried this [musket] back, and [when] we got back to Chicago, Dad and Mother said, "Well, we've got to hear all about [the trip]," so Dad sent the money for us to come to El Paso, and I presented the gun to him. But I had had time to write a little thing I call "Memoir of a Flintlock," and I knew a book-binder up on North Clark Street in Chicago, and [I had it bound]. It's in my handwriting telling about being in Delacroix's studio and has a few little draw-ings of this [gun]. It was one of the things that my stepsister Bertha [Schaer] found in the old house on 1400 Nevada about two or three years ago. I pre-sented the gun to Dad and Dad, of course, was delighted with it. He had quite a gun collection [but] he didn't have a gun of that kind. But that was the sou-venir we brought back to Dad from our trip to Europe. For Mother we bought some embroidered linens. It was a trip that came at just the right time. See, we were children, really, Nancy and I, and we had never been anywhere or set foot on any kind of foreign soil.

Norton had a lot of work when we got back, and I started right in to work. But one of the curious things [that happened in Europe] was when we had to change trains in Marseilles. I had a rupture. I could feel it pop when I was putting our big suitcase overhead. I worked about a year in Chicago and John wrote Mother and Dad, "I don't think Tom ought to work now until he gets this hernia fixed up." Well, that scared Mother and Dad very much and they scrounged up the money, and Nancy and I went down there. And I was operat-ed [on] by old P.H. Brown, the surgeon that did most of the work in El Paso in those days at Hotel Dieu. In those days, when you had a hernia operation, you had to stay in bed a month afterwards. And you got weak and puny and didn't do any good. And when I was in bed there, that's when I would take those Casas Grandes bowls and pots in Dad's collection and analyze the decorations that went around them and make drawings. So I was occupied when I was having to stay in bed. I went back to Chicago then in good shape and I didn't have to have another hernia operation until about five years ago.

I worked hard for Norton then until early in 1933. John knew he had a cancer and they had operated on him. It was cancer of the stomach, and they told him that he could live awhile. It was in December and early January of 1933 and I was up in St. Paul, Minnesota, installing murals that Norton had designed and partly painted and which I had finished. When I came back, Norton paid

me and told me that it was time for me to row my own boat. He sat down and didn't ever say, "I'm going to die" or anything. He just told me, he said, "Oh, hell, you'll hear from me and I'll hear from you. You ought to get down there where you love the country. I wish I could go with you but I'll stay here." So he did some murals for the Chicago World's Fair in 1933 and he died the next year in January 1934, [after] Nancy and I had moved to Santa Fe.

When John told me that it was time to leave, of course, I felt that it was. And I knew exactly where I wanted to go, but we came back to El Paso first and I bought a 1926 Dodge sedan for seventy-five dollars. One of the back windows of this sedan got broken and never was replaced. That was a two-day journey to Santa Fe in that old Dodge, and I saw my friend Fremont Ellis up there and he didn't live on Camino del Monte Sol anymore. He lived out about eleven miles south of town in this place that he had bought, called the Rancho San Sebastian. So we got a deal going there. He let me have four acres and I didn't have to pay anything. And I had enough money to build this one-room adobe house.

And being isolated that way, Nancy and I had very few contacts with the art circle or other residents of Santa Fe. Our main socializing was with Fremont and his very beautiful wife, Lencha, who was a native of Santa Fe. I do remember one evening we were invited over for dinner at Haniel Long's, the poet. I think the only reason [we were invited] was that he and his wife were interested in young painters and young poets. We had a very pleasant time, but our association with that group of people in Santa Fe was limited.

I met very few of the artists. I remember Gus[tave] Bauman most vividly. He was instrumental in signing me up for the WPA paintings that I did for the New Mexico Fine Arts Museum and which they still have. Initially I thought [the WPA] sounded like charity, and I was not going to do that. But Bauman told me, "You're crazy. You need the money. Why don't you do it." We were paid by the week regardless of what we did, and it gave me the opportunity to do anything I wanted to with southwest material. I think there were five or six paintings. One of them was *The Snake Dancers*.

A grocer named Dick Kaune gave us credit at his grocery store. We'd go in once a week in this old 1926 beat-up Dodge, and he would let us take whatever we needed and charge it. I didn't get him paid until after I'd moved to El Paso. I wrote him this letter and sent the money that I owed him and he wrote a nice letter back saying that he had never lost a penny giving credit to an artist. And he said, "That doesn't hold for a lot of other kinds of people." Isn't that kind of interesting: starving artists pay their bills.

One of my best friends up there was Dr. H. P. Mera, who was a retired medical doctor and a very skillful archaeologist and ethnologist. He worked at the

Laboratory of Anthropology, and he and Gus [Jesse] Nusbaum, who also worked there at the Laboratory of Anthropology, were very interested in the drawings I had made of the designs on my father's Casas Grandes bowls. They hired me as a staff artist to make diagrams and maps and copy. I worked there at the laboratory I think it was three half-days a week, and I was paid by the hour for my work. My first job was to do a painting of a Navajo [blanket] which was very elaborately colored and the most valuable [blanket] they had. That took me quite a while, and it was later published by the [Southwest Museum in California], and it was the first color reproduction of anything I had ever done.

Nancy and I lived out there in the boondocks with no electricity, no gas, no modern connection with the world. The winters were fairly severe and we had nothing but a little corner fireplace and, of course, our kitchen stove. I had to chop some wood to keep it going. We had a corrugated iron roof, and we had a little drain pipe that led into a 200-gallon cistern at the end of the house. That was the extent of the water that we had there at the place. So we used to have to haul our water for drinking in five-gallon cans. And, naturally, the water for a bath was very short. So Dr. Mera and his wife, who was a motherly, fine lady, very kindly asked us if we'd like to come to their house for a nice bath. I guess I needed a bath or Dr. Mera wouldn't have mentioned it. Anyway, we'd go in about once a week and have a nice bath in the Meras' bathroom.

One time our good friends, Fergus and Josephine Mead, drove out to Santa Fe and lived our primitive life with us for two or three weeks. They slept in our double bed, Nancy slept in the studio, and I slept out on the little patio in front of the house.

Life there, close to the hills and the piñon of Santa Fe and its environs helped shape me so. We had a fine time, a very good life and then . . . Nancy got this pain in her side and I got her into town in the old Dodge at night and took her to the hospital. And they operated on her the next morning. I didn't know the doctor or anything else. And the antiseptic equipment was no good and the wound became infected. [It] never healed.

We came back to El Paso where Nancy was in the hospital a lot, and during that time we lived with Dad and Mother. Nancy had to be near Dr. Harry Varner in the hospital here in El Paso. She saw him quite a lot. And Abby and Ewing Thomason had a house down on the corner of Newman and Rio Grande, two blocks from [my parents' house]. And they had to go to Washington [D.C.], and they hadn't made any arrangements, so they wanted to know if we'd tend to the house. So we took that house and lived there for two or three months in 1935. She died here in El Paso [April 1, 1936]. And I've chosen to blank that part out of my life. After her death, I went back to Santa Fe with a friend

[Bill Waterhouse] in a pick-up truck, up the hill to this little house and picked out some stuff that I wanted to take. The rest I just left there, left the key in the door and never went back. I've never been back since. And I . . . the only way I could handle it was to just . . . I think this is the first time I've ever . . . but this is something I don't like to think about. When I came back here to El Paso, why, I just forgot Santa Fe. I never saw Fremont Ellis again or anything. I started over.

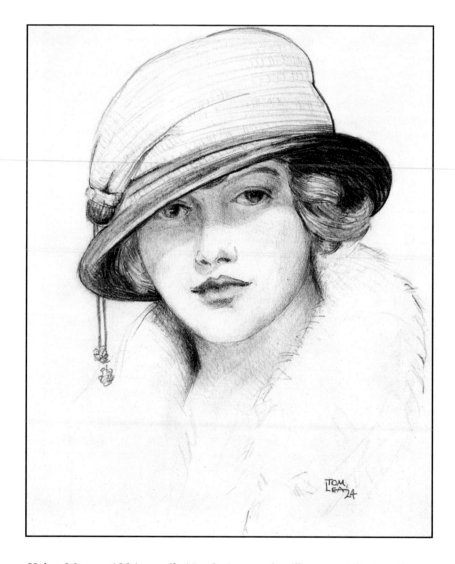

Helen Moore, *1924, pencil, 11 x 8. A magazine illustrator who saw this portrait suggested Tom Lea attend the Art Institute of Chicago. (Collection of Mr. and Mrs. Wallace Lowenfield, El Paso)*

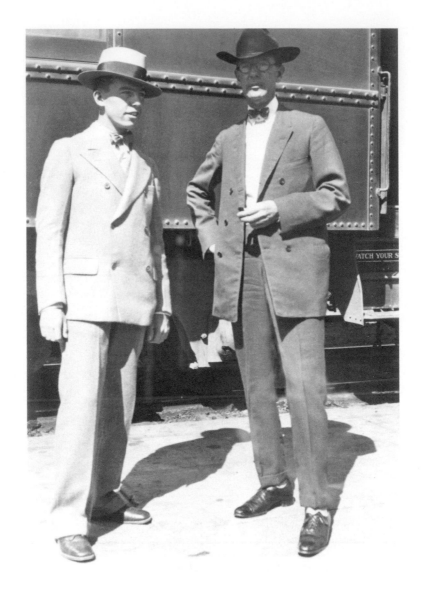

*Eighteen year-old Tom Lea departing for the Art Institute of Chicago, with his father at El Paso's Union Depot, 1924.*

*The Art Institute of Chicago, Michigan Avenue Entrance, c. 1920. (Courtesy The Art Institute of Chicago.  All rights reserved)*

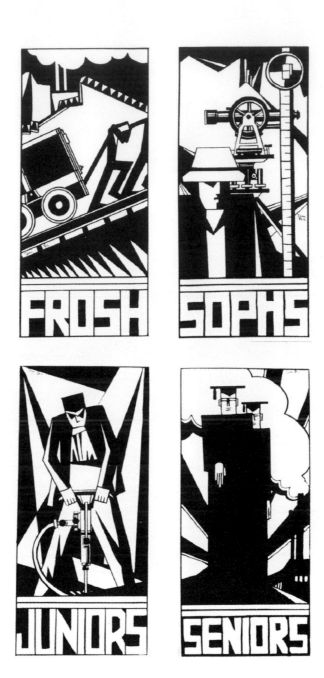

*Class headings for the 1926* Flowsheet, *yearbook of Texas College of Mines and Metallurgy (now the University of Texas at El Paso).*

Girl with garter, *1929, carbon pencil, 21 x 16 1/2. A drawing from Lea's Chicago years.*
*(Collection of the artist, courtesy Adair Margo Gallery)*

Caricature of John Norton, *1928, pen and ink, 5 1/2 x 5. Lea's drawing of his teacher and mentor*
*at the Art Institute of Chicago. (Collection of the artist, courtesy Adair Margo Gallery)*

Marina Piccola, Capri, *1930, pen and India ink, 4 3/4 x 7 1/4. Sketch
completed during Lea's first trip to Europe.  (Collection of the artist,
courtesy Adair Margo Gallery)*

The Old Beggar Woman, *1930, dry brush and ink, 9 x 7 1/2. Lea's
encounter with this woman on Capri left an indelible impression on the
young artist.  (Collection of Dr. and Mrs. James D. Lea, Houston)*

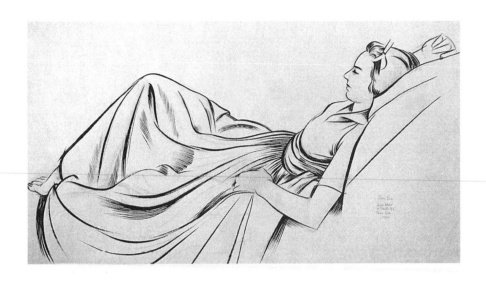

Josie Mead in Santa Fe, Casa Lea, *1934, brush and India ink, 22 1/4 x 36.*
*Josephine and Fergus Mead, friends from Chicago, visited Tom and Nancy Lea*
*in Santa Fe.  (Collection of the artist, courtesy Adair Margo Gallery)*

Casa Lea Window, Rancho San Sebastian, *1934, ink and watercolor, 12 x 18*
*1/4. Study looking out from the window of the Leas' one-room adobe home in*
*Santa Fe.  Indian ceramic designs influenced his work. (Collection of Mr. and*
*Mrs. John Knight, San Francisco)*

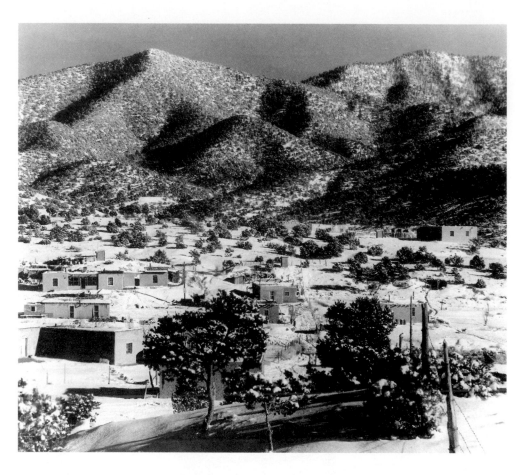

*Santa Fe, view across the Santa Fe River southeast from Cerro Gordo, c. 1936-1940. (Courtesy Museum of New Mexico, negative number 43242)*

## Chapter Three

# *Back Home,*
# *1936 – 1941*

I came to El Paso in 1936 and reestablished myself here with my friends. It was a strange year: Nancy died in April; my grandmother, who was living at our house, we called her Granny, died in June; and my mother died in December of that year. All three of the women in the family died that year. That's when I painted *Lonely Town*. I think the deaths in my family probably echoed in my subconscious mind in this painting. One summer evening I looked up one of the side streets off of Avenida Juárez, past the houses to the edge of Juárez. In those days there wasn't much, just the *acequia madre* and these little houses and then the Juárez mountain. It was something that grabbed me.

My little brother Dick was nine years old when Mother died, so he had a hard row to hoe. Dad tried to perform the functions of both mother and father and I think he did fairly well. There was a nice Mexican woman named Pomposa Macías, who had been washwoman, assistant cook and everything for my mother for years. She stayed on and took care of my little brother Dick in the house. Brother Joe and [his wife] Marjorie were living up in Las Cruces. Joe was working for the [International] Boundary [and Water] Commission and they'd come down every weekend to sort of help us out.

I lived in the house at 1400 Nevada with Dad, Dick, and Pomposa from 1936 to 1938. By that time I wasn't doing any WPA [work]. I didn't need it because I had other things. The government projects [Treasury Department, Section of Fine Arts murals] came along and kept me occupied as [did] the centennial celebration of Texas. And [Percy] Pop McGhee, the architect, gave me a private commission for a mural up there in the Branigan Library in Las Cruces.

[I did most of this work in] my studio in the Hills Building on the first block of Texas Street [where] Norton Brothers and the Guarantee Shoe Company had stores adjoining each other. It was a two-story kind of office building and it had no elevator; you had to get up on the second floor by stairs. It was [managed] by the Coles brothers, Billy Coles's Dad. Billy was my friend in high school and his daddy and his uncle were the ones that let this artist have this studio at a very modest rate. It had been a bookie's joint. And it had fine, big windows

northside and drapes to control the light, and it worked out beautifully. And I had a scaffold built, [the] kind that I had learned from Norton. It was on wheels and the ceilings were high, so I could work up to about eleven feet [on] a canvas. So that it was a very satisfactory place to work.

[While I was working in that studio I met some interesting people, craftsmen who influenced my life.] One day Carl Hertzog came up and knocked on the door of my studio there above Norton Brothers. I had never met him and he introduced himself, and I invited him in because I was working on those murals for the Hall of State Building there in the Texas State Fairgrounds in Dallas for the [Texas] Centennial. He came in and he said, "Well, Mrs. [Maud] Sullivan said you wouldn't mind if I came by and introduced myself. I'm a printer down here on San Antonio Street and got some work here from Billy Tooley, who's managing the [Hotel] Paso del Norte. He wants some drawings to go with the advertisements I'm doing and would you be interested?" Well, I was interested in any damn thing that would bring in a dollar and I said, "Certainly." So that was the first job we did together: two or three ads for the Paso del Norte Hotel. And, incidentally, that was one of the first brushes we had with, I don't know what you'd call it, the proper way to look at the what are known now as Hispanics. One of the characters was a real raw-bone cowboy who was obviously from Oklahoma or somewhere, and I had a Mexican guitar player who was round and fat and jolly and had a big moustache. And it seemed that some people thought I was caricaturing the Mexican people, so I said, "Okay, Carl, we'll fix that up." And I pasted a real skinny *charro* guy that looked very serious and glum over the little fat Mexican. That was better public relations. This was in 1937.

Carl had a very, very interesting upbringing. He was born in Lyons, France. His father was a concert musician, and he was traveling with Carl's mother in Europe when Carl was born in France. The father died when Carl was quite young and his mother came back and settled in Pittsburgh and that's where Carl was raised. When he was eight years old, he stuck his nose in the neighborhood print shop and smelled that printer's ink and it got him just like linseed oil got me when I was young.

The first book we did together was my [first] wife Nancy's notebook. She had left some manuscripts and among them was the journal that she had kept, and I thought it was a fascinating kind of record of her mind and of something about our life and when I showed it to Carl, he said, "Let's do it!" And we printed twenty-five numbered copies. That was all. In those days you could send off and get this wonderful handmade European paper from I think it was called the Fairbanks Company or something, and he got the paper and he used his own press. He had no type faces that he could hand set; he did have a good set of

mats for Caslon Old Style, just one size, I think it was twelve point or ten point. And he used that and he hand set little titles out in the margin of every page. It was a beautifully done book. There was never a copy sold; most of the books were given to Nancy's friends up in Chicago. And I gave some away here. And I always felt that in giving them, it was sort of a loan some way . . . to my friends . . . about something that I didn't want to speak further about. I don't know. This was very . . . I think my friends understood it. Several of them on their death beds have given the book back to me, which I have thought was wonderful and I could give it to another of my friends. So there was a great bond between Carl Hertzog and me. Ten minutes after I first met Carl, he and I were lifetime friends. We just hit it off.

We were dreaming of a book of Castañeda's account of the Coronado expedition, and I had done a drawing and Carl had set type for the wonderful title page, and we took some proofs Carl made to Mrs. Sullivan and she said, "Well, you've got to have an introduction by a good historian and you probably should have it annotated, too. I know just the man: Frederick Hodges, and I'll write him." So she wrote him. He was at the Southwest Museum, I think it was, in San Diego. And he wrote back and he said, "Well, the Grabhorns have just done it." The great Grabhorn press in San Francisco, see. So that took the wind out of our sails as far as Coronado was concerned.

Carl and I would go over to the old Tivoli there on Avenida Juárez just across the Santa Fe bridge. The bartender Carlos Mora was a very friendly man and he also was an aficionado of *toros*. And when Carl and I would come on summer afternoons, and we were talking big things about the books we were going to do and everything, Carlos would fix us these fine, very tall, very pink planter's punches. And Vivian [Carl's wife] would be sore as hell at me for bringing Carl home a little stiff, you know. We had a great time.

I met Urbici Soler very much the way I met Carl Hertzog. One day he knocked on the door to my studio when I had it above Norton Brothers' store there on Texas, in the Hills Building. And he could speak practically no English; he had a very hard time at first because he knew so little English. He was from a little town outside of Barcelona [Spain], and he had just come up from Mexico. His friend and a fellow Catalán, the priest Father [Lourdes] Costa, had told him to come up, [that] he had a job for him, and Soler asked who the artists around town were, and the priest had given him my name. Father Costa was a very peppery priest and he's the one that actually got Mount Cristo Rey going. He went to the bishop and said, "We want to have a fine statue up there where we can make pilgrimages."

Well, Soler had to first investigate where he could get proper stone to carve, and the nearest place for the quality of the stone that pleased him was a quarry

near Austin. And he went down and supervised their cutting the stone out of this big quarry. Then they had the difficulty of getting the very heavy stuff out here. This was in the days before there was much trucking and it all had to come out on the railroad. And then to get these stones up to the top of Cristo Rey . . . there was no path, nothing. He had a little engine installed at the top, a sort of cable lift that could haul these big stones up the incline. I imagine the main stones weighed 1,500 to 2,000 pounds. It was really quite an engineering feat. He got the stone for the Christ figure all in place up there [with] some metal bolts holding it together. And then he carved. He carved that thing in place up there.

One time Ellex [Elliott J.] Stevens and I went up to see how he was doing and what he was doing. And there was no other way up there except straight up this path alongside the cable and the little engine. So we climbed up to the top and there was Soler, hat down around his face, like a beach hat, and very rough clothes with powder all over. He always had a good haircut, and he was always shaved, but his face was just like a ghost's with this powder. He had some gasoline engine tools up there to drill and he'd use his chisels by hand. And, of course, I think the figure is something over twenty feet high, and in order for it to appear correct from the spectator's point of view down on the ground, Soler had to elongate Christ's head. He used his eye to do the foreshortening in proportion. The whole thing was done with great, great knowledge and perception. [The church] ran out of money and as I understood it from him, he had a little money saved and he actually used his own money to finish the thing. It was very difficult for him to do that because he never had much money. [With him] it was always, "Let me do it because I want to give it."

Soler had worked with the sculptor [Aristide] Maillol in Paris and he had briefly been in Rodin's studio when Maillol was there. He was a traditionalist, and he had a great perception. He lived with Father Costa a long time until, oh, the last two or three years of his life, why, he got a little house out at Anapra and lived out there by himself. He married a girl who was from Santa Fe and it didn't work out. And then for some reason Soler went back to South America where he had been when he first left Spain, and he did a lot of portrait commissions in Buenos Aires. He also went over to Chile [where he became interested in] indigenous people.

The portrait I did of him was done right after I got back from the wars. He came in the studio and he said, "We should do portraits of each other." And I thought, "Oh, that's great. I'd love to have a bronze bust made." So he worked on the bronze that is now in my library. Two were made, and the other one is down at the UT Humanities Research Center [Harry Ransom Humanities Research Center]. It was great fun to see how he would trace out the forms of

my face and my neck and the narrow shoulder. He'd watch and look a long time. Then he'd take a little piece of clay and [ptk!] on there, you know, and then scoot it around with his thumb. See, he had a big thumb. It was his right hand that he did his work with, you know. In my portrait I had Soler telling one of his stories. I tried to get something about the way he used his hands; he was always animated. And on the table I included a sort of beaker that held wine, typical Catalán. He was a great friend. He looked like he was enjoying everything.

In that same studio in the Hills Building, where I had met Hertzog and Soler, I did *The Nesters* [mural] for the Post Office Department Building in Washington [D.C.]. I had won a national [Treasury Department, Section of Fine Arts] competition of painters, and a lot of the painters had great reputations up in New York. They sent out a flyer notifying all painters that wished to compete in the competition. They set the architectural space and you designed in full color and in scale your intention for [it]. It was very comprehensive; what you had to submit had to be quite finished. I think I worked as hard on that as anything I ever worked [on] in my life. There were eight spaces and I suppose there were a hundred entries for the eight spaces, and [I did a proposal for] a space that was on one of the upper floors, two panels in the elevator hall [*Design for The Western Frontier: 1st Phase, 1830-1860*] and [*Design for The Western Frontier: 2nd Phase, 1860-1890*]. [They chose] just a little fragment of it for me to enlarge and put on the ground floor in the Benjamin Franklin Post Office on Pennsylvania Avenue [*The Nesters*]. It was a big canvas mural, and when I got up there with it, why, I found a paper hanger to help me mount the canvas to the marble wall. That mural was the first real recognition that I had ever received.

And then I did the *Pass of the North* mural. That was also a [Treasury Department, Section of Fine Arts] competition that was held for painters, I believe in eight states. And I was tickled to death to get that one because I didn't have to leave town or anything. I did all the full-size studies in charcoal, and I went to Hollywood to get a morion and cuirass and the doublet and hose and all that the Spaniards wore at that time. Found a guy who had been in the rodeo at Roswell that had a beard trimmed nicely and I got him to pose for me. Bill Waterhouse took photographs. We went out in the desert to see how wearing this metal on your head and on your chest would work. It was terribly hot. I don't think the Spaniards really used it unless they had to. You know, they didn't ride around in that stuff. It was so hot that the sweat dripped off of the point of the beard of this very nice young man and it hit the cuirass and went "sst!" just like your [wet] finger on a hot iron. So we had quite a time.

The old prospector's pants were my grandfather's buckskin britches that he used when he was a surveyor up in northern Minnesota back in the 1870s and

55

Dad had them, the old suspenders and everything. And the brand on the horse was the I-Bar-X Ranch [where Dad had worked]. And Dr. [R.F.] Stovall, Dad's great hunting pal [who] lived up at Mimbres Hot Springs, he gave me photographs taken by [C.X.] Fly, of the Apaches and the capture of Geronimo. And I had that for firsthand information. Doc Stovall had ridden out to see what happened when the Apaches had burned a wagon and killed the oxen and murdered the people and mutilated them and so on. So he was rather strong against the Indians. I think of him often when I think of all these people who make the Indians the heroes. There were two sides to that question.

Anyway, then I used a buckskin jacket that I brought back from Hollywood for the plainsman, one of the figures, and I got a *charro* from Juárez to pose for the Mexican. And I went out to Saint Anthony's Seminary, the old [James G.] McNary home out there in Austin Terrace, and asked the main padre out there if I could have one of the men pose for me to be the Franciscan friar in the mural. And they were very cooperative and very nice. So I had a very serious, ascetic-looking man pose in the cowl with his rope and his rosary. I tried to make it as authentic as I possibly could and had great, great pleasure in doing that.

It really got me started, that one mural. And they paid a decent price per square foot. I've forgotten exactly what it was, but I think it was just a little under four thousand dollars for this mural down here in the courthouse. Well, gosh darn, that's how I got married.

I was painting it in the courthouse after I had made all these full-size studies when I met Sarah. So that's when she came into the picture. Sarah had a dear friend, a schoolmate, Catherine Hawbaker, who went [from Monticello, Illinois] to the University of Arizona for college and met a schoolmate and friend of mine named Percy Pogson. And after a suitable courtship, why, they were married up in Monticello at Catherine's home. When they came back [to El Paso], Percy worked for his father's Pogson Peloubet [and Co.], accountants who did mostly mining books, Phelps Dodge and AS&R [American Smelting and Refining, Co.] and God knows what all. And Catherine thought that Sarah ought to get out and see some other places.

Sarah was working as a clerk in the farm and loan thing for the government in Piatt County. Monticello was the county seat of Piatt County. Sarah had gone to Monticello Seminary near Godfrey, Illinois, where her mother and her grandmother had all been to school. Then she went to the University of Illinois and quit when she married a guy. I met her after she had a divorce and had a child [James Dighton]. And Catherine invited her down to spend a week or so, just on vacation. And I was sort of floating around, a widower at the time. Nancy had been dead about [two years] when I met Sarah.

56

Sarah came down and the first evening she was here in El Paso, Catherine had a dinner and invited Percy's dad and his wife and, of course, Sarah was there, and [they] invited me to kind of make six, you know. I looked at her and I knew damn well I was all set. The first time I saw her I says, "Well, [she's] the main thing in life for me." So when I went to leave the Pogsons' house after dinner, far too short a time to sit in the living room and look at Sarah, I asked her if she would have dinner with me the next night. And, you know how girls are. She was sorry that she had other engagements. But I said, "Well, would you like to see what I'm doing? It's down in the courthouse. I'm a painter and a muralist." "Oh, I certainly would."

The next night I didn't see her; then the next night we had dinner together at the old La Posta, Severo González' place on this side. We had dinner and then I took her down to the courthouse. I had a grey Nash coupe and parked the thing down there in front of the courthouse and took her in. I said, "Well, you have to get up on the scaffolding to see it." Well, I turned on the lights, a very hot light, 500 watts. I had been working there every night so that I could get some work done. There were people who'd like to talk to you when you're up on the scaffolding and make sort of silly remarks, and so it was much easier just to work [at night]. I'd work sometimes 'til three and four in the morning.

Anyway, Sarah got up there in the heat and I think she was very interested. She'd never seen anything like this before. And I showed her how I painted and I was showing off, you know, like I'm crazy. Then all of a sudden she felt bad and she said, "I'm so warm. I think I'm going to faint." So she fainted and I sat her down on this old scaffolding, a great big thing that went clear to the ceiling and you could raise the platform on pulleys up and down. She wasn't unconscious but a very few moments, and when she came to, she sat there, and I said, "Well, I'll go and get you a drink of water." And she said, "Oh, I'd like to get down." And so I very handsomely helped her down the ladder. She sat on that scaffolding and I ran and got the janitor and he brought some water and a wet towel. She was embarrassed but all right. So I said, "Well, let's knock this off. I'm sorry it happened. Let's go for a little ride in the car and get some fresh air and you'll be all right." That was great for her.

We drove up to McKelligon Canyon and I asked her if she'd marry me. And she allowed as how she'd like that but . . . . So I said, "Well, let's discuss it tomorrow night." So we went down to Zaragosa [Mexico]. It was on the other side of that little old wooden bridge down below Ysleta. There was a nice nightclub down there in those days. We had a dinner and everything and on the way back to the Pogsons' up on the Robinson Boulevard, I said, "Will you, please?" She said, "Well, yes. I want to, but I think before we do anything we ought to know

each other a little longer and also I want you to meet my father and my mother." She stated it nicely.

And so I finished the mural *Pass of the North* about the sixth of July. I couldn't afford to keep the studio in the Hills Building, so I gave [it] up the [next] week when I went up to Monticello. The Dightons turned out to be absolutely wonderful. Sarah's mother had heard I had lost my mother and Sarah's mother was just like I was already the family. Her dad was a true intellectual who ended up with farms. He should have been some kind of an academic person. He majored in romance languages at the University of Michigan, and he was Phi Beta Kappa. He would read *Beowulf* in the original Anglo-Saxon and early antique Spanish poetry. He's the only man I've ever known to read the *Encyclopedia Britannica* from the first item in the first volume to "z" at the end.

So Sarah and I got married. Let's see, we were married in July [1938] and for our honeymoon we went up to Chicago and we stayed at the Palmer House. We went to the nightclub there in the Palmer House and the maitre d' gave us a table. And we ordered scotch and soda or something like that. And he came over and said, "We don't serve minors." I was twenty-nine years old and Sarah was twenty-two. So we were kids. And we spent our honeymoon with the Fergus Meads. It was great. And [we] came back to El Paso and stayed with Dad for less than a week and then hunted around and found an apartment on [1715 North] Stanton Street. We walked all over that whole Kern Place when we were first married, in the evenings when I'd get through work. We'd walk and the fall came on. That was when [we] first began to get the things about Hitler. And I remember in that apartment, why, we'd turn on *The March of Time*. It was a radio program and they would have the footsteps of the Wehrmacht and Hitler yelling and hollering "Sieg heil!" and all of that stuff on the radio.

I think the first job I had after our marriage was the illustrations for Frank Dobie's *Apache Gold and Yaqui Silver*. I had met Frank in the summer of 1937 when Dad brought him to my studio and introduced him as "my old friend Frank Dobie." Frank spent the afternoon, and the first portrait I did of him I made that afternoon. And Dad came by the studio after court and said, "Come on, Frank, and have some dinner with us." And we went [home] and Pomposa, the housekeeper that Dad had to take care of little Dick, [made] some real hot enchiladas. And Frank was used to that darned Tex-Mex stuff in Austin that wasn't [that hot]! And we stayed up, oh, it was past midnight in Dad's den, and by the end of that night, why, Dobie had said, "Well, I'm writing a book now, and Tom, I think you could do the illustrations." I had always been interested in books and typography and calligraphy, so it just worked together.

I had lost a competition for murals in the San Antonio Post Office [in 1937], [but] as a sort of a booby prize, why, my friends up at the [U.S. Treasury]

Section of Fine Arts gave me a commission to do a mural in the post office in Pleasant Hill, Missouri, which by sheer accident is about ten miles from Lee's Summit, [a town] my great-grandfather had established and where [during the Civil War] he [had been] killed by [Union] soldiers from Kansas. And so [the commission in Pleasant Hill] was just great [because] I knew exactly the story I wanted to tell. I knew what I wanted to paint because I had heard all the stories from Dad. So instead of [the more commonly used story] of the Union soldiers ordering everybody out of Jackson County, why, I painted *After the War [Back Home, April 1865]*. It shows four figures returning home [after the Civil War]: the old grandmother, the woman holding the child, the vet, and the old grandpa. And there's a horse and the wagon and the charred chimney that was all that was left of their house there in Jackson County. I got a certain feeling, a very strong feeling, into this painting out of thinking of [what was happening in Europe]. This was at the time when Hitler had gone into Poland and was soon to go into France.

I painted it in the living room of our apartment [Highland Court, 1715 North Stanton Street], owned and operated by Miss [Ella] Ambrose and her friend. In front of the sofa in the living room, the only room big enough for it, I built this big panel with beaverboard and one-by-four planks. And I told Miss Ambrose that I would be very, very careful about [not] getting paint on the carpet or anything, so Sarah and I put down some old gunnysacks and stuff. And we'd go out almost every night, and [when] we'd come home, we'd see that Miss Ambrose had come check to see if we were doing any damage to her living room. Well, we didn't. We parted very happily when we left with the mural to go to Pleasant Hill.

It was in Miss Ambrose's apartment that I painted a portrait of Sarah holding a book. That's the one that's down in the [El Paso Art] museum now. I submitted that to the All-Texas show [in 1939] and it won a prize. And IBM was buying a painting from every state in the union for this exhibition that they were going to travel all over the world, and they bought it then as representative of Texas. And so I thought, "Well, that's very regional. That's something about our land, about living in it."

The back of [our] apartment had kind of a sleeping porch, good light, and I did quite a bit of work back there. I did Ellex Stevens' portrait there, too. Ellex was a very close friend of mine through many, many years. He was a great hunter, a duck shooter. During the season, there wasn't a weekend that he wasn't out trying to find a duck. So I put that picture of a duck in the background [of his portrait]. Ellex was my great buddy in those days and he and Tuffy von Briesen were always at the apartment. They sort of taught Sarah how

to cook and everything. We had a wonderful time, the four of us. It was a great place, a great time.

Sarah and I went and installed the mural [*Back Home, April 1865*] in the post office in Pleasant Hill, Missouri. The postmaster was a heck of a nice guy, and he helped us get a scaffold and two ladders and an extension board, and Sarah and I got up there and installed the mural. I had brought along in the car not only the mural rolled up, but Venice turpentine, spar varnish and white lead, and that was our adhesive mixture which John Norton had taught me. And it was very good, very well received. And twenty-five years later I got a *Pleasantview Times* and they had a twenty-fifth anniversary issue with my picture with the mural in the center of the front page. See, those people really felt the Civil War because they had had so much contact with it.

Then we went over and spent the summer in Monticello [Illinois]. That was a wonderful summer of quietness. [The Dightons] gave me a bedroom in Sarah's grandmother's house to make a studio and it had windows at the front. It was one of these big, old, two-story, typical Middle Western houses. It was brick rather than frame. And right next was the garden patch for the kitchen that Sarah's dad kept as the source for table vegetables. Oh, they had berries and strawberries and all kinds of things in this garden. And on past that, why, there was a house and then a cornfield. And I could look out and almost hear the corn growing in this quietness in the shade of this great big elm tree, so different from the Southwest and the open space. This was a green world. So it was another quite different experience for me that whole summer we were up there.

When we came back [to El Paso] we didn't have a place to stay. We found a one-room apartment, temporarily. I had gotten some money from the *Saturday Evening Post* illustrations and the Little, Brown, and Company wrote and said they wanted me to do an oil painting which they could exhibit for these [Ernest] Haycox novels which they were pushing. So I did that painting *Haycox Country*, of a cowboy sitting up on high ground and his horse, and they made a poster of it on real heavy cardboard and passed it out to book stores all over.

I remember exactly what they paid me for that painting: they paid me $600. And on the strength of that, why, Sarah and I started looking for a little house. We found what we were looking for, out on [1520] Raynolds Boulevard, only it didn't have a studio, of course. So I went into debt with one of those government loans, mortgage on the house, and built that wonderful studio in the backyard. It's still standing. The studio was 50 feet long, 25 feet wide and I think it was 14 feet 6 inches high, so we had a real ceiling. The whole north side is all glass. It's really nifty. And I did the *Stampede* mural for the Odessa [Post Office] there and the one for Seymour, Texas, of the Comanches. I also did some commercial work. For instance, old Maurice Schwartz, bless his soul, he'd always hire

60

me. Whenever they had an anniversary sale or anything special [at the Popular Dry Goods Co.], why, he'd call me up and ask me if I'd come down and do some of the things for him. I think Herbert [Schwartz], and I know [Albert] "Sunshine" [Schwartz] have got some of those brush and ink things that I did for the Popular. They're very good. There's one of them of Sarah planting a tree in our backyard there at 1520 Raynolds.

It was the next year after we had bought the house on Raynolds Boulevard that Frank Dobie and Raymond Everitt, who was the editor-in-chief at Little Brown, and Company, decided I could do the illustrations for *The Longhorns*. Frank said, "Well, let's go and see what we can of them." So starting in July of 1940 Frank and I took a wonderful trip for, I guess, three weeks down all through the brush country and camped out, just moved along these ranches that had examples of longhorns. Old Frank met me in San Antonio, and he had two bedrolls, regular old suggans, and a tarp and two blankets. And we had a cooking pot, a dutch oven for making biscuits – old Frank was pretty good at making biscuits – and we had a couple of watermelons for dessert in the car. And we just started out from San Antonio and went down into the brush. Our first host was [J.] Evetts Haley – this was before Evetts and Frank came apart – on a wonderful old ranch down there on the river. We were down there two or three days and sleeping out in the front yard, you know, under the stars. It was lovely. Then we went on south to the Tom East ranch, that was in the brush country. Tom East married Alice Kleberg [granddaughter of Mrs. Henrietta King]. And Tom was a great guy, a great friend of Frank Dobie's. He had a ranch called the San Antonio Viejo.

I had the opportunity to spend a little time all by myself at the ruin of one of the outbuildings near the horse tank of the old Spanish ranch of Randado, they call it "Randa'o" down there. A great strain of Spanish horses were raised there in the old Rancho Randado. And I wrote a piece about my feelings about it and showed it to Frank and he said, "Well, I don't know if it's prose or poetry, but it's pretty damn good." And when I got home I showed it to Carl and he said, "Let's print it!" This so-called poem that I wrote was about horses of two colors, the *bayo coyote* and the *grullo*. The *bayo coyote* was the lineback dun and the *grullo* is the gray of the sandhill crane. I think the cowboys call it a mouse gray. And Carl said, "Let's print it in those two colors." I call it *Randado*. R-A-N-D-A-D-O. And I think it was eight pages with my drawings on practically every page and the drawings and the text were done in the *grullo* color and some with the dun color. The legend was that the old guy that established the ranch had taken the print of his cup as his brand, a round circle of the world. Carl had the round rim of the world in the color of the *bayo coyote*. It's unique, and I think the edition was 110 copies. Oh, we charged two dollars and I think we sold ten

61

or fifteen. The rest we gave away. Oh, we'd save up to do projects like that, Carl and I.

There were still wild steers and bulls in the brush [at San Antonio Viejo], and I was able to make very nice drawings of the real thing. Frank and I also went over to the King Ranch in order to see some examples of longhorns that the Klebergs had kept. We just went into the headquarters there at the Santa Gertrudis Ranch and saw the old stables, but we didn't get out into any of the pastures at all. That was later, much later. Then we went on up through Fort Worth to old Amon Carter's place, where he had a few longhorns. And then on up to see the longhorns at Cache, Oklahoma, at the Ouachita Wildlife Refuge. They had a big herd of buffalo and a big herd of longhorn cattle. And it was just like living in the old days. Frank and I camped out there for several days and just, oh, it was wonderful to go out and just sit and watch the cattle graze and the light on their big horns and how they moved and when they moved and what it took to scare them. And then over on the other side of this big hill was this shaggy dark, dark mass of buffalo, you know, grazing in there. It was like being somewhere a hundred years before, the quiet and everything. And Frank and I, we ran out of food. We didn't have anything but water and two quarts of whiskey and a watermelon. We were in great condition!

Oh, Dobie was such a wonderful guy in those days. Let's see. I didn't ever know the reason that . . . . I did know that the Klebergs were very much against Frank. I'm not sure what the origin of the trouble was except for Frank's great liberal politics. But I remember that I read somewhere that old Dick Kleberg, Bob's older brother, had referred to Dobie as "that academic clown acting like a cowboy." And that really fixed him up. So, that's why I, and not Frank, got the job [to write *The King Ranch*].

*Carl Hertzog, the book designer, and Lea, c. 1950.*

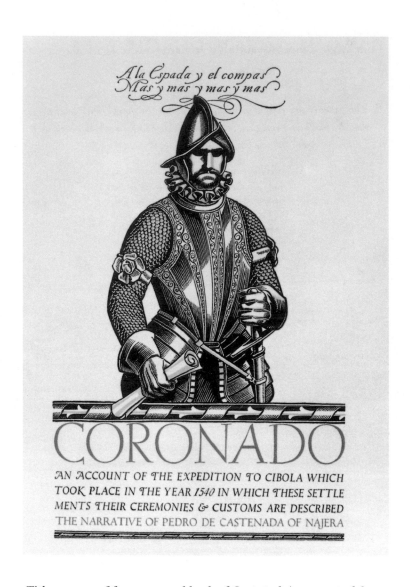

*Title page proof for a proposed book of Casteñada's account of the Coronado expedition, an early example of Lea-Hertzog collaboration. The book was never published. (Collection of the artist, courtesy Adair Margo Gallery)*

*Lea and the sculptor Urbici Soler, 1946, with Soler's bust of Lea and Lea's portrait of Soler.*

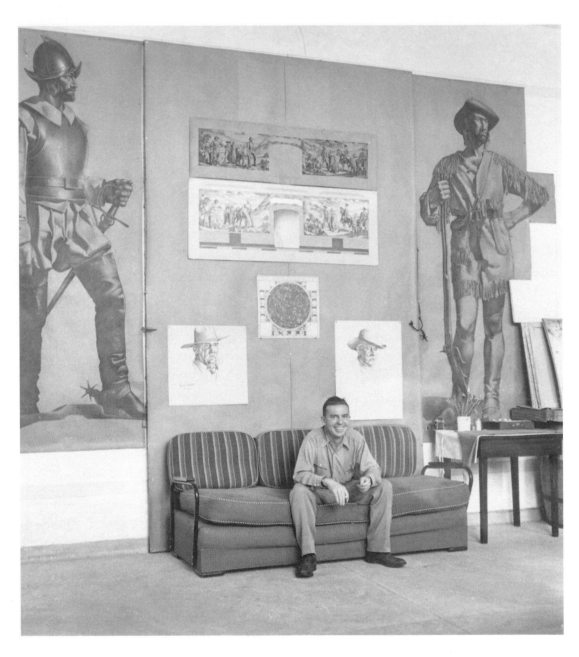

*Tom in his studio, 1520 Raynolds, 1943, with full-scale drawings for the* Pass of the North *mural.*
*(Photo by Alfred Eisenstaedt, New York)*

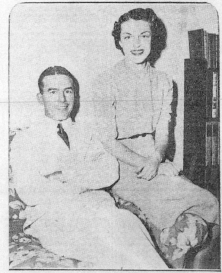

Are At Home In City

Mr. and Mrs. Tom Lea Jr., who were married July 14 in St. Louis, Mo., are shown at home in El Paso. Mrs. Lea is a welcome addition to the young set in El Paso where her husband has accomplished distinguished work in the field of art. Mr. and Mrs. Lea have taken an apartment in the Highland Court Apartments at 1715 North Stanton street.

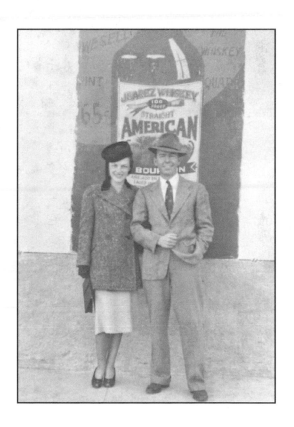

*Announcement of the marriage of Tom and Sarah Lea in an El Paso newspaper.*

*The Leas celebrating Sarah's twenty-seventh birthday in Ciudad Juárez.*

67

*Tom and Sarah Lea in front of the U.S. Post Office in Pleasant Hill, Missouri, after installation of his mural in May 1939.*

J. Frank Dobie, *1953, Chinese ink with charcoal and chalk, 17 1/2 x 15. Lea illustrated the Texas writer's* Apache Gold and Yaqui Silver *(1939) and* The Longhorns *(1940). (Courtesy Harry Ransom Humanities Research Center, The University of Texas at Austin, on permanent loan to The University of Texas at El Paso)*

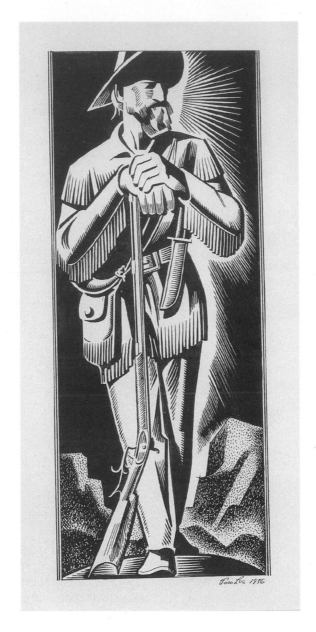

*Illustrations for newpaper advertisements for Popular
Dry Goods Company, El Paso, 1936. Brush and
India ink, 9 1/4 x 3 1/2. (Collection of Albert
Schwartz, El Paso)*

Simba 1936

71

## Chapter Four

# *World War II,*
# *1941 – 1945*

So I was not only a muralist but I was doing illustrations and took that trip with Frank to do the research for *The Longhorns* and then along came World War II. I had a Rosenwald Fellowship, and I was planning. I prepared a notebook and I had my schedule pretty well made out for what I wanted to pursue for my fellowship year. The war really disrupted what I was thinking about doing with this fellowship. [But] I never, ever regretted that I did exactly what I did.

The war was perhaps the most vivid and maybe one of the most meaningful things that I did with myself in my life because I really tried to be a voice for a lot of people. I knew they were with me and I was with them. That's the kind of thing that few artists ever feel. And I think it was a point of some egoism and pride that I did go where people were getting shot at. I didn't stay in headquarters or sit on my butt in a battleship and make up what I was seeing; I went out and took a look at it.

That's when I got to see another part of the world, another kind of humanity. I had written, you know, above the doorway that cuts the middle of the mural in the Federal Building here, "O, Pass of the North, now the old giants are gone, we little men live where heroes once walked the untrammeled earth." It wasn't but five years [later] when I was seeing heroes walking the trammeled earth, real men, and they weren't so little either.

The first intimation I had that I might be involved with [the war] was when I got this unexpected telegram which said the staff of *Life* magazine wanted to know if I would do a painting of a trooper out here at Fort Bliss. They had two of their writers and a photographer out there. And Dan Longwell, the managing editor, I found out later, had seen some of my work in Frank Dobie's *Longhorns* and a mural that was in Washington. So he said, "Well, let's try him on a drawing to go along in this story of the First Cavalry Division." And that was just great for me. I knew my dad was a great friend of Gen. [Innis P.] Swift, and I was a good friend of Roy Lassetter, his aide. So I did that for *Life*, got it in quickly, on time before the writers and the photographers were even through out there. And it was never printed, but it must have had some good effect

because about a month later I got another wire, asking me if I would go to San Antonio and do young soldiers at Fort Sam [Houston] and young student pilots at Randolph Field. And I went down there and did four portraits, and I did one of an old master sergeant that they liked so well that they got Joe Kastner, who was one of their best writers, to do a whole piece about him and put my portrait full page in *Life*, my portrait of this old sergeant. So I felt very good about that and they paid me a little money and [by then] it was summertime, [1941].

So Sarah and I and my old pal Ellex Stevens and his girlfriend, we all got in Ellex's car and went to the Grand Canyon. Jim was with us, too. Jim was Sarah's son from her first marriage. He was eight years old by then. [I had formally adopted Jim in court with all the legalities and from that day onward he has been my own truly beloved son.] Anyway, we were all in Flagstaff when I got a telephone call from my dad. In those days, you know, long distance telephone calls were really something, and he said, "Son, a telegram has come for you, which I think you ought to answer. It's from San Antonio and the man says that he wants to get your background in case the Navy wants a security check on you, in case you would like to go to North Atlantic Fleet for *Life* magazine." At Flagstaff, Arizona, this was a kind of an exotic thing, but wonderful, you know. So I got a telegram off to Dad and got back.

And that was how I made arrangements and I went up to Washington and met all these people. Some of them on the *Life* staff were really great and interesting people, the kind of people I had never met before. And Dan Longwell, himself, took me down to Washington and introduced me to Adm. [Arthur J.] Hepburn, I can't remember his initials, but he was the Chief PRO [Public Relations Officer] for the whole damn [U.S.] Navy. And Admiral Hepburn, I think, was amused because I was such a callow youth, you know. And I had had this one trip to Europe in steerage and second class and that was the extent of my sea knowledge. But he said, "That's fine, Mr. Longwell, we'll tend to this."

I stayed in Washington and in New York and then they sent me up to Boston. There in Boston I got a letter forwarded through Dan Longwell from Ernest J. King, the commanding officer of the Atlantic fleet, saying that I would have free gangway. I didn't know anything at all where I was going or the ships or anything. There were twenty-six U.S. destroyers helping deliver the goods to Britain in the terrible time when the German wolf-packs – they were submarines – were just playing hell with all the shipping in the Atlantic.

And I went up to Newport, which at that time was a base of Admiral King, and he actually sent his barge in for me and had me piped aboard. I didn't know which end of the ship was the starboard or the larboard or the hawsepipe or anything else. And the boatswains piped me and then the marines aboard gave me a "Present arms!" and I didn't know how to salute the fantail or nothing. But

74

Admiral King was very nice. A few days later I left on a little converted yacht, which was classed as a gunboat, but it had nothing but depth charges, antisubmarine stuff. And it was equipped with sonar but not with radar; we hadn't gotten any radar from England yet. Well, all this stuff was highly secret and everything and so [hush-hush].

My first voyage was in the rough weather and I think it was in October out to Argentia. It's all in *A Picture Gallery* about my time there. I came in one night from a trip up to what they call MOMP [Mid-Ocean Meeting Point], which is where we met the British destroyers off the coast of Greenland. We were on convoy duty, and on our way back to Boston, we put in at Argentia and it was just at sunset. The executive officer and I went in to a little quonset hut on the beach with a bar rigged for the officers. We were walking towards it and a fellow came out and he said to the man I was with, "Hey, Eddie! Have you heard?" And my friend said, "No." He said, "The Japs have hit Pearl Harbor." And so my friend said, "Um, well, what's the rest of the joke?" He says, "That's it." He said, "Well, you'd better come back with us and have a drink." He said, "I've already had one and I'm going out to the *Prairie*," that was the name of the support ship, "and see what they say on the radio." And, sure enough, that was how I found out about Pearl Harbor and then we went in and had several drinks against the Japs, and nobody could believe it.

And the next morning, why, goddamn, the ships had all gone. The *Wasp* [had been] there and the next morning it was gone. I was doing a portrait of Adm. [Arthur L.] Bristol, [Jr.] and I went in and instead of his [usual] map there on the bulkhead with all the destroyers and their positions up to MOMP and Greenland, he had a great big map of the world and they weren't saying a thing. The navy wasn't saying a thing. The only [information] that we found out at all was [over] the commercial radio wavelengths in the wardroom of the old *Prairie*. And, you know, the whole world was different. So I had a wild ride from Argentia in an old four-pipe destroyer down to Boston and we hit a great storm and it knocked us around very badly. There was a big list to port and one of the bulkheads caved in and a wave took the whole forward gun platform clear off the ship. And we were wounded coming in. The navy had heavy security before Pearl Harbor, but when Pearl Harbor hit, boy, you were a captive. But they let me through the gate there in Boston.

And I went on down and reported to Dan Longwell in *Life* and he took me down to the censors. I had done quite a number of sketches of the way they were trying to fight the submarines and I got them all past the censor. Then I came home to El Paso and did my first big story for *Life*, and they printed the whole thing. It was several pages in color and, you know, enough to make you feel awful good. So that's how I got started.

75

Then when I took those paintings back to New York, why, they said, "Well, would you like to be on the staff and just work for us." And I said, "Hell, yes." Because, you see, my brother had joined the army and three of my best friends here in El Paso had all joined up. And I thought, "Hell, I'm seeing a lot more than they can see." So I went to the draft board and told them what I was going to do, and they gave me an exemption for as long as I was a war correspondent in foreign theatres.

That's how I got started in the business of going around, trying to record what I saw. And I had . . . oh shucks, a cigar box with all my materials, and I took three pads of artist's paper. Oh, one of the interesting things about being with the navy as a war artist, you had to make allowance for the fact that you might lose all of this stuff going overboard in the water. So I always made it a point to be friends with the signal bridge and the guys that had the little weather balloons and the balloons that they used for target practice. They were good rubber, wonderful rubber to wrap my materials in. And I would put my pen and pencil in a condom. And it was very good waterproofing.

In the early summer of 1942, I finally got papers and accreditation from the Navy to go out to the Pacific where the Battle of Midway had just happened. [This would be my second tour during World War II]. I was aboard the [aircraft carrier] *Hornet* for over two months while we were escorting troop ships and supplies to Guadalcanal. And those were the days when we didn't know whether we could hold it or not. The American forces had their backs to the wall, really, and they were waiting for better times when new recruits and the new engines of war and all of the things that were required to beat the Japs were finally in the hands of our armed services. So that was a great experience aboard the *Hornet.*

One of the ship's officers called that part of the Coral Sea that we were patrolling "Torpedo Junction." I think they all thought some day there was going to be a torpedo right in our face. After the sinking of the *Wasp*, the *Hornet* was the only carrier left in the Pacific, and it was thought that the Japs would come down with full force and try to get the *Hornet* because they knew that that ship had carried Jimmy Doolittle and his bombers on the Tokyo raid. I've written about it in *A Picture Gallery*.

I got off the *Hornet* September 23 or 24, 1942, and I had a hard time [getting home]. I had to make a forced landing. They nearly wrecked the plane up on a little fighter strip in northern New Caledonia. I finally got a ride to Pearl [Harbor]. By the time I got home, it was almost Christmas. I came home to Sarah and Jim, and Sarah and I went up to New York to present all my work.

I was occupied with several stories about the *Hornet* and its personnel and so on until the summer of 1943, [when I was sent on my third tour of the war].

76

I decided I didn't want to go back to the Pacific because there were so many things that were happening by that time in North Africa. The North African campaign was going on, and we were going to go into the southern part of Europe and Sicily and up through Italy. So I got an accreditation through my old friend, C. R. Smith, who had become a major general in the air force. You know he was the founder of American Airlines and my first patron. He bought some of my western stuff very early.

He wrote me. He said he had seen the drawings I had made in *Apache Gold and Yaqui Silver* and in *The Longhorns* and he wanted some of my work. He was still in Chicago at that time. I had never met him then until the war, but he had bought my pictures and paid for them. He was a wonderful man. They made him a general because he knew so much about the handling of freight and passenger stuff, and that's what the ATC was, Air Transport Command. It was to haul people and supplies all over the world where there was war.

C. R. Smith had a big house, and he would invite people in his command that had received commissions from civilian life to come and stay over there whenever they happened to be passing through Washington on orders. One night we all got pretty tight there at C. R.'s house, including C. R. and Rex Smith, who later became a dear friend of mine – he was a bullfight aficionado – and Rex said, "Hey, C. R., what about all those beautiful sculptures you have of Frederic Remington and Charlie Russell?" And C.R. said, "Yeah, I got them." He said, "Well, where are they?" He says, "They're out there in the rafters of my garage in safekeeping." Rex said, "Well, let's go get them." We were all tight and we got some ladders and we climbed up and got them, and we put them all out in the driveway. And there must have been fifteen bronzes. A bunch of drunks standing around, yeah.

It was great times during the war. Later C.R. gave [those bronzes] to The University of Texas [at Austin]. But one of the reasons he wrote the nice ticket for me was that he was very interested in getting a pictorial record of what the ATC did. And he wrote me wonderful orders, anywhere I wanted to go in the world. Anywhere the ATC flew, why, I was to be received as a correspondent for *Life* magazine and given every courtesy. This was marvelous. A year and a half later they took that free ticket away from me and said it no longer belonged to me and "to hell with you!" Anyway, that was a real trip.

So I started out in Goose Bay, Labrador, and up to Baffin Island to Greenland across to Iceland. In Iceland, I did a good portrait of Berndt Balchen, who was the great arctic flyer. He landed on the east coast of Greenland and knocked out a weather station by hand, you know, with dog teams and riflemen. And that weather station was one of the main things to forecast weather in northern Europe, so it was very important from a military standpoint.

Then I went to London, and I passed out on one of the trains when we were going out to see somebody in a little town near London. [When] I came to, some stranger was fanning my face and so I got off and they put me in a taxi. I told them I was with *Time-Life* and the office was at 8 Audley Street. It was quite an establishment because they had a big deal going in the European theatre. And they said, "Well, the only thing for you to do is to go and rest up." They had a country house out there at this little town named Penn, and I went out there a couple of days and I felt like hell. So they sent me back in to London and made an appointment with Sir Cedric Shaw. I'll never forget his name. He was, oh God, the King's own heart man or something. And Harley Street you read about, where all the physicians in London were. Well, I went there in the morning and I was in his offices and his lab and everything all day into the evening. He couldn't find anything wrong with me. I was hyperventilating. I guess it was from nervousness or something. And he said, "You're fine. Just take it easy for a little while."

So I went back out to Penn and then went in to get started on my assignment and that led me from Prestwick [Scotland] down to Marrakech, Morocco. And we were on this flight on the way down to Morocco from London and [there was] an electrical storm. It's the only time I ever had seen St. Elmo's fire on the propellers. We were really all electrified. And there weren't any seats. I was in a freight, a DC-3. There were three passengers and all this gear: a couple of aircraft engines and stuff like that. And we had to sit on this cold deck and we had no oxygen. Those DC-3s, they weren't pressurized or anything. And it was kind of a wobbly trip. [The actor] Leslie Howard, I think it was, was killed flying to Portugal in the same storm we were in.

Now we got down to Marrakech and I had to thumb a ride; I hooked a ride to Algiers because that was Allied headquarters in Africa. And they didn't know I was coming, but I finally got a billet in the photographers' villa. And it was taken over from some rich Frenchman. It overlooked the bay there in Algiers, a beautiful place, but it had fleas. We were all pretty busy with fleas there. And we had an Arab – he had a red fez on – and he would go out and get us food in the black market. And then we had a cook. There were about fifteen photographers and one artist in this thing. And we had lots of fun. One of the things I think is interesting is [that] we now take color photographs for granted, [but] the photographers weren't able to do color photographs in World War II. There was some movie color film and [Edward] Steichen and few of those famous photographers got assignments to go out and do color work, but not the news photographers.

Anyway, from Algiers I [went] to Tunis and there I met one of the most interesting and genial men I met during the war, Jimmy Doolittle. He had a villa

78

in a little town north of Tunis, called La Marsa. It was a little Arab village and right on the beach and it was very pretty. He was a friend of C.R.'s, and naturally that's how I got in. He invited me up to his place and he said, sure, he'd pose for me. And we spent until nearly three o'clock in the morning, my doing his portrait. And in those days, you know, whiskey was very hard to get, especially overseas. We drank about a fifth of scotch. He had been on the *Hornet* and so had I.

And then he said, "And now you're in the air force and now you're going tomorrow morning with Gen. [Charles F.] Born up to Italy." They had just bombed the hell out of a place outside of Bari, and they had cleared the debris out and our planes had just landed. And General Born wanted to see how it was going, so he gave me a ride. I flew with him up to Italy the next day and I made a drawing up there. And I came back to Tunis and from there got a ride to Cairo.

There were two wonderful *Time* guys, one was a reporter and one was the photographer, there in Cairo, and [we] stayed at the Shepheard's Hotel. At that time that was one of the great international hotels. Of course, it was taken over by the British military forces all during the war and it was not available to anyone but the military. One of these guys was Johnny Phillips, who later made a name for himself parachuting into Yugoslavia to Tito's forces, and the other was Harry Zinder, who was the correspondent who went all through that trouble in Palestine. And they got me deloused and defleaed. They had a regular place for it, the air force did. And we had a wonderful time in Shepheard's Hotel, booze and everything. And I hated to leave Cairo, kind of.

Let's see, I finally got a ride to China. That was my aim. I had a civilian passport, visas, and all the rest of it in case they wouldn't let me in. And we flew out of Cairo and had engine trouble in Abadan [Iran] right on the Persian Gulf. And I remember that in Abadan it was so dad-gum hot! This was like in September, but they stayed in these air-conditioned quonset huts in the daytime and did all their work at night. And a bunch of rear-base sad sacks, that was what they were, those guys.

Our people were receiving fighter planes from the U.S. and turning them over to the Russians there. They'd take them out of the crates and assemble them and see that the engine worked and everything. And once I saw this bunch of Russian pilots come in, in an old Russian transport plane, and they were to take these P-40s. These Russians climbed in, told the guy to turn the prop, gunned it a little bit, and took off without ever seeing the plane or without ever testing out anything. The craziest bunch of guys you ever saw fly an aircraft. I imagine three-fourths of them were wrecked before they ever got to Russia. Anyway, that was the war.

79

And finally I got to Karachi out in India. And about all I remember about Karachi was there were so many insects and bad ants and things. You had a big mosquito net, and they had iron cots, not the regular old army cots that we had. All four legs of your cot were put in a little pan of water and in the morning you'd see all kinds of animals that had drowned in the water, that hadn't gotten up to bite you. And strangely enough there weren't any lice or fleas.

I thumbed a ride then from Karachi. Oh, it was tough there getting a ride. I made friends with a B-26 pilot, a fellow named Brewster from Massachusetts. I'll never forget him. We met in the officers' bar there in Karachi and he said, "Sure, I'll give you a ride if you don't mind flying without a manifest. Your folks will never know what happened to you if anything happens to us." I said, "Sure." So, I flew with him all the way up to Agra. And we stayed in Agra several days until they got further orders. I stayed in a beautiful tent with a Texan named Tex something. He was a real hard-bitten colonel. He had a servant, one of these poor Hindus that emptied your latrines and did everything for you, you know, kind of a valet. He would want to help me and everything and I didn't like it.

But, anyway, I finally got in the B-26 and got up to Upper Assam. Anyway, I was around there for a while until these guys got their orders to report to an airfield about forty or fifty miles north of Chungking. So I flew over the Hump with them and that was quite an experience. I flew without any oxygen and I lay in the nose by the gunner, and we had some excitement there with a Jap. I was pretty excited when the gunner cleared the magazine in the machine gun and I thought we were going to get to see something, but I didn't. The Japs never turned in toward us.

We landed in the rain on this drizzly, sorrowful October day in Szechuan Province. And we got a ride on a flat-bed truck in the rain down to Chungking. And the truck driver said, "Where do you want to go?" And I said, "Well, wherever there's a headquarters." I went in and introduced myself to a guy named Rankin, a major at the headquarters, and he turned out to be a great friend and he took me in to Gen. [Joseph W.] Stilwell. Stilwell said, "What the hell are you doing here? We haven't any word that you're supposed to be here." And I handed him this letter from C. R. Smith and Stilwell said, "Well, we'll take you on anyway. Welcome!" And he got me a place in the old press hostel which is a real funny old walled compound, and we had a mess hall there and I guess there were, oh, maybe two dozen correspondents from everywhere, including Russia. And I remember one [day] we spent in drizzly Chungking, and I wrote about it in that little thing called *A Grizzly from the Coral Sea*. And I was making drawings. I met Teddy White, Theodore H. White, who became a very famous writer and correspondent. He was a delightful fellow. And he got a telegram from

Henry Luce saying, "If Lea is in Chungking, have him do some paintings of China unrelated to war with some of the character and appearance of China." Well, that suited me fine. And I did quite a number of things there.

And also [the telegram] said, "See if you can get Lea a sitting from the Generalissimo and Madame Chiang Kai-shek." And White went to Dr. Hollington Tong, who was a minister of information for the Chinese Central Government [to ask permission]. And two days later Dr. Tong called up and said, "Would you like to make a drawing of Dr. H. H. Kung?" He was at that time the minister of finance of the Central Chinese Government. And I said, "Sure." And he turned out to be a kind of a roly-poly man with very slicked-back hair and pleasant. I had found that to do these kind of people, it was much better when they were in their own surroundings, in their office, seated behind their desk in a chair that they were, you know, comfortable in.

Tong had arranged it so that I could go right in to Dr. Kung's office. He was across the desk and there were portières, curtains, all in back of his desk and chair, and the windows were at the sides. And this was in the evening, I guess, nine o'clock at night. And the lights were on overhead and it made it kind of an interesting light on this very Chinese face, this Mongol face. I finished the drawing and I was so involved in thinking about it that I moved my chair back and stood up abruptly with a pencil in my hand, and there was no carpet on this slick floor. And immediately with that noise of the chair, from behind these curtains came two men with submachine guns pointed at me. Now this is true! I sat back down! And you know, Dr. Kung looked around at them and looked at me and smiled. They went back behind the curtains and we finished everything and what he had done is to test me to see if I was some kind of an agent or something by having me do Kung before I could get to the big honcho [Chiang Kai-shek].

Two weeks afterwards, when I had just about given up, all of a sudden there was this call for me at the press hostel and Dr. Tong said, "The Generalissimo and Madame will receive you at four o'clock this afternoon. Be sure and wear your uniform and see that you're well policed. The Generalissimo likes to see smart military turnout." So I polished up my little war correspondent thing and put the wire back in my hat. I was all raunchy from the air force. And here came Dr. Tong in his official car and we went up the hill to the residence.

It was really quite impressive for a country boy. And we went in and we didn't wait for five minutes in this rather sinister office 'til the Generalissimo came in with a Big Ben alarm clock, tick-tick-tick-tick. And he set it right in front of him as he sat at the desk and then . . . . He wouldn't speak any English. Tong did all the interpreting and asked him to sit in a certain way for Mr. Lea and I sat on the other side of his desk. I got what I thought was a pretty good drawing.

I was having trouble with placing the ear or something and I asked him for ten more minutes. And he grumpily took out a little notebook, I guess "The Orders of the Day," and granted the ten minutes, looking at the alarm clock and working on his book. And then got up and he left.

And Dr. Tong said, "Now you will wait and Madame will receive us in her apartments upstairs." And so after a little while we went upstairs. We were held at the doorway and we could see through this long hall in this apartment. And here came the Generalissimo in a long gown, not in uniform. Tong explained later that he had come into the apartment to be there when I first saw his wife; that would make [my appearance] proper and correct. Isn't that something?

We were met by this very charming woman, who was ill disposed and was on a white chaise longue with a pale lilac-colored satin coverlet and a white sort of a gown and great big gold earrings and a perfect American accent. When the Generalissimo walked out, she very casually said, "You know, my husband would be a very handsome man if he'd keep his teeth in." He had taken off his uniform and taken out his teeth. Anyway, they let me do the portrait [alone with Madame Chiang], just the two of us.

She was delightful. She asked me all about my hometown and then I found out that they had investigated me and found out that I was a relative of Homer Lea and that was the reason they received me. [Madame Chiang Kai-shek was the daughter of T.V. Soong, whom Homer Lea met as military advisor to Sun Yat-Sen.] And she asked me if I had known Homer and I told her what little I knew about him, and that I had prepared a piece about Homer Lea for Mr. [Henry] Luce, the *Life* magazine editor, but it had never been published. And we got along just fine. She gave me more than two hours for the sitting.

And when I got up and thanked her and said, "Oh, I can't take any more of your time, Madame Chiang," she said, "Well, stay a moment. I've prepared something for you." And her amah [maidservant] came in with a tray, the most wonderful tea I ever tasted. There was a lid and no handle on the cup. Marvelous, and a whole walnut cake with lemon icing on it. And she said, "It's one of my old recipes." And I had walnut cake and tea with Madame Chiang Kai-shek in her apartment in Chungking! When I got back to that old press hostel with its one light bulb swinging and all that, "God, this couldn't have happened to me!" It was a great thing.

Her [portrait] was very easy because she was so decorative, but his was difficult. He wouldn't hold still worth a darn and I had a very limited time with him. But I think I got a good characterization of him [although] some of our friends didn't like it for political reasons. I got some static and Mr. Luce wouldn't print it. I was told later that when Luce came to see my China pictures, he said,

"Tom Lea is a good portraitist, I know he is, and he's done some very nice things about China but he has missed the character of Chiang Kai-shek."

Days later then I got a ride down to air force headquarters at Kunming and I did the portrait of [Maj. Gen. Claire L.] Chennault. They were great enemies, Stilwell and Chennault. And [I] did the portrait of Chennault there in Kunming. He was a very formidable gentleman. He treated me with curt, decent respect. But his officers that came in to report to him were, I think, intimidated by him. He was a tough, tough commander. I think they sort of worshiped him. I sat on the floor because you had to look up at the man to do the drawing because he was just performing business at his desk. And these young lieutenants would come in, "Yes, sir," and they were almost trembling. He had his Chinese lady friend there, and there was some quiet talk amongst some of the aviators about what the old man was getting and they weren't getting anything half that good. You know how it is.

Then, down in Kweilin [Guilin] was the part that I loved the best of China. It's the great landscape. You know those wonderful landscapes of the Sung masters, around [the year] 1200, at the very height of that wonderful Chinese painting. Those sugarloafs, they're true. I couldn't believe it. They're really true. The people who did all these paintings weren't making it up; there they are to this day and beautiful. And the River Li, which I liked very much, flows right through all of these strange sugarloaf mountains. It's really an enchanted place and the mists almost daily hang part way down on these cone-shaped mountains. It's the old Sung masters, but there it is in real life. China made an impression that would never ever die in me.

We came back by way of Africa. We made another forced landing out in the desert near Lake Chad and they had to send a rescue plane for us. We gassed up in Ascension Island, crossed the South Atlantic, and then to Brazil, and finally over Brazil to the Caribbean. And we landed at some kind of military air base near Miami and I got out and went over to the edge [of the runway] where I could get some dirt in my hands and I just rubbed it on my hands and my face. I was pretty glad to get home.

Then I did *[USAAF] Fighters Across the World*. I had the layout and the engravings and everything, but for some reason *Life* never printed it. I did portraits of these various fighter pilot types. And in the course of that, I had the opportunity to do portraits of three of the great flyers: [Berndt] Balchen, [Gen. James H. (Jimmy)] Doolittle and [Maj. Gen. Claire L.] Chennault.

And I also did all these landscapes of the various places that ATC flew. And that was for my friend, C.R. Smith, the guy who cut the orders for me so I could do it. That took me until . . . oh, I was working on it, I think, until May of 1944.

And for my next [fourth] tour, why, I wanted to get back with the navy. I went to San Francisco and checked in with the PRO there and he said, "Have your people in New York given you an assignment?" And I said, "No, I'm to choose what I want to do." And he said, "Well, you better go to Pearl [Harbor]." So I did. And I had just had a big argument with my pal, Bill Chickering, who was a correspondent for *Time*, there in San Francisco, and he said, "Ah, you 're going with the damn navy. Why don't you go out with some people that really carry a rifle and spill their guts on the ground?" And I said, "Well, that's all right for you, Bill, but I'm thinking about getting home."  And he said, "Well, I'm going to New Guinea with Gen. [R.L.] Eichelberger." So we left, kind of in a huff with each other, and we never saw each other again. I went to Pearl Harbor and chose the First Marine Division landing on an island. I didn't know the name of it or anything. Bill went out with the army bunch there in New Guinea. And the weird part of it was that I went with the marine corps and lived through it, and Bill was on the bridge of the *USS New Mexico*, aboard a naval vessel, and a kamikaze came in and killed him.

I did a portrait of him for his wife and family and I'm sure they couldn't [cope with] the portrait. That portrait . . . I tried . . . there was something about Bill's eyes that I put in my portrait about death or something. Just a few years ago William Chickering's widow, Audrey, sent it to the Harry Ransom Center [in Austin], without my knowledge or anything, to be a part of that collection, which I thought was wonderful of her. I did a lot of portraits during the war. I did them out of admiration and out of friendship [at a time] when friendship, you know, was so brief: you were there and then you were gone.

I [had seen] Pearl Harbor in 1942 when they were trying to get fixed up after that terrible attack of the Japanese, and when I went back in 1944, [there] was a real great contrast. In those two years it had become a real powerhouse. One could see the power and the immensity of our war effort, the steamroller that was absolutely knocking the Japs over. As we grew stronger and greater, the Japanese grew more desperate and more fanatical and started all this kamikaze stuff, which was very, very terrible on our casualties. They did a lot of damage that way.

Those were some mean little fighters, those guys. When you're there in the middle of it, you have a great curiosity about your enemy that you haven't seen. I have talked to two other guys that [experienced] the same thing. There he is lying dead and you look at him and you have a very, very different feeling about a dead enemy than you do over one of your guys. And it's not hate; I don't know what it is. I remember one little guy whose head had been shaven; his hair had grown out to be, oh, maybe a half inch and it looked just . . . and it came to me at that time: it looked just like the worn plush on the theatre seat. You want to

know what or who the heck he is and then you have the people that come in and search him. Some of these Japs had little bands around their bellies that were called a "belt of a thousand stitches." Before they would leave for battle, why, different ladies would sew little stitches as good luck and they called them "belts of the thousand stitches." And there were lots of them out there and, of course, that was a big souvenir item, that and the swords that the Japs had. And there was some sake, if you could ever find any in the wrecked mess halls.

I didn't know exactly what [was in store for me] when I asked for orders to go to the Pacific with the marines. It was only after two or three days on the voyage that I knew we were going to Peleliu. That was, of course, the most vivid part of the war to me. It happened in September of 1944. [When the fighting was over], I remember this bunch of marines came aboard a naval transport as they were leaving Peleliu, and this starchy, nice bright-faced naval guy, says, "Hey, buddy, have you got any souvenirs you want to trade? I got a little money if you got anything good." And this marine looked at him and said, "Sonny, I brought my ass off of Peleliu and that's the greatest souvenir I ever had." That's the way we felt.

Well, I came back and did the paintings. I got back some time in October to El Paso and laid around for a week or so and then started working on the oil paintings from the sketches that I had made. And this was reported to me later by one of the assistant managing editors there at *Life* magazine. He told me that they brought my paintings into this room where every week the managing editor would decide which pictures went into the layout for that week's magazine. And they lined them up against the wall on this shelf where they could put large photographs and paintings or whatever. And they put my stuff up and told Dan Longwell that they were ready and he could come in and decide which ones should be used in the issue. And Dan came in the room and looked at them and he said, "Print every damn one of them in color and I never want to see them again." He felt guilty about sending me there. Anyway, I guess there has never been any emotion in my life that surpassed the assault on Peleliu. I think people, in seeing those pictures, see the horror of war. And you know, actually, I wasn't thinking of the horror of war. I was thinking of the heroism of the men that performed under those circumstances and survived. I really thought of heroism rather than war. And I think that's the vision of the marines in all of these paintings.

And [while] it was all fresh in my mind, I wrote the narrative. And Carl Hertzog saw it and said, "Let's print it." And that's how *Peleliu Landing* was done. I think he printed 550 copies of it. There again, Carl and I paid for it. Carl wrote such an appealing letter to the marine quartermaster in Philadelphia that he

turned loose enough of this real green dungaree cloth – which was supposed to be under high priority – to cover the whole edition.

It seems to me that [World War II] was a watershed, a division of generations. We had more illusions or we had more ideals, we had more patriotism or we had more optimism than the generation that followed us. Tough. Well, I'm not going to talk about it, but I got damned sore at a fellow that told one of my best friends who had spent twenty-six months overseas, "You didn't even know what you were fighting for. You didn't even know that you were fighting for Rockefeller's fortune." Everyone that fought and observed World War II knew why they were fighting. Now, why, patriotism is kind of a corny thing and outdated. Nobody believes in their country anymore. It breaks my heart. I think that somehow or other standards in every branch of life have sort of withered, and I don't see how we're going to get along 'til some of those standards are reestablished. I'm very conservative in my views.

Between all these trips during the war I always came home and painted. I'd be home for four to six months. I'd get to see Sarah and Jim, and one of the guys that was very close to me then and I'd see every time I'd come home was Bob Homan, the doctor. I did a portrait of him in Chinese ink right after the war about the same time I did the one of Carl Hertzog. And he has one of my good paintings of China, the one of the river with the sunlight shining on the little farm in the foreground. I didn't ever know until after his death that Bob kept two huge leatherbound scrapbooks of all the stuff that I had done. And I have them there in the library in the house. There are two of them, this thick with all these old yellow newspaper prints. These scrapbooks didn't start until wartime. They have an awful lot about writing because, of course, there was more said about my books than there ever has been about my painting.

I'd see Dad, too, when I'd get home. Dad's last days were made much happier and much more comfortable by his marriage to a very fine lady named Rosario Partida Archer. He married her in 1940, I guess. She had a daughter named Bertha, and she and her husband Arthur [Schaer] moved into the house at 1400 Nevada for the last years of Dad's life. In 1941 Dad had a stroke, not a bad one, but it cut down his activity a good deal. And then he had a heart attack in 1943 when I was out in China. And when I got back [from China] Dad was getting around, but slowly, and he seemed more . . . . He had never seemed vulnerable to me, but he seemed vulnerable then.

I felt bad because he wanted so much to know [about the war] and to be there fighting, and he was out of it. Sad. He wrote all the kids that he knew that had gone to war. He'd write them at their APO address. He kept in touch and told them about how things were at home, and he made the wills for a lot of our friends that had joined up. He did everything he could.

86

During the war Dad hung the [American] flag from the roof. It wasn't on a staff. He hung it properly with the stars on the left side, and he said, "This flag is not coming down until we whip the Japs." I think because I'd gone out there [to the Pacific] he became more interested in seeing the Japs get whipped than the Nazis. And that flag hung on the house at 1400 Nevada day and night. He'd put a light on it at night, and it was there when he died.

He died two days before they dropped the bomb on Hiroshima. He was buried at Evergreen Cemetery by my mother, my grandmother, my grandfather, and Nancy. They're all buried out there. After his funeral at the undertaker's parlor, the procession out to Evergreen must have been over a mile long. They held up the traffic on Alameda Avenue somehow. Anyway, he was quite a guy.

One of the things Sarah remembers the most about my dad is that every time he'd come to our little house on Raynolds Street, the first thing he'd do was go over and put his gun on the mantel. He had a little .32 Savage automatic and very flat, and old Sam Myers built him a special little holster that would fit inside of his belt, and he always carried it under his right arm. He always [wore] his buttoned square-cut coat, so people never suspected that [he carried a gun]. The last thing he'd do was he'd kiss Sarah and me and then put his gun [back in his holster] and go out, [start his car], smash the curb, turn, honk the horn, and away he went!

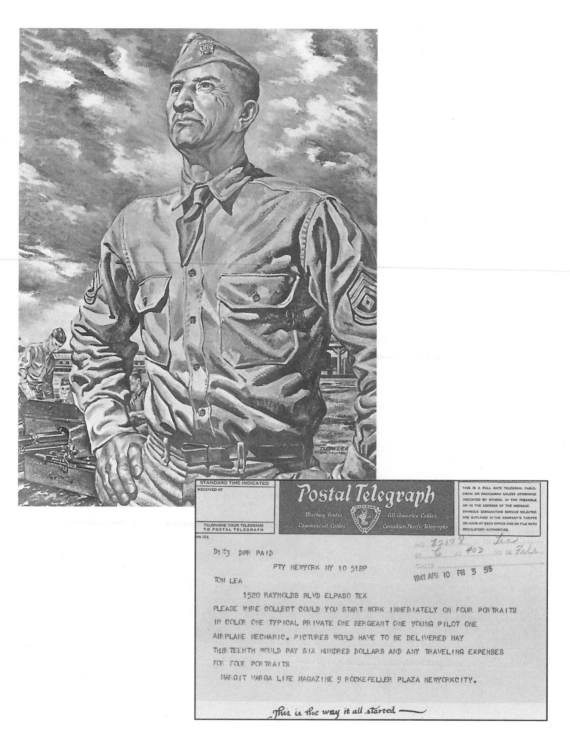

*One of four portraits commissioned by* Life Magazine, *Lea's painting of a master sergeant at Ft. Sam Houston, July 7,1941 issue.*

*Telegram from* Life *magazine commissioning Lea.*

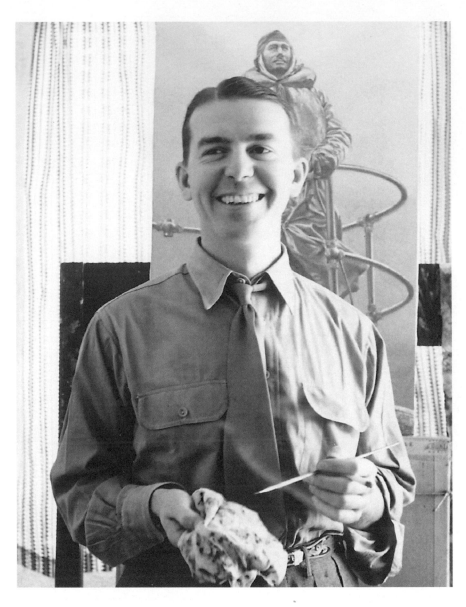

*Lea in his El Paso home following his first wartime tour of duty. On the easel is his painting* Coxswain - Argentia Bay, 1941.

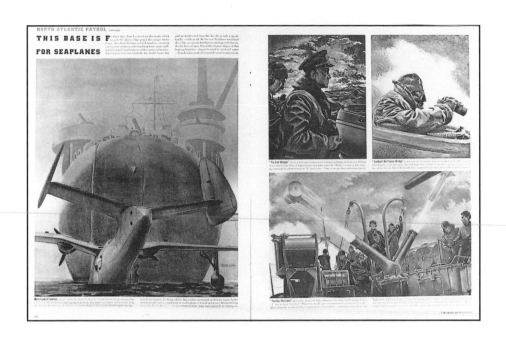

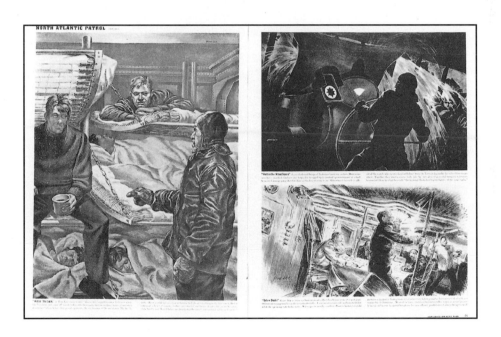

*Two pages from May 25, 1942 issue of* Life. *The article was based on Lea's experiences with the U.S. Navy in the North Atlantic.*

91

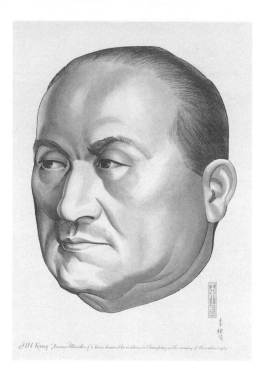

Fantasma de Guerra, Torpedo Junction, *1942, carbon pencil, 10 x 14. Drawing from a sketch book carried by Tom in the South Pacific on his second tour. (Collection of the artist, courtesy Adair Margo Gallery)*

H.H. Kung, Finance Minister of China, *1943, brush and Chinese ink, 21 1/2 x 15 1/2. Chinese government officials asked Lea to draw this portrait before introducing him to Madame and Generalissimo Chiang Kai-shek. (Collection of the artist, courtesy Adair Margo Gallery)*

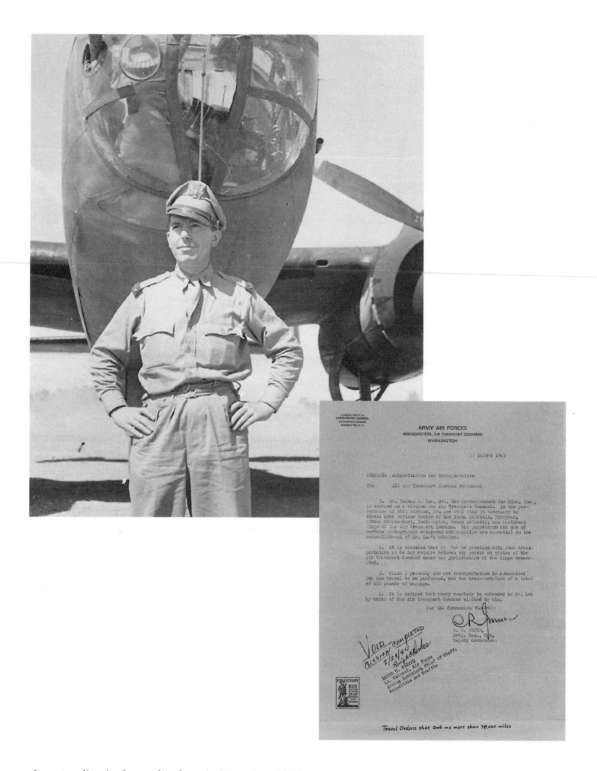

*Lea standing in front of a plane in Kunming, 1943.*

*Orders from C.R. Smith, founder of American Airlines who headed the Air Transport Command (ATC) during the war. This letter served as Lea's free ticket around the world to record activities of the ATC.*

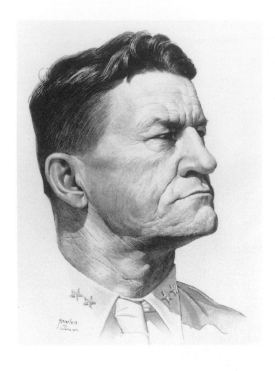

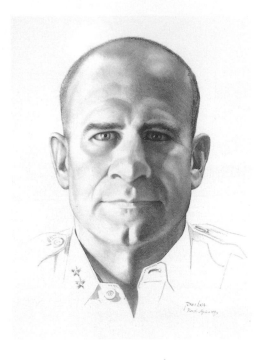

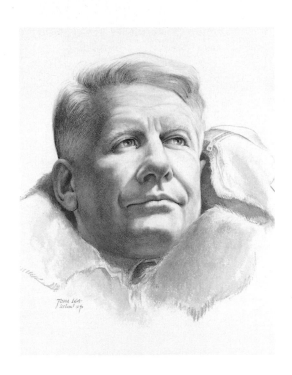

*Lea's portraits of:* Major General Claire L. Chennault, *1943, Chinese brush and Chinese ink, 19 x 14,* General James (Jimmy) Doolittle, *1943, ink, 19 x 14,* Berndt Balchen, *1943, 19 x 14. (Courtesy U.S. Army Center for Military History, Washington, D.C.)*

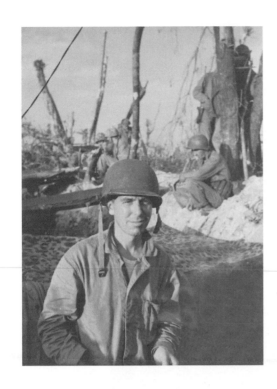

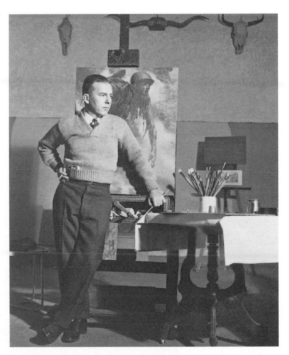

*At Peleliu, September, 1944.*

*Lea in his studio working on* The Price, *published by* Life, *June 11, 1945.*

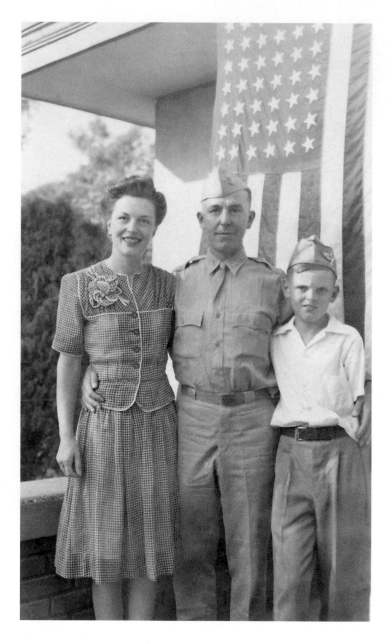

*Sarah, Tom and son Jim on the porch of the family home, Nevada St., El Paso, 1942.*

# Chapter Five

## The Writing Years, 1945 - 1974

Yeah, the best part of war is getting home. When I got home I made a complete drawing, full-size, of Sarah and it was on brown paper. I had the painting [*Sarah in the Summertime*] started within six months after my return from the war, but I didn't finish it until about two years later. I think on the back it has Sarah's age and where it was painted and when. It's dated 1947. I would work on it in between [jobs] I was doing for *Life* – they were still paying me as a staff member – and commercial things that would come along where I could make some money. The painting was based on a little Kodak photograph taken in the backyard of our house there at 1520 Raynolds Boulevard. I carried it in my wallet all during the war, and when I came back, I decided to set it up again and have Sarah pose. And that's how the portrait grew; [it] is mainly from that pose and that kind of backlight in our backyard when the sun was coming over Mount Franklin. It was a wonderful thing to be able to recreate the image I carried in my wallet, that sort of distant worship.

It's a very traditional piece of canvas that Sarah is painted on. I went to New York – I forget for what – and [saw] an old friend named Cliff Saber, who I met in North Africa, and he was a very good watercolorist. He had been to an auction in the Village [Greenwich] and bought a fine linen canvas, already sized and primed, out of the estate of William Merritt Chase from the early part of the 1900s. And Cliff said, "I don't paint in oil and how would you like to have this canvas?" And I said, "I'd love it." There was a store called Delsemme's, which was a great place where the artists in the Village and everybody in New York went to buy their materials, paints, and stretchers. And I had them make stretchers so that it would be the size of this big drawing [of Sarah] that I [had] already made. It even has a stretcher, a crossbar in the middle of it. Delsemme's made it for me and I brought it home and I stretched the canvas myself. [There was] a label, a stamp, on part of the linen that wasn't primed. It said "Whistler." And it was apparently the kind of linen that [James McNeill] Whistler used.

I had painted those things that *Life* had printed and a lot of people had commented on [them] and I thought I was pretty good as a painter. I was trying

to get back into this world and away from the South Pacific. I painted *The Shining Plain* because of a line that I had always loved in A. E. [Alfred Edward] Housman's poetry: "I see it, shining plain, the happy highway where I went and cannot go again." I did this old guy on a horse. I made a play on words there.

And Jerry Bywaters, a friend of mine who was the director at the Dallas Museum of Art, wrote and said, "Why don't you submit something to the All-Texas Show?" The exhibition was to go to Dallas, San Antonio, and Houston. It was an annual or every other year thing. It was called "All-Texas Exhibition," I think. Jerry, incidentally, didn't fit quite the category of some of these very snooty directors. So I sent this picture and I got back this form [letter], "Regret very much the jury could not find your painting [suitable for exhibition]." I don't know exactly how they put it. It didn't fit in with what they were think-ing. I don't even know who the judges were, but I was pretty darned disgusted. I don't think Texas had anything to do with it. I think it was imported jurors. This doesn't make them any better or any worse in my book. It's just that they think in different terms.

See, I had been away for those years during the war. I had been away from any thought about regionalism or the things that were occupying people before the war in the terms of art, you know: John Stuart Curry and Thomas Benton and Grant Wood and all of them. And I was thinking that, well, I want to get back into my part of the world the way they did. But I found that while I was away, the whole art world had changed and the New York expressionists were setting the tone for even our little Texas exhibition. I guess being a westerner, you're kind of a cornball back where they know what art really is!

And that helped me to be oblivious, not just independent, but oblivious to [art world trends]. Maybe I chickened out a little bit because I turned to writing prose. I did some novels and was really engaged as a writer for several years. I would paint things but they would never be submitted to a jury. I've never sub-mitted anything to any jury since. I like working without any comment by any-body except my friends. And my friends make allowances for me, and they more or less participate in the same kind of life that I have led. I had some friends that have been [in] different walks of life and they've brought different things to me and I think I've given them something, too. I have had great good fortune in my life.

*Time-Life* kept me on after the war. Dan Longwell was such a good friend and a generous man. See, I had put in a chit to go to watch the occupation of Honshu Island and that was refused me, so Dan said, "You know, you don't want to go over there anyway. You've been in the war enough and you go back home to Sarah and Jim. We'll keep you on the payroll until you get straightened around. Do us a story on, well, on cattle, beef cattle in North America." So I

98

thought, well, that's fine. I started making drawings and studies for the history of beef cattle and I knew that I'd have to find the origin of the cattle that first came to North America. And Frank Dobie's book, [*The*] *Longhorns*, was a help to me on that. [I had already learned] about this Gregorio Villalobos that brought the first cattle from the islands in the Caribbean to Vera Cruz and hence to the mainland in 1521. Well, I wondered what those cattle looked like; they were referred to as *ganado prieto*, black cattle, the breed used for bullfighting. There was another breed called *ganado corriente*, common cattle. They were the kind that were used in Spain to plow, like oxen. Well, you know, you can't think about what a certain type of cattle looked like until you've seen the cow and the calf. And it struck me that the only way I could do it would be to go down to Mexico and see some of those *ganaderías de reses bravas*, but I had no idea about how to get there and no connections.

I think it was at a party one night just before Christmas of 1945 when I met Raymond Bell, Jr. He was the son of the founder of that marvelous great cattle-raising hacienda called the Hacienda Atotonilco near Yerbanis, Durango. That hacienda was a very big and powerful piece of the economy in Durango. And Ray and I struck it off immediately, got to be friends in that one evening. And he said, "Well, come on down to Mexico. Maybe we can do something about your seeing those *ganado prieto*. I think I know how to get you there."

And about two or three weeks later he invited Sarah and me and Jimmy [Gen. James] Polk's wife Joey. Jimmy Polk was still off in the wars somewhere in Austria; I think he was still in the Occupation. So the three of us went down to Yerbanis. It was in January. In those days there weren't any airlines, of course, and you changed trains at Torreón and then you went west. Well, we got to Yerbanis about eleven o'clock at night and looked out and it was snowing. It was the first snow they had had in a hundred years or something. It was very deep snow. The ranch had some people there that got all our baggage for us and we rode over to the ranch, which was maybe fifteen kilometers from the Yerbanis station.

And the next morning it was quite beautiful. It was a different kind of life, you know, medieval. Old Ray Bell, Ray's dad, was really quite a character. I don't want to go into that because later Ray and his father came apart and it was very bad. Ray and his mother came up here and lived in El Paso. But we were down there about ten days just living it up in this beautiful place, and everything was done for you. Like one night Joey busted into our room and said, "I can't stand it anymore. I just saw him." I said, "Who did you see?" "Maximilian. You know I'm sleeping in his bed and I just don't like it. Can I sleep in here?" So, she slept in our room. There was another bed in the corner; I guess it was for a maid or somebody. But the bed that Sarah and I slept in was one of these big canopy

jobs, you know. It was sort of disconcerting because at any hour of the day or night somebody would come in and tend the fire. So the privacy was somewhat limited. Anyway, both of the girls had to go back to El Paso and we put them on the train.

And then Ray said, "Now we're going down into country where a friend of mine can help us, I think." He didn't tell me too much about it. He had a truck that was all fixed up with bedrolls, and a water carrier that was attached to the side, and gasoline, even oil, and two guys to change tires. And we started down to the state of Zacatecas and arrived late at night at this hacienda and we were met by this wonderful gentleman, Don Julián Llaguno. Don Julián was a great friend of Ray's father so we were treated cordially as guests there, and the next morning, why, we went out and saw the bulls. I spent about two weeks writing notes, like I had learned to do in the war, on the actual breeding procedure of these cattle. It was fascinating. *Toros de lidia*, the fighting cattle, have a longer registry than even the thoroughbred horse, and their records are very carefully kept. They're bred entirely for their spirit. The cows are really something; they act more like deer. They are very light-limbed and they jump! They have quite as much spirit as the bulls, so you have to be careful. And their calves are almost born that way. In just a few days, why, they can get around pretty well with their mothers. And they're put out in these pastures for cows and calves and they're not tended; they're allowed to be wild, you know.

So that was great to make these drawings and studies, to get my mind on the grass that grows and the men that make their living with animals, and that led off into a whole new avenue of adventure, really. I guess it was just the right time because Manolete [Manuel Rodríguez], one of the greats of the history of bullfighting, was in Mexico that winter that I was down there. And the whole of Mexico was all stirred up over how beautifully he fought in the *Plaza México*, and all the Mexican bullfighters were trying to be as good as he was. Manolete was perhaps the greatest bullfighter of our time. They called him *"El Flaco"* and the critics said that he fought a bull as if he were saying mass. It's a very beautiful, slow kind of statement about man's bravery and the look of death, and he could do it all with the way he passed the bull. And I got this excitement of the *ambiente taurino*, you know, and it was a great thing. We began to get in this bull-fighting thing instead of just bull breeding and the history of the breed, the *toros de lidia*.

From Ray Bell's I went back to Torreón, and I stayed over there for twenty-four hours waiting for the train. Those Mexican trains were really something in those days. Bud [C.A.] and Harriet Luckett lived there, and Bud always handled our transportation from the different trains. He was a cotton broker; he bought cotton for MacFadden, that big Memphis firm, and later for Anderson-Clayton.

Bud was the guy that would lend money to the farmers for them to get their crop and then they'd bring it in. And he was a grader; he could grade the length of the staple, and he was quite a guy in that business.

Bud and Harriet were wonderful. Anyway, Bud said, "I want you to meet a friend," and it turned out to be Salvador Cofiño, a young Spaniard, whose old man had a great big ranch and all kinds of financial interests in the state of Durango. Salvador got a law degree at the University of Salamanca; [he was] a very cultivated man and a great aficionado of the bulls. And Cofiño said, "Well, you've got to come and see Manolete." So let's see, we made the arrangements to go back to Torreón about a month later when Manolete was there.

Cofiño was very proud of the fact that he could walk right into Manolete's room in the Hotel Galicia, and he took me in and introduced me. Manolete was dressed in a sloppy old sweater, and he didn't look at all like this elegant figure of the bullring. He was so nice and he had thought it was amusing that here's this gringo, you know . . . . Anyway, I asked Manolete in a sort of a half-hearted way if he wouldn't mind if I did a portrait sketch of him there. And he said, "Yeah. When?" So he sat down. This was about 12:30. See, they don't eat on the day they fight until after the fights. They have some tea and maybe a little piece of toast or something early in the morning and then they don't eat until dinner. They'll wait so that if they do get gored there won't be quite so much infection in the abdomen. Anyway, he posed absolutely great, like a statue. And there were all these guys, oh, ten or fifteen of them, these aficionados that [would] travel even from Spain to watch him. You know, it was like [following] the world's boxing champion to a prizefight. This was a bunch of very interesting people, Manolete's sword handler and his valet, too. Well, he kind of kept the guy. Then Salvador Cofiño was there smoking a cigarette and holding forth on all the things that he was looking for that afternoon when there would be a performance by the great man seated there. I think Manolete was twenty-eight. Two years after that he was gored to death in Spain. Anyway, I made the sketch and, you know, it didn't look . . . it was a great face, but I wanted it to appear to be a bullfighter. So I had plenty of photographs and sketches of him. He had some *trajes [de luces]* there in Mexico that were sky blue and gold, beautiful things, and that's the way I made the portrait.

I brought that back and I prepared then a 7,000-word piece for *Life* magazine with fourteen paintings and watercolors about how a bull was born and raised and sent to the ring and then fought by a bullfighter. I sent it in a great big crate and I didn't hear for a long time and I got very nervous. And finally I got this letter. It was an interoffice memo and it said, "We thought you were down there studying beef cattle. What's this all about? What are you doing down there with the bullfights? Nobody's interested in bullfighting here in the

101

United States. Hemingway is way out-of-date." It sort of threw me, but I knew I had to do something.

I worked on the beef cattle story all through the year 1946 with those sketches of those great bulls tucked away in a closet. And I worked until January of 1947 on those beef cattle. We really went around. I even spent a week on the killing floor of Swift and Company in Chicago. That was the final end of the beef animal, quite a different end from the black bull being dragged out by the mules with their jingling harness and all the people giving ovations. And I even went to Gov. [Roy J.] Turner's. He was the governor of Oklahoma and he had a great Hereford bull named Hazford Rupert the Seventy-second [the Eighty-First] or something like that. He sired I don't know how many international stock show winners. Well, old Hazford Rupert was the nicest old bull you ever saw and he had had so many photographs taken. I don't think he had ever had a painter work at it, but he just would pose nice, you know, and I spent a day out in the pasture with old Hazford Rupert.

And we got that whole job done and I took it back to *Life* and they liked it very much but they never published it. They kept them on file. They published one, my portrait of Hazford Rupert, but nothing about beef, the range and the branding and the sending off to the feedlot and all the rest of it.

When I took my cattle pictures up to New York, I went up to Boston as a guest of my old friend the bookseller Charlie Everitt who had already [handled] that book *Peleliu Landing*. And Charlie sold a number of them up there in New York and he thought it was the finest reporting by a combat witness that he had ever read. He was even saying, "Stephen Crane doesn't bring what you did." Well, of course, he set me up pretty well. I had done a number of dust jackets and illustrations for Little, Brown and Company. But I had never met them. Charlie Everitt's son and daughter-in-law worked for Little, Brown, and they took me to lunch at some club up there with the production manager who was a wonderful guy, a fine typographer named Arthur Williams. They took me to lunch and I said, "Well, I think I'm going to write a book." And, golly, I remember how shocked they were when they thought I was going to do a book about the war. "Oh, good, about the war?" And I said, "No. I'm going to try to do a book about bullfighting in Mexico." And you should have seen their faces. My God, you know, here's another guy barking up the wrong tree. And they said, "Well, all right, when will you have a manuscript?" I said, "I'm going to have to teach myself. I'm going to write a novel." Well, this was further a terrible thing for them.

Anyway, I went back [to El Paso] and oh, when Dan Longwell severed me from the staff of *Life* magazine, why, I got regular severance pay. I had worked for them for four or five years and so it was substantial and it gave [me a living].

So then the first thing I did was to go across the river and make myself known to Roberto González, who was the impresario there in the bullring in Juárez. He turned out to be a damn good friend of mine.

My dad had taken me to the bullfights and I had read *Death in the Afternoon* and so I began to follow the bulls. There's a festival every spring around Easter time in the city of Aguascalientes. It's called the Fiesta de San Marcos and it lasts a week and every day they have bullfights and, oh, it's a great [gathering] of all the rascals and gamblers and bullfight people and horse racers and everything else. So I went down and spent the whole Fiesta of San Marcos through the patronage of Salvador Cofiño. I got to meet some of these young, want-to-be-bullfighters and it just enchanted me, the whole thing.

So I came back and I thought, well, there's no way I can put what I feel about bullfighting into any kind of an illustrated book about fighting bulls. I'll write a novel. So that was my occupation. I went to Mexico a lot and old Bud Luckett was wonderful and helped me and [so did] Salvador Cofiño. And the next year Manolete came to Juárez. He didn't have good bulls, so it was a disappointment to all the aficionados, but his performance was flawless for the kind of bulls he had to fight. And all of that was the most animating and inspiriting thing for me.

I haven't been to a bullfight in several years and my thoughts about bullfighting now are in terms of the days of Manolete and some of the others that fought at the time he did: Silverio Pérez, Antonio Velásquez, Luís Procuna, those guys. People ask me often, who is Luís Bello? I tell them he's a figment, he's a combination, a hybrid of all these great matadors.

I started writing *The Brave Bulls* about March of [19]47. I rewrote Chapter One fourteen times. Anyway, by the fall of [19]47 I sent the first four chapters up to Boston and, by golly, they said, "We want to give you an advance. You stay right with it, we're hanging on, looking at what you're doing." I think they gave me $6,000 or something like that.

I sent them a little outline; I had the chapters all figured out and just like a muralist, I knew the first line and the last line but I had to study the design in between. It was a hard thing to learn to make people talk because before, I'd only shown their faces. They encouraged me on those first four chapters, and I really went at it and finished it. I sent it off in the spring of [19]48, fourteen months [after I started it]. I remember it was fourteen months because I counted all of the ways I tried to get started on the book and it was fourteen efforts. It was met enthusiastically up there on Beacon Street in Boston.

And then I said, "I want to make illustrations." Now Arthur Williams, [the typographer], had been a good friend and a patron for all those book jackets and illustrations that I made for some of Frank Dobie's books. So he said,

"Wonderful. Do it any way you want." The editor up there, Ray Everitt, was a little bit puzzled about a novel with illustrations. You know, that just wasn't done. They didn't have novels with illustrations since Victorian times. And I did the illustrations and took great joy in them because I hadn't done any real art work for all that time. And they were very well received and they said, "We think we can really go to town selling this thing and [make it] a best seller." Which they did.

I got them a fighting cape and some *banderillas* with all the fancy paper frills on them and a *muleta* but I couldn't get them a sword. Those guys [the bull-fighters] were pretty tough about giving up a good sword. But they made quite an exhibit at Scribner's, that bookstore on Fifth Avenue in New York. In those days it was quite a place for best-selling books and all of that.

Anyway, it turned out to be a great success and I remember the editor sent a telegram that said, "Count your chickens. We've just sold *The Brave Bulls* to Hollywood." So that was good. Hollywood paid a lump sum for the rights to make a movie. And I said, "Now, I don't want that money. I want you to keep it up there in the bank and I want you to send a monthly stipend for Sarah and me and Jim to live on." Which they did, and *The Brave Bulls* financed the three of us for six or seven years. That's why I have that bull, Don Julián Llaguno's, hanging there in the entrance way to our little house here. I did extra things of course, commercial art and sold a few paintings and so on, but *The Brave Bulls* paid our expenses.

That was a great time. They had a party for the author at the Baker Hotel in Dallas, which was about as far west as they could conceive of going from Beacon Street in Boston. Frank Dobie's book on coyotes had just been published, so that party killed two birds with one stone. And that night we all got smashed, too! Oh, it was a big deal. And I refused to do an autograph party, you know, where you sit there and hope somebody will come by and then you write something nice and then here's another one, "Oh, how do you do?" I said, "I will autograph all the books that you've got, if you let me do it just sitting and tending to the business of signing them."

Let's see, there was something else that came up. I was on a hunt with Frank Dobie down in the brush country when the editor at Little, Brown wired and said that I should come up to New York. Every year the critics voted for the best fiction and nonfiction, and they gave [an award] to *The Brave Bulls*, but I didn't go. I said, "No. I'd rather be hunting down here." It sort of gave them a different idea of [me as] a writer. I wanted to write and not be this great figure of a writer.

Rex Smith, who was one of the vice-presidents of American Airlines, was a great bullfight aficionado and was very interested in my doing the book.

When I finished *The Brave Bulls* I sent one of the first copies to Rex and he wired back, *"Su libro tiene muy buen[a] casta."* *Casta* means breeding. It's, you know, when you say it's traditional and it's correct and it's also strong, it has *casta*; it's a word that is hardly translatable into English. Anyway, that delighted me.

Columbia Pictures then paid me to go out and write a script for *The Brave Bulls* movie. The producer and director was a guy named Robert Rossen, who had won two Oscars: one was about a prizefighter and the other one was a fictionalized account of Huey Long. Rossen was very prominent in Hollywood and he bought it and he was under contract to Columbia Pictures. Columbia Pictures was run by Harry Cohn, who was [a rough-edged, foul-mouthed front office despot], but he sure ran a tight ship at Columbia. And everybody was scared of him because he wielded power with such an iron [fist].

I guess I was out there [in Hollywood] a couple of months and I had a very nice set-up there in a fancy hotel. And then at Christmas time, why, Jim and Sarah came out and we got a place up at Malibu. I'll never forget how Jim made great friends with the Chinese chef, who was great at chess, and so was Jim. Jim was just a little kid, you know. And they'd play chess while Sarah and I would take these long walks along the beach. It was idyllic. Anyway, us Leas had quite a time in Hollywood, but utter frustration and disappointment in how my script was received. [They] didn't like it at all.

Rossen got another guy in to write another script, and then we all went down to Mexico City. Rossen didn't know a thing about bullfighting and had never seen a live bullfighter. So I went down to introduce him to the *ambiente taurino* and he took his set designer and his costume woman and a lot of go-fers and one of his financial advisers and so on. And he made all these contracts with the bullring and [he] got Mel Ferrer as Luís Bello, the main [character]. He chose Mel Ferrer because Mel looked so much like a bullfighter, and he picked a Hungarian girl named Miroslava who later committed suicide in Mexico City over the love for a bullfighter.

I went down there on that first trip when they were picking out locations and everything. It's not an atmosphere that I care for at all with its nonproductive kind of people. There are so few of them that are really creators. What creation they have depends on several other departments, so that I didn't like it. You know, you're almost a prisoner of this system. And the fact that they didn't like my script sort of teed me off. I refused to go back during the filming in Mexico. And that's how I got so fond of Bob Parrish. He was Rossen's cutter, his film editor. He was worried the movie wouldn't go well [if I wasn't there during the filming]. I remember what I told him. I said, "Well, we just won't go to the movie." And this killed him because his heart was in it, you see; he was the cutter for the thing. I knew, even at that time, that Bob [Parrish] might never hit

the high peaks in Hollywood because he wouldn't do just anything to get up there, [like] kick his grandmother in the teeth. He was a very fine gentleman and knowledgeable.

Anyway, that whole Hollywood thing turned me off. The premiere of *The Brave Bulls*, incidentally, was held in the Plaza Theatre here in El Paso and I don't remember anybody but Parrish coming to the opening and a couple of the Columbia guys, not Harry Cohn. Chris Fox presented Sarah and me with a great big silver platter with an inscription about *The Brave Bulls*. The film came out early in 1951.

Since I had such a profitable time with *The Brave Bulls*, I wanted to do something that had been in my mind since I was a kid: write about this border-land and about the people on both sides of the river. That's *The Wonderful Country*. The writing was entirely financed by [the money I made from] *The Brave Bulls*. There again Ray Bell was a great help to me in Mexico. He had moved with his family to Cananea, where he was general manager of the Cananea Cattle Company in northern Sonora, not too far from the border. Ray took me down south into the Sierras and we had a great time in this little town of Arizpe. We went to a great, smashing wedding that lasted three days and got to meet all these kind of guys that are out in the country. That was [the inspiration for] the painting I did, *Everybody's Gone to the Wedding*, you know, the empty streets in the little adobe town. And, of course, my father had told me about some of his early experiences, how he rode from Chihuahua all the way down to Colima, stopping off at Guadalajara. And then he found some place in one of the *barrancas* that he described to me one time. So with the information from my Dad's experiences and Ray Bell's keeping it alive for me and helping me with all the Spanish idioms and names for plants and all that kind of thing, why, I got *The Wonderful Country* done.

When traveling down in Mexico I never carried anything more than a little notebook because I was trying to train myself to hear rather than to see. I was trying so hard to be a good writer, you know. So I sort of had to forget about illustrations and paintings. A lot of the characters in *The Wonderful Country* are people that have been part of my life. You can hardly avoid that, you know. I gave a few of them their own names, like Doc Stovall. The hardest chapter in that book was where Martin goes with Joe Wakefield across the river in the springtime. I was trying to tell how much this fellow felt about both sides of the river. I remember I struggled and struggled for some way to express springtime and I settled it by saying, "A mockingbird sang on a budded cottonwood" or something like that. I had to watch myself about using the big word. I always chose the shortest way if it could say exactly what I wanted.

106

I've always tried to be a real writer. And maybe that's why I've only published a few books. I tell people, the young people, that want to write, I said, "You don't want to just write. If all you want to do is just write and be a writer, why, forget it. If you find a subject that's eating your guts out and you really have to have this in order to have peace in your mind, then write about it and you will be a writer." My writing may not be first class but it's the absolute best that I can do after full consideration of every page, every paragraph. I'm not very prolific. Writing is finding words that speak what you hear. It's not in any way pictorial. It's speaking, isn't it?

The Literary Guild took *The Wonderful Country* on as one of their books. It was an alternate choice of the month; it wasn't their big choice. And they paid fairly well, but not as much as I had hoped. In those days, you know, if you got $50,000, that was big. [The book] was translated in Spain, called *La Frontera*, but in Mexico it's never been published because there are two rather villainous *políticos* [in the book], the Castros.

Bob Parrish had gone on to direct pictures and by the time *The Wonderful Country* came up as a possibility for a movie, why, he had done two or three successful pictures. [They] made money and so he was in a position then to ask me if I would let him – I think I volunteered – I said, "If you want to make a movie, I think it'll make a good one." I gave him the contract; we never did anything but shake hands, Bob and I. [I] didn't make any money off of that, but I made this great friend.

We couldn't get the thing financed. United Artists wouldn't give us any money unless we got one of the first five box office big guys to take the lead, the main part. We immediately thought of Gregory Peck but he refused. He had just married a beautiful French girl and he didn't want to do any kind of location work [in Mexico]. Bob had known Robert Mitchum, and Bob Mitchum agreed.

And then we started on the script. I stayed out there [in Hollywood], oh, it must have been six weeks anyway, doing a script on *The Wonderful Country*. And Bob said, "I don't think it will sell." There wasn't enough, you know, love interest and all that stuff. And he took it to United Artists and, no, they wouldn't do it. So Bob finally got a fellow who had written a lot of scripts, and he wrote a script that seemed to please the people well enough there in Hollywood. Hollywood is a pain in my neck and still is, you know.

Anyway, we got it all arranged and I was down there on location with them [in Mexico]. And Bob said, "There's only one way I can get you some money. I can give you a speaking part. If you only say two words, you can get a very nice [sum] of money." All the money I ever made out of the movie *The Wonderful Country* was as an actor. I took a very small part. I was Peebles, the barber. I gave Bob Mitchum a shave and a bath. We had old Mitch in the tub and he was

expecting some warm water; we had to pour it in from a bucket. We had this old, beat-up Mexican tub and absolute ice water. And I poured it on him and he jumped out of there! Bob Mitchum was a tough bird; he was awful on those sets sometimes. He'd talk bad, very, very obscene. But, you know, there's something about Bob that was okay. When Sarah came down to San Miguel de Allende to see some of the filming, why, Bob was this perfect angel, you know. He had been around those kind of people that are like Sarah so little, that it kind of came in on him that he was doing wrong, you know, at least that's the way I thought. Anyway, he had a lawyer that was, I guess, in cahoots with United Artists and it was very unfortunate. All the picture was distorted by Mitchum and the script, and the financial part of it was very lean. Mitchum and United Artists made all the money.

Then, you see, *The Wonderful Country* wasn't quite over when I got the first inquiry from the Klebergs about doing a book on the history of the King Ranch. The centennial of the ranch was coming up, and they wanted a little mono-graph and well, actually, a good part of five years of my life went to that King Ranch thing.

Holland McCombs had been down at the King Ranch doing a piece for *Fortune* magazine. He was one of their researchers. Holland was a friend of mine; he [had been] a correspondent, too, but not a combat correspondent. He was a great advocate of my work; even before I wrote *The Brave Bulls*, he [had admired] that little poem *Randado* and *Peleliu Landing*. So I think he mentioned *The Brave Bulls* to Bob Kleberg's wife, Helen Campbell Kleberg. She was a very fine and wonderful person, sort of kept Bob on line. And they had some discussion about *The Brave Bulls*, and Bob Kleberg told Bob [Robert C.] Wells, who was his chief PRO or whatever you call it, to write me and ask me if I would be interested. And I said I'd be interested only if I could have Holland McCombs help with the research, that I didn't have time or the knowledge to do all the research that it would take to do the history of South Texas, which it grew to be. And I didn't want to do it unless my friend Carl Hertzog could design and print the volume. So I pulled those two guys in from the very first, and Bob Wells and Holland came here to meet Carl and me and that was our first sort of tentative agree-ment. And Wells, then, wrote a King Ranch letter that was sort of a contract. It was a very informal contract. We didn't even know what we were going to do, you know. So that's how that happened. And the minute we met, why, I think everybody concerned knew it was going to be okay. You know, it just jelled.

Anyway, we got it all arranged and I was down there on location with them [in Mexico]. And I think they were very interested and maybe dismayed a little bit over the way I wanted to see the ranch. I had just been at headquarters with Frank Dobie once, but I asked them to take me over the ranch with a map so

108

I could see the topography of it in their airplane, take us down to Brownsville and then after going down the mouth of the river [Rio Grande], see Padre Island and the site of Bagdad where Capt. [Richard] King got off the steamboat and came ashore.

And then I wanted to ride on the old ranch trails behind all the fences from the southern end up to the Santa Gertrudis headquarters, taking our time, camping, moving. I think we were out for three days. And old Carl was with us, and we had a great time. The superintendent of one of the ranches, the El Sauz Ranch, was a wonderful, great big fellow named Bland Durham. The El Sauz was the ranch where that man had disappeared and there was all of that sort of wondering whether the King Ranch had done away with him for breaking down a fence and entering. I went as far as I could in investigating that. There was never any truth in that. They called the King Ranch "the walled kingdom." It was all press, you know, to . . . . But, later that evening Carl said, "Say, isn't that fellow Bland something? You know if he asked me to leave, I'd hurry."

That was the first time I had ever seen Bob [Kleberg]. We flew over the ranch with a map in hand and we landed in Brownsville and hired a little boat and went down to Port Isabel and Padre Island and around to the mouth of the river [Rio Grande], and to the ruins of old Bagdad, the smugglers' joint over on the Mexican side, and then Fort Brown, which was there before Brownsville was established. There's a picture of us that Helen, [his wife], took of Bob and me in the stern of this little motorboat. We got the flavor of what old Capt. King was. This was the first time that Bob had ever known what all his grandfather did in the early days, you see? And oh, we had a regular picnic, you know. We traveled north in those hunting cars, and we'd go through these pastures where there'd be all of these cattle and this tremendous quiet. It's a wonderful, wonderful place, the King Ranch.

The part that I thought the most of, and I think Bob and Helen certainly did, was the ranch called the Norias. That's south of the Santa Gertrudis, and in between the Santa Gertrudis and the Norias is the Armstrong Ranch. And of course, Tom Armstrong married Henrietta Kleberg and there's all that connection, you know. Old man [Mifflin] Kenedy had most of that property earlier and then the Armstrongs took it over. Anyway, the Norias is a wonderful place and it's kind of like going back into history — this great sprawling house and the houses of the *vaqueros* and even a little church for the *vaqueros* and a school.

The last [time] Sarah and I were there was at Bob's funeral. It's in the most beautiful, isolated part of the Norias Ranch, where there are these big live oak trees and a little lake which Bob had stocked so that Helen could catch bass. And Bob and Helen are buried out [there]. There's no monument, just a flat slab with

their names on it, side by side there in the Norias. And that's where they spent their honeymoon and all the good times of their life.

I remember that during [Bob's] funeral services, when they were lowering the casket into the grave, that one of the ropes came loose and darned near spilled the casket. God, it was hard to keep a straight face, you know. That's the same as another time when Lon Tinkle and I were the short guys as the pall-bearers for Frank Dobie's casket and the burial place was up on top of a rise in that state cemetery down there in Austin. And that thing got so heavy for Lon and me we nearly dropped the thing on the ground and the undertakers had to come and get it up.

I never was able to do any actual writing at the King Ranch. There were too many people always coming in and telling me stuff. But it was enchanting to know a lot of these people. The *vaqueros* were really great characters and some of the guys like old Ed Durham, who ran the Norias part of the ranch, and his brother Bland, who was a great character . . . those kind of people and Bob Kleberg. He taught me so much about how to look at country, what he saw in country and what he saw in animals. At that time old Assault, the triple crown winner, was there and in great shape. Their seed bull Monkey had died; he had really established the Santa Gertrudis breed cattle. I learned an awful lot, especially how those people knew the points of conformation on horses and cattle. That gave me confidence when I was drawing and painting animals. All those people had a very great feeling for the breeding along a certain line.

Old Dick Kleberg was there, prowling around the ranch . . . . You know, Richard Kleberg took LBJ [Lyndon B. Johnson] into his office as his paid assistant up there in Washington [in 1931]. Old Dick was elected twice with the goodwill of the vice-president, you know, the old guy from Uvalde [John Nance Garner]. Then later [1937] LBJ just decided that he could be [elected to Congress]. So old Dick had to leave Congress [when he was defeated in the Democratic primaries in 1944], and his assistant [LBJ] had become a congressman. There were no kind feelings between the Klebergs and LBJ, ever.

But the main thing that I loved about doing the King Ranch thing was the rides. Bob and I would get in one of those hunting cars that didn't require a road, or very little road, and we rode all over that vast acreage very slowly and he always took along his man, Adán, who always had very nice collation and some drinks in the back of the hunting car, so that whenever we felt that we should stop and contemplate something or have a bite to eat, why, he was always handy. And we'd go out and spend the whole day just riding around and he would tell me things that had happened in various places on the ranch, and how he'd changed this and changed that. And he'd point out the cattle and the

quarter horses that were there in the big pasture. And it was quite a privilege, and I felt that I had learned a great deal.

And I made friends, Bob and Helen Kleberg; Helen died not too long after the book was published. And Sarah and I made dear friends, young Dick [Richard M. Kleberg, Jr.] and his wife Mary Lewis. Young Dick had some of the greatness of his uncle Bob in him but he was fractured. He was always a dear but tragic figure to me, quite unlike his Uncle Bob, who was the "the-hell-with-you-if-you-don't-like-it" kind. Dick wasn't like that. I think it was because his uncle maybe had forced him to be a second voice instead of letting him function on his own. I wrote the eulogy for Dick's funeral, but I couldn't deliver it; the preacher did. And Mary Lewis is still a dear friend.

These have been lasting friendships and a good thing for both Sarah and me. For instance, well, we'd be in New York and here'd come Helen and Bob and they'd say, "Have you seen *My Fair Lady*?" And we, of course, were kind of country bumpkins. "No, we haven't seen it." "Well, would you like to see it tonight?" You know, it was in the days when the tickets were sold out eight months in advance. They'd say, "Well, let's go! We'll have early supper and go!" So we got together and had a little early supper and went to the theatre and there were Sarah and me, third row seats in the middle. How it was done, God knows. But I have never seen a show that was so enchanting as *My Fair Lady* with Rex Harrison and Julie Andrews and the original cast. It was really great. Things like that were so appealing to Sarah and me.

It was immediate friendship, trust on both sides, you know. You can tell when. So I stayed a hired man but it became a kind of a friendship. Bob, of course, was always a very good businessman, and I had a contract for one year. My work took five years, but the contract was not changed as far as compensation was concerned, although he did buy the drawings for the book. He paid me as much for the drawings as he did for five years of work writing, just to help. But we later just . . . "Come down to the ranch" and "Come down to the sale" . . . and we were always down there and having fun with the whole bunch. It was not any kind of a feeling that I was being paid for doing work. I never did feel that.

There's still a warm feeling. So often people write books and [those who commissioned the books] get angry about things. I was able to not make [the Klebergs] angry [but I told] the truth. I don't know exactly how to express that. But there's not a thing in that book that I don't know to be a fact. I got so damn mad at Frank Dobie when he said that I had been overly impressed by the Klebergs and their big ranch, and I had become sentimental over things. That's the one kind of criticism that I hated the most and my good friend made that criticism.

111

You see, he was out here for a big dinner at the El Paso Country Club, and all the Klebergs came out, too. And all the time he knew that review of his [was going to be printed]. He left on Sunday morning, and Ned Bradford, the editor-in-chief of Little, Brown and Company showed me the review and said, "Look what I just [read in] the *New York Times*." And it was this review. I read this thing before I went to the bullfight and I was pretty upset. It just made me goddamn mad that Frank had been here knowing that he had written it and that it had been printed! So it burned me. So I let Ned Bradford know how I felt, and Ned felt kind of responsible because he was Frank's editor, too. And there was a dropping off of my friendship with Frank Dobie for about three years after.

I never said anything. And my silence was, I think, just the correct thing. It got old Frank a little bit. At least Lon Tinkle said that it did. In his biography of Dobie, Lon said it's the only time that he [Dobie] ever displayed jealousy toward anyone. I think Frank really had wanted to write [*The King Ranch*]. I don't want to talk about any of that because we buried it. One time Sarah was in Austin and she said, "I'm going by and see Frank. I think it's terrible that you all are so far apart." And she went. And Frank was very, very happy, and so was Bertha [his wife]. They parted as dear friends, and the Dobies said whenever i could get to Austin, why, they would like very much if I would come by. So when I took that painting *Ranger Escort West of the Pecos* down to John Connally, who was governor at that time, I went by the Dobie house. He gave me an *abrazo* and was very happy that we let bygones be bygones. It wasn't more than three or four months later that he died. And, of course, Bertha made me one of the pallbearers. And I didn't feel hypocritical at all because Frank had done so much for me and we had patched it up. I think Frank was genuinely sorry that he had written that review. Bertha said he suffered over it. And I was glad he had suffered! I could never figure how a friend would do that. But Walter Prescott Webb countered it with a grand review in the [New York] *Herald Tribune* saying that I had done a good piece of historical writing and that he liked it.

From the standpoint of a creative writer, *The King Ranch* was a kind of prison for the imagination because it was all simply a factual thing, and you had to prove every fact. The problems of writing nonfiction were so very different from the creative effort of a novel. I learned a considerable amount about how to handle facts that I hadn't known about. I had no background, no training for this kind of thing.

The part about old Captain King was by far the most interesting part of it. He was really a character. You know, I did a whole bunch of illustrations for the book, maybe fifty of them, maps and all. Bob and Helen decided it might be [better] not to show one [of them]. It's old Captain King with a jug of whiskey and his fingers crimped in the handle of the jug of whiskey and he's got a rifle

in the other hand. They called him *"El Cojo."* He was crippled in an accident aboard a steamboat. And the other thing that was interesting: he bought a parrot down in Matamoros for his wife. And on the way up to the ranch in the stagecoach the damn parrot bit him in the nose and took a chunk out of one side. So the rest of his life, [he had one] very large nostril compared to the other nostril. That's why he grew a beard, to make it less prominent.

My general feeling is that the writing and printing of the book *The King Ranch* was a great experience. Of course, there were some very irritating times and all, like when Carl got drunk and called me up and said, "You dirty son of a bitch, you ruined my life!" He didn't mean it at all. And Vivian [Carl's wife] called up right after and said, "Now, Carl doesn't mean that. He's just been drinking." Oh, me! We had some times.

Carl let things get to him. He'd say, "People come and bother me. They come and talk to me. I can't escape all of this!" All he had to do was shut the door. The minute anybody got there, "Sit down. Let's visit." He'd talk all day and then feel under pressure again. And, then, "Oh, God, the people are killing me," you know. He was always a talker and also a kind of a hypochondriac. He always had something that was bothering him in his physical state. I think as it turned out he was pretty dad-gum healthy. He lived a long time, and he used a heck of a lot of Camel cigarettes and bourbon whiskey in the process.

Carl was always searching for some kind of a religion that would fulfill his great need for understanding the mysteries he saw around him. Oh, he was something. Carl was terribly concerned about his relationship to the Deity. And he would get new ideas all the time and different ways of thinking that he was getting a little closer to God or something. It really took a lot of his time and emotion. Finally, why, he sort of gave up and I think went to the Presbyterian church and his wife, Vivian, took it up. But Carl used to come by in a great sort of quandary over what is fate, what is the hand of the Lord, what is all of this? And he couldn't . . . he said, "Now, why is it you get back from an experience, like with the marines down there in the South Pacific, and so many of them got killed and you didn't. Now why was that?" This used to bother Carl. I'd say, "Oh, hell, Carl, I don't know. Who can say?" And Sarah was usually there, too, and Sarah is very good at, you know, saying, "Well, now, Carl. No one has ever known exactly how to answer that question. There's all kinds of concepts of fate and destiny and what's the hand of God." Well, Carl was very busy creating a God that he knew could do anything, you know. Funny guy.

Carl was great for difficulties. He was always suffering quite a bit, and, of course, the peak of his suffering was *The King Ranch*, and that was *years* of suffering. Carl and Holland McCombs did come apart on certain issues. They got into a mess because Holland would forget or neglect to cite his source. And, of

course, Carl and I both felt that the book should be annotated and every statement be from a source that was reliable. So Carl hired Francis Fugate [of the English faculty at Texas Western College] as annotator and editor. And I managed to get along all right with him. Fugate never told me how to do anything. He knew I wouldn't pay any attention. But he and Holland really came apart over some of the citations and parts that Holland had written. The point is that Fugate and McCombs really complained: Fugate to Carl and McCombs to Carl because they weren't having much personal contact. And one of Carl's stories was that Holland called him on the phone from Kingsville and says, "Carl, I know that on this project we need a Fugate, but do we need *that* Fugate?"

I think Al Lowman [Hertzog's biographer] has a somewhat exaggerated idea about the greatness of the book and the typography, but it's very pleasing to me what he says. I think Carl created one of the most interesting books ever printed in this part of the country as far as design is concerned. A lot of collectors wanted what is now called the Saddle Blanket Edition, but Carl and I never called it that. We just called it the Ranch Edition, but I think Walter Webb dubbed it the Saddle Blanket Edition. That was how it was bound, of course, so that's how it's become known. Anyway, we produced the book and it's still a pretty solid piece of work.

[While I was working on *The King Ranch*] in the early [19]50s, I was made a board member of the El Paso Public Library, and we got a bond issue through to build a new library [because] the old Carnegie building was in pretty bad shape and we had outgrown it. So Robert E. McKee was kind of the papa around here for any architectural improvements in the town or any big jobs, and when the bond issue was passed he said, "Well, I'll see that we build something that the bond issue can take care of, but we'll build it right." And, of course, we knew he would.

The architects were Ed Carroll and Louis Daeuble. My friendship with Louis Daeuble goes back to the times when Louis worked for Percy McGhee. We called him Pop McGhee, and Pop was the one that designed the Federal Courthouse, in which I have the *Pass of the North* mural. He was also the architect of Centennial Museum on the campus at UTEP, and Percy gave me the job of designing that lintel over the main doorway of the museum. Louis Daeuble was working in his office, and we struck up a good friendship.

Carroll and Daeuble, Architects, was out on Yandell Boulevard opposite Houston Square, and they had a wonderful kid in there who was a designer. His name was Carl Young and he was a marvelously gifted man. And they set Carl and Bill Waterhouse, who was a chief designer there in the firm, to work on a good design for the library which old McKee would build. Well, Mrs. [Maud] Sullivan, of course, had died by that time, and there was a new librarian named

114

Helen Farrington, and she thought that we would be wrong to go ahead with any local designs without consulting first an architect who had had experience doing libraries, how the traffic worked and all the various technical things that a library needed to know. So we hired a man named Githers from New York. He had been the designer of the Brooklyn Public Library, I believe. And I remember that Louise Wilmarth, who was a darling, was on the board, too, and she'd always say, "Now, Mister Ginthers." And it burned the old boy up, you know. His name was Githers, without the "n." Well, anyway, he provided us with a sketch suggestion at a certain cost and it looked just like an icebox, a refrigerator, you know, a big square with some places in it that would allow light to come in and a place to come in and out of and that was about it. So we said, "Well, thank you very much and we'll take your advice about traffic patterns and so on in the interior, but we're going to have our local architects do the building." He went off with his fee very happily and Carl Young and Bill Waterhouse and Louis Daeuble then started work on it and I think they did one of the finest original pieces of architecture in our town.

Bill Waterhouse went out to Hueco Tanks and made some copies of some of those pictographs and he said, "How about putting some of these indigenous designs in the ceiling of the library entrance?" And so we cut little patterns and nailed them down to the concrete forms so that when they poured the concrete, why, here were these incised little figures of Indians and horses and I think we found one with a conquistador. I think they are a very attractive part of the library to this day.

And Louis said, "Now, we've got to have a mural of yours." And I said, "I'd love to." And he said, "We're going to design it so that it's got a good place, right opposite the entrance. We're going to make the Southwest Room [there], and we're going to put our fine pieces of Southwestern Americana in this room, but it will in no way conflict with the view of your mural. And we're going to have it so that there's a gate so people cannot enter to do anything that might damage the mural, but they can study in there."

There was room for some study tables and, of course, the racks. And everybody kind of pitched in. Joe [José] Cisneros designed the little wood reliefs, Southwestern motifs, on the ends of the bookshelves, and I got Stan Stoefen, the framer, to design work tables and chairs. He was a marvelous man with wood; he got some pecan wood and did several tables and chairs in a beautiful modern style that fit in with the style of the room itself.

But, anyway, I couldn't do the mural then because I was absolutely up to here in *The King Ranch*. And I said, "As soon as I get *The King Ranch* done, I'll do the mural. You better prepare the wall, though, so that when I get ready, why, we can do it." There were a lot of good craftsmen around our town in those

115

days, and Ray Schenk, the guy who installed the canvas in the courthouse for me, was a great paperhanger, and he could handle a heavy linen canvas as if it were paper on a wall. And I ordered the canvas from Arthur Fredericks, my friend up in New York. [It was] Belgian linen canvas, and Ray Schenk mounted it there on that back wall of the Southwest Room. And the canvas waited for me for two years and got nice and mellow.

And every once in a while I'd see Ed Carroll and Louis Daeuble at a party and they'd say, "When are you going to do our mural?" "Well, I'm going to do it soon." So the day came when I could do it, and I already had in my mind exactly what I wanted to do. And so I made the sketch, and the [library] board and the architects were all very pleased with it. And I said, "This is all on me. You provide the wall and I'll do my work as a gift to the library and to the city." So everything went fine. I needed an assistant and I had one very handy in the name of Sarah Lea. And so I showed Sarah how to read scale drawing and we would snap lines a foot apart, and our scale was two inches equals a foot. And I explained all that. And she helped me draw the [outline of] the design with charcoal onto the canvas. And then we painted the thing. I think it only took us about three weeks, something like that. We went every day. I would mix up a batch of paint, we'll say, for the mountain over on the right hand side of the painting, and then she would paint right up to the line. She was perfect on doing things like that, you know, precise things. And when we got it finished, I insisted that Sarah also sign it. And we had a lot of fun over that. And it was very well received by the library board and by the people. They had a party at the library one afternoon and asked everybody to come in and see it, and we were all delighted. Carl [Hertzog] had prepared a bibliography of the history of this part of the country, and particularly of El Paso, [to distribute at the library], which tied in nicely.

The one thing that I think is interesting about it is [that] it has no evidence of people. The human race [is] not in it. And the only human connection that you might have is that the horizon line is at the same level as the eye of the onlooker, so he can fit into the level of the horizon. The Hopi and the Casas Grandes and Pueblo pottery designs [always] fascinated me, and if you'll look, you'll see in the mesas and in the clouds and over in the patterns in the sand dune some of the thoughts that the Indian ceramic people must have had about the natural forms.

Each summer that I was working on *The King Ranch*, why, Sarah and I'd take three weeks or a month off with the Leavells, Charles and Shirley, and go up to the Wind River Mountains in Wyoming. Charles and I got to be close friends after he married Shirley Terrell and after I married Sarah. That would be in 1938. Shirley and Sarah hit it off very well, just as Charles and I did. During

116

the war, then, Charles was being very successful doing general contracting work, and he would help me when I'd get my paintings done. He would have his men make these nice crates and cases. And he and Shirley always came over to see what I was doing on these paintings before I sent them away. And after the war, why, we became very, very good friends.

In 1951 Charles [introduced us to his] uncle John. I loved John Leavell. He was one of the wonderful old boys that helped me shape my life. The following year he told Charles and me, "You kids don't know anything at all about the joys of being up in the wilderness. You're city boys and I'm going to take you, if you'll go." So we got on the plane and got off at Rock Springs, Wyoming. And this old boy named Clem Skinner, who was John's outfitter and guide, gave us a good indoctrination because Clem stopped off a couple of times from Rock Springs to Pinedale. He knew all the barmaids as well as the contents of the bar in every place that we went. He had even been John's sergeant in World War I, and John had the Distinguished Service Cross for bravery as an artillery officer.

We got to Pinedale feeling pretty good and the next day, why, we rode this old decrepit government-issue mail truck – it still had "U.S. Mail" on it – up a rocky road to this lake. We had to get out of the truck because the battery acid would slosh all out and ruin your pants if you sat in the front seat. Anyway, we got up there and he had some good horses – John had seen to that – and we rode a whole day and got up to this beautiful Horseshoe Lake, and there was old John. He had this Osage tepee, real one, pitched there for his camp. And, of course, there was a cook shack there that old Clem was tending. He'd send Clem for some ice, and Clem would go back of the tent to the snow bank, you know, and we had a great martini and started off our fishing life that way. We spent a couple of weeks with John up there in the mountains and we'd ride and fish these great streams and in all of these beautiful lakes up there. We saw nobody, nobody. And it was just like when Jim Bridger was out there catching beaver, you know.

I did a portrait of John Leavell and I gave it to his wife and she didn't like it because I did him up there in the mountains with whiskers and a red kerchief around his neck and looking pretty rough. And he *was* rough. God, he had even been a whaler. He'd done all kinds of things. He ended up owning a lot of oil wells. I loved John Leavell.

That [trip to Wyoming] brought Charles and me very close together so that after a year or so, why, Charles said, "Let's take our girls up there." And we did. For several years then we were together up there in the Wind River Mountains of Wyoming. It was one of the good and vivid parts of our lives, I think. We shared it, and we've shared many trips together.

117

And another close connection [happened] when the Leavells had a big party for me when *The King Ranch* was all finished. The Little, Brown editor came out, and Frank Dobie and Rex Smith and C. R. Smith and all the Klebergs and everybody. We had a big time. My brother Joe and his wife, [who] lived in Beaumont, came over to join the festivities, and Charles said, "Joe, what are you doing now? I really need someone in my firm." And the result was that Joe and Marjorie moved here to El Paso and Joe became vice-president in Charles' construction company. They did construction all over the world and Joe worked for him for maybe thirty years. That was a wonderful connection there, see?

[In Wyoming], we'd start at Pinedale and get up to Boulder Lake and then get on horseback and ride up into the mountains and cross the divide and fish for goldens and have a wonderful time. It was so different from what I had been doing and it was in such different country, such wonderful, beautiful, inspiriting country that when I got through with *The King Ranch*, I already knew what I wanted to do and that was write a novel about those high mountains. And I thought I could combine or weld it into experience about the war, so I made the principal character a marine just home from the Pacific. The coconuts and the pines were such a contrast. I took great pleasure in writing the whole story. This was about a family in the mountains; they were skiers and mountain climbers and all the rest of it.

Sarah and I went up one winter to Sun Valley and learned to ski so that we could know a little bit about what these characters were doing when they strapped on a pair of skis. We had a great time. Sun Valley was a heck of a nice place. There were some interesting people there [like] Ann Sothern, the movie actress, and a gal named Clara Spiegel, whose old man owned that big mail order house in Chicago, Spiegel's. She had a house in Ketchum [Idaho], which was delightful. Our guides were ski instructors there in Sun Valley. They introduced us to the various things going on behind the scenes in Sun Valley. And then at night, why, we'd have these parties [with] Peter Duchin playing [the piano]. It was just a great time.

When I was doing *The Primal Yoke*, why, Ned Bradford, who was the editor at that time, came out to see what I was doing and I said, "Ned, for five years I've been working on *The King Ranch* where every word I said had to be annotated and it had to be proven truth." And I said, "I am inventing now. I'm making stuff up out of my own little head. And you can't see it, Sarah can't see it, and nobody's going to see it until I get it finished and [I] say, 'Will you print it or will you not print it?'" It made him mad. He packed up and left and went to California. [I] hurt his feelings because I wouldn't show my editor my work. But I never let the editor in Boston ever tell me to change a word or to change a paragraph. I can say very truthfully that every word that's been printed in any of my

118

books is exactly the way I thought it and wrote it, with no change. And this is not true of very many writers.

And when the *The Primal Yoke* came out, I was on a trip in the Mediterranean on the carrier *Saratoga*. I was the guest of the skipper Alan Fleming who had been a pal of mine on the *Hornet*. He was stationed at White Sands [Proving Ground] right after the war and he and his wife Mack became very dear friends. He got permission from the secretary of the navy to have me come along on the *Saratoga* with him, and I was just there for the ride and for the fun of it. Gosh, I did a portrait of old Al Fleming sitting on a high stool conning his ship, the great aircraft carrier. And you know, here's this great ship, a thousand feet long, with twenty-two hundred men and over fifty airplanes, and here he's sitting on a stool and there's a little windshield wiper just like on a Ford car, and when it rained, here's the captain cleaning off the windshield by hand. But I made the drawing when he was up there working, just like I made the drawing of Chennault when he was sitting there at his desk, briefing his pilots. Now those were fun. I was on the *Saratoga* for about six weeks, including a trip we made around the whole western edge of Europe, from the Mediterranean clear up to Norway and even to Spitzbergen, way up in the cold country. I'd go ashore with him. For instance, the first time I ever put foot on Spain was in a helicopter with Al Fleming off the *Saratoga*. Anyway, we had lots of fun.

When I got back from that cruise, why, the book had come out and had gotten very poor reviews. It got one favorable review; I think it was in the [New York] *Herald Tribune*, not the *New York Times*. Anyway, it didn't sell very well. I knew I had put my heart in it but people didn't seem to think I had because it was a long way from mesquite. It was up there in the middle of pine and spruce and water and trout, and nothing about sand and desert. So it was outside of what people expected me to write about, although there were some horses and things like that. And it had some romance in it. It was about a man that met the wrong girl – that's what it amounted to – when he got home all beat up from the wars, and the wrong girl got him, and the mountains killed him. I had been reading some of the Greek writers about the structure of the drama and I tried to make the mountains like the gods who were handling human destiny. And I thought it was a good book and I still do, the old *Primal Yoke*.

You know, it's a bad thing for a writer or a painter to do something from his heart and then to have people not understand or care. I was very sad. I thought about a poem by A. E. Housman, I confess, sentimentally, when *The Primal Yoke* came out. It said, "I hoed and trenched and weeded,/ And took the flowers to fair:/ I brought them home unheeded; The hue was not the wear. So up and down I sow them/ For lads like me to find/ When I shall lie below them, A dead man out of mind." Excuse me. . .but I'm moved by that, and it's very

119

sentimental but I think most artists feel like that when they really try: take the flowers to fair and no one wants to buy them.

How *The Hands of Cantú* started is kind of interesting. One winter's day in Cloudcroft, New Mexico, we passed a little, funny bookshop and in the window was a copy of *Horses of the Conquest* by Cunninghame Graham. Well, I went in and bought the book and I read it with a kind of super interest. I don't know, it just hit me right. It was a story about horses, about the nineteen horses, or something like that, that Cortés [brought] onto the continent. I began to think about how the fine Mexican horses had originated and I thought, well, I've got to do something about it. So I read all I could read. I had one book that my dad had given me when I lived in Chicago, Obregón's *Chronicle*. It was mainly an account of the frontier efforts and governorship of Francisco de Ibarra, who became a central figure to me.

And I then began to think about where the Indians first got their horses. You know, all of the experts say that it was from the Coronado expedition, when they let some of the horses loose or traded them to Indians or something. And I sort of thought that maybe the Indians had had something to do with horses before Coronado. Anyway, I had great pleasure in first going down to the King Ranch and talking to my friend, Dick Kleberg, about the project and he said, "Well, gosh, I'll translate anything you can find." And I found a book about horsemanship in the time of Philip I. Horsemanship was *a la jinete y a la brida*, the long stirrup and the short stirrup. *La jinete* was the style borrowed from the Moors with the short stirrup and the lance and the light, armorless horse and rider. *La brida* was the long stirrup that the knights in armor used. It was much more cumbersome, and the horses were a northern European strain, a little bit like plough horses. They had to be in order to survive the [collision] of armor and heavy lance.

So things began to tie together and not too long after that, why, Bob Kleberg invited me to go with him down to Argentina to see their beautiful *estancia*. And when I was there, he introduced me to a wonderful man who had a great library about early horsemanship, all in Spanish. And I was able to get more information about how they rode and how they trained the horses.

And then Sarah and I went to Malta, a great place to go and study about horsemanship of the latter part of the sixteenth century, a little after Cortes' time. I had a lot of fun there in the old Castel Sant'Angelo. The equipment of the Knights of Malta was all there: saddles, bridles, armor, the kind of cinch straps they used, stirrup models, even the horse blankets. It's what's called tack now. And I was especially interested in the bridles because it was said that the second viceroy of Mexico was the man who invented the *jáquima* which became the hackamore in English. The idea of the *jáquima* was not to do anything at all

120

to hurt a horse's mouth or nose; it was to tie a hairy, prickly knot under the very sensitive part of a horse's chin. Pulling up on that [suddenly], you know, made the horse stop. And that's the origin of the hackamore.

And then we went up to Florence to this little museum, the Museo Stibbert. It was established by a British brewer who had bought a villa and wanted a place to house his great collection of arms and armor. They had different bridles that were used where, in addition to a bit in the mouth, there was a considerable attention paid to a tight band around the sensitive tissues of a horse's nose for control.

And when I came home, I suppose I had just pure fun writing *The Hands of Cantú*. My friend Robert Denhardt, that had annotated Cunninghame Graham's *Horses of the Conquest* for the University of Oklahoma, sent me the original copy he had used. So it all worked together. The main character is Don Vito Cantú, a great horseman and breeder of horses, who established a hacienda in the state of Durango in the early days of the Spanish Viceroy Mendoza. I had some background for that because of Ray Bell's hacienda Atotonilco.

And I didn't have to persuade Ned Bradford, the editor of Little, Brown and Company, when I finished it. He wanted to see it, and he said, "It's unique. I don't think I've ever read anything quite like it." And Ned said, "Well, illustrate it any way you want to." And I said, "Well, Harold Hugo at the Meriden Gravure Company does nice work. Can I do them all in Chinese ink and get them done in that fine screen lithography?" And he said, "Sure." And so I did these illustrations, which were a new departure for me. My previous illustrations had been pen and ink line drawings, and these used half tones. And they were beautifully reproduced.

You know, [*The Hands of Cantú*] didn't have a wide [audience]. I think there were only two or three printings of the thing, but it got a very warm response from people who were interested in the subject. I've had people comment, "How do you write Spanish in English? You do it so that I feel like I'm reading Spanish but it's in English." You know, it's as if the whole book was translated from Spanish. And that was a point of great pride in this book. I was able to convey some of this feeling about how these people communicated with each other in that courtier-like fashion even out on the frontier.

It's a book I'm very glad I did because I got letters from old horse people that said, "Oh, I'm glad you wrote the book because I want to have my boy read how a horse should be trained." It was very nice. And the people in South America liked it very much. But it was never translated in Mexico. It was about Mexico, but I think it's very interesting that Mexico would have no part of it because it was about one of those dirty Spaniards, the conquistadors. That's really what my agent told me.

121

I think the illustrations for *The Hands of Cantú* are kind of unique, as is the text. When I was working on [it], I started really thinking [in terms] of the characters' faces. I could see these faces, the old soldiers and the first *vaqueros* and the noblemen that came over. I did the portraits [before I wrote the text] and hung them over my work table, and I'd see them every morning and they'd speak, and I was back in the story.

Of course, I've always been interested in portraits. I did so many of them during the war and afterwards. It gives me a good feeling about my relationship to [a person] when I put down what I feel about him [or her]. Very seldom have I done a portrait of someone who didn't actually pose for me.

I do remember one time I did a portrait from photographs. It was [after] Sam Rayburn died when they decided they would name the new congressional office building for him. They hired a sculptor to memorialize him . . . it's life-size [but] it looks like Sam's a dwarf there by a fountain. And a great friend of Ewing Thomason's, Judge Gene Worley, who liked my work that I had done in the war and had read my books, said, "Well, why don't we get Tom Lea to do a portrait." And that was the way it got started. He took up a collection from congressmen that had known old Sam, and he came to me and said that they'd like to have a portrait to hang at the main entrance near the statue and that fountain.

Instead of doing it life-size, I thought, "Well, Sam should be immortalized a little larger." I did [the portrait] as I had been doing those heads in the war, almost twice life-size. I studied, oh, fifty photographs. One of the most satisfactory photographs came from Lloyd Bentsen. And he told me, "Now, this is the only picture that I think is worth a damn that I have of my friend Sam Rayburn. And you sure better get it back to me safely!" Which I did.

I worked on the portrait quite a long time and got one finished, but I destroyed it. I didn't think it was right. So I made [more] studies, particularly of the hands holding the gavel and the posture of Rayburn. He was sort of a small fellow. And this second portrait pleased me better, and I sent photographs of it to Judge Worley. They were all enthusiastic and [said], "Bring it up [to Washington, D.C.] and we're going to have a nice occasion here to dedicate the portrait." So Judge Worley got Ewing Thomason and Abby, and Lady Bird and LBJ [Lyndon B. Johnson], and Sam's kinfolks. It was quite a dedication in one of the committee rooms in the [new congressional office] building. Some guy made a political speech and everything and then they pulled the curtain and there was old Sam. Everybody liked it, which relieved me and Sarah very much.

And one of the guys that came down to Washington was C.R. Smith. I think he was one of the contributors so he knew about the portrait. C.R. had told me, "Well, when you get ready to transport the portrait up here, why, let

122

me know and I'll bring it up on a plane by hand." So I let him. A regional office boy of American Airlines came by to pick up the thing to take it out to [the airport]. And it was a windy day. And that guy had a little peewee Volkswagen Beetle. He said, "Sure, I can take it. I can get it all right." And he had some rope and he roped the thing on the top of this Beetle and I saw him disappear around the corner with this great big portrait. It was bigger than the top of his car!

It didn't have any wrapping. He just put it on there. Of course, it was very good linen canvas on masonite, so it wasn't anything that could punch through, and it was a very sturdy frame. Anyway, the guy got it out to the airport and the next time I saw it, it was in fine shape there in Washington, ready to be dedicated.

The night after the dedication, why, the Johnsons wanted to honor the Thomasons and kind of left-handedly honor Sarah and me. They asked Sarah and me who else we'd like to have at the dinner there at the White House. And we said, "Oh, we'd like to see our friends, C.R. Smith and Joey and Jimmy Polk." So we all had a very nice evening at the White House up in the living quarters. Everyone was so cordial and everything. And I noticed that C.R. Smith and the president went over in the corner and were discussing something. And not long after that, the president appointed a new cabinet member, C.R. Smith as secretary of commerce. I think that was the first time he'd ever met LBJ.

[A little later]. . .this is a funny thing that you mustn't ever tell because it'll get back. Oh, it's all right, [but] I've never told anybody this. An editor of *Time* called me up and said, "We're going to do a cover story on Lyndon B. Johnson, and would you do the portrait for the cover?" And I said, "No, I do portraits of people who come to my studio and then I hand them what I did, and I can't do it because I know the president can't come. I'd have to work from photographs and from other people's opinions of LBJ so I can't do it." And they said, "Oh, well, who could we get?" And I said, "Well, another guy lives right close by and he might be able to tackle it. How about Peter Hurd?" And that's how that much argued-over portrait originated. They asked me first and I told them to get Pete and Pete [later] did that big portrait about which L.B.J. said, "It's the ugliest thing I ever saw."

When I finished *The Hands of Cantú*, which is really the last piece of fiction I've written, why, I started some paintings that were pretty remote from John Norton's influence. I think the painting loosened up considerably and the color deepened. When Sarah and I went to London when I was doing the last part of the research for *The Hands of Cantú*, we had time to go and really look in the Victoria and Albert Museum, and there I was really [impressed] by these wonderful sketches that John Constable made straight from nature and from the sky. He was like a meteorologist in doing [his] cloud studies. He'd have the direction

of the wind and the time of day and the temperature, everything, written on the back. And that fluidity and that closeness to the reality of the earth and sky that I felt so strongly in John Constable [stayed with me]. I [began] having an adventure in the spirit of John Constable here in the Southwest. Couldn't find a more contrasting landscape, but the earth was the same and the sky had a different message.

I wanted to paint more. Writing is a kind of a burden to me, which painting is not. I sweat and stew and fight paintings, but I am not overwhelmed sometimes by problems like I was in writing. I taught myself to write and never had any kind of a mentor or formal course in writing. I taught myself to write by reading, reading good stuff. And I have the feeling that my painting is by no means a new contribution to the long train of the history of art or anything. It's a man born in West Texas who's looking at the world as he sees it with the means that he has at hand.

I found myself really [into] paintings when I had to go back to Boston because I had a contract with the Little, Brown people to do another novel. And they were kind of pestering me about it, but I decided I didn't want to write another novel, [even though] I [did have] one sticking in my craw about a man who had the nondescript name of Juan Sánchez. And I even did some pictures related to some of the things that I thought Juan Sánchez was going to do in the book. Juan Sánchez was way up in the sierras, a fugitive from some hard times he'd had in Villa's *ejército del norte*. And he kind of faded away and paintings became what I did.

But with old Juan Sánchez I wanted to say things about the Mexican Revolution. You know, it became nothing but a kind of a dog fight between local leaders, and its original revolutionary aim was more or less hidden. I wanted to get into a little town in northern Mexico where the people had all suffered and had some of their families killed, and some of them had had their houses and their little churches burned and others had had some of their citizens become the generals and they were just as corrupt as anything that Porfirio Díaz had ever done. The feeling was very strong and I wanted to have Juan Sánchez, a guy who had been in the wars, decide to come back. Well, it was more or less the same theme, I guess, as *The Primal Yoke*, the guy that had been off fighting and then the uncle, the old man.

There's always an old man in my books and I suppose it's the influence of my dad and John Norton and maybe Frank Dobie and maybe John Leavell, I don't know . . . all of these guys that I have thought so much of. Maybe they're all echoed in everything I wrote. Maybe they're the reason why I love to think about heroes rather than villains. I love to think about people who are adequate to life rather than inadequate in problems.

124

[As I said], I didn't want to work on another novel, so while I was up there in Boston, why, they said, "Well, we think you should do a book about your paintings," and that's how *A Picture Gallery* came about. That was an interesting thing because those people in Little, Brown [and] Company, they never lost a nickel and I had never asked for an advance on anything I had written. They had made money on Tom Lea's stuff. I was *persona grata* around on Beacon Hill there and I said, "Well, if we do this book, let's really pour it on just right. I want to write text that is simply an explanation of when and why I did my paintings, why I did these things in visual terms rather than trying to write prose." So, I got the text for *A Picture Gallery* together, and I got the photographs of the work that I thought ought to go into the book. I did that all myself. I put in the little foreword in *A Picture Gallery* that my work is my autobiography and my autobiography is my work, which I think is true.

Anyway, we did the book *A Picture Gallery*, and that seemed to kind of complete my turn in the road toward painting. The only other time my paintings set the atmosphere for my writing was in [my last published book]. I did *In the Crucible of the Sun* for private distribution. The way it happened was just a conversation one evening. One night old Bob [Kleberg] and I were talking down at the ranch and Bob had just come back from a flying trip down [to Australia]. He wanted me to do a book to show what he was doing out there, and he followed through. He did everything that I asked for. And I had a lot of fun because old Bob said, "Do it any way you want to." I said, "Well, I want to try to do a book where the painting is an imbedded part of the writing so that it's all together in one thing. And I think I need color for Australia." He said, "I think you ought to see Australia. And I think you ought to see what we're doing down there." And I said, "Well, I'd sure like to." Well, we saw it! Gosh, he came by for Sarah and me in his airplane and we flew in it right to Sydney. Well, we did stop off to see Cañonero, his race horse that was out at Santa Anita, and then stopped in Hawaii, then Fiji, and briefly in New Zealand, and then over to Sydney. And we went clear around the outback and into the heart of it and just had a wonderful sort of a picnic [for] six or seven weeks. We had enough time to really get some idea about the country and to see it with this guy who was enthusiastic, just as enthusiastic as Captain King was about finding this place where there was grass [South Texas], you know.

Hot damn, Bob was really . . . he had a great big ice chest and champagne glasses, and they had all of this very good champagne on ice at all times. He was a character. And also very interesting, I saw it in action in Australia at various times . . . . When he set out from the ranch, Bob'd go into I guess it was the Kleberg bank there in Kingsville, and he had a fairly big, black boxy briefcase, and he'd fill it with money and put it in the airplane. And, you know, like, we'd

spend the night at Fiji and he'd just get the money out and . . . . But that brief-case of money really stunned me.

I started the book in the spring of 1972, and it was finished a week before Bob died in September of [19]74. Before the text was finished, I had all the paint-ings done, so he came [to El Paso] and brought Helenita, his daughter, and old Tom Armstrong and a whole planeload [of people] just to see the pictures. [Sarah and I] took all the pictures in the house down and hung those Australian pic-tures. We had a kind of a celebration.

You know, Bob was in Africa when he began to feel bad. He'd taken some of his grandchildren to Africa, and they were all out there on safari when he began to feel bad. This was in early [19]74. He came back and had some tests done and the doctors didn't say anything much about it. And by the summer-time he was real sick and I think he was terminally ill and sick in the hospital for maybe a month and that was all. He died in Houston. He had cancer. But he had led a very hard life. The only thing [was] he never smoked, but he drank a lot and he was extremely active. He could still get up on a horse after he was age seventy. He was something. Well, I miss him.

The Killing Floor, *1946, charcoal and pencil, 22 3/4 x 33. Lea completed this drawing for a story on western beef cattle for* Life. *(Collection of the artist, courtesy Adair Margo Gallery)*

*Chapter illustrations for Lea's first novel,* The Brave Bulls, *published in 1949.*

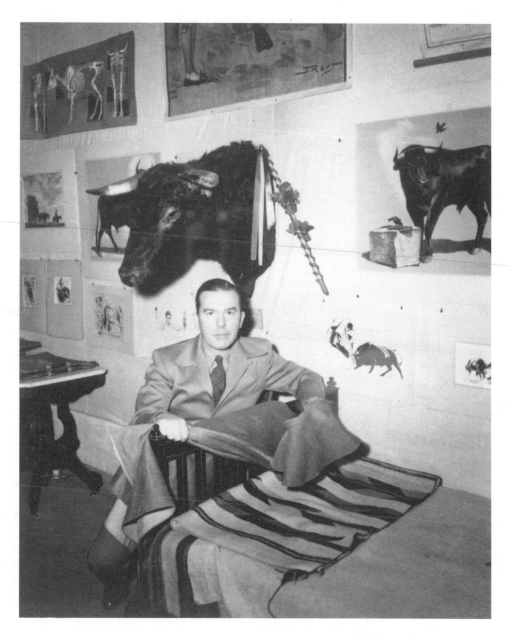

*Trophies and drawings that reflected Tom's passion for the pageant of bullfighting, c. 1950.*

*Publicity posters for movies made from Lea's books* The Brave Bulls *and* The Wonderful Country. *("The Brave Bulls" poster courtesy El Paso Public Library; " The Wonderful Country" poster courtesy Cynthia Farah)*

130

*World premiere of the movie* The Brave Bulls, *1951, Plaza Theater, El Paso. (Courtesy El Paso Public Library)*

*On the movie set of* The Wonderful Country, *Lea, as Peebles the barber, with actor Robert Mitchum, 1958. (Courtesy El Paso Public Library)*

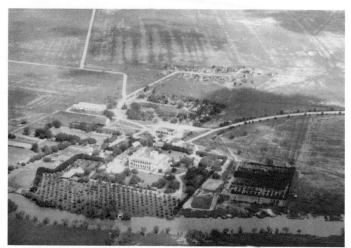

*Lea (with glasses) and Robert J. Kleberg Jr. of the King Ranch, 1952.  (Photo by Helen Kleberg)*

*Aerial view of the main house at the King Ranch.*

*Robert J. Kleberg, Jr. on the King Ranch. (Courtesy King Ranch Archives)*

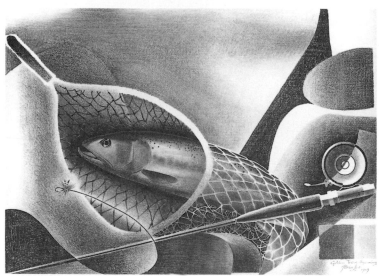

*Lea with his catch in the Wind River Mountains, Wyoming, 1958.*

The Golden Trout, Wyoming, *1959, encaustic, 20 x 27 1/2. (Collection of Mr. and Mrs. Lloyd Borrett, El Paso)*

Sr. Don Teclo Paz

Don Teclo Paz, *1963, pen and ink, 11 x 8 1/2. Preliminary sketch of the
character for* The Hands of Cantú, *published in 1964.  (Collection of Mr.
and Mrs. William Kiely)*

## Chapter Six

# *Studio Painter,*
# *1974 – Present*

For the past twenty years, I've been very, very happy as an adventurer with a renewed interest in painting, painting alone, not painting related to prose . . . just being there with brushes and canvas and some pigment. Painting has been the primary reason for me to work. I'm glad I'm a Texan, but I don't know if that classifies me accurately. As a landscapist, I think I'm more a New Mexican or a Chihuahuense than I am a Texan. I have done some things of Big Bend, but most of my landscape is northern Mexico and New Mexico.

In looking back through the years, I've been fortunate that there were several people that have continuously bought my work. Anything I'd paint, why, they'd usually say they wanted it so that I had an income that was sufficient, and Sarah and I could travel and we could live nicely. I just did what I was doing and people would be interested. Friends would come around to the studio and say, "Oh, let me have that." So really, it wasn't much of a selling job for me. It was a matter of trying to produce something that spoke to people. For instance, the Leavells were very interested when I told them that I had made a sketch of those little houses above the Hacienda Restaurant over on the other side of the river [Rio Grande], and when I got the thing finished, why, they both came to the studio and said, "Well, we've got to have that." That's that big painting *Unto the Hills*. I like to see that one over their mantle. It makes me think, "Jesus, I'm a pretty good painter," you know?

One of the things that I treasure most is the fact that my paintings are mostly in the homes of friends and not somewhere where they're in the public view. They are a kind of [conversation] between me and my friends, these paintings. It's a happiness to me that [my work] speaks to people like Shelby Longoria – the Longoria family of Mexico is so powerful – who wanted me to paint him a picture about Mexico, and Maury Kemp who said, "Paint something about Sinaloa where I love to fish." That's how I did *Grace Note in a Hard World* down there near this little town of Fuerte in Sinaloa. And on that one, why, while I was making the sketch, a guy started throwing rocks at me from that house. I quit sketching!

137

I don't know all of these things about talent and genius and all of these high words. I think that what's known as talent is strong desire rather than a nebulous gift you were born with. Talent might be some kind of a starting point, but for it to ever come to fruition there has to be a very, very strong desire to do a good piece of prose or a good painting. I think it's a matter of having the desire to do better. The human has got to be competitive or he can't live. And the artist, speaking to himself, is competing with himself. He's challenging his ability every time he picks up a brush, I think.

I have tried to stay on a path that would lead to something better in the performance of my craft. After all, so much of what I've tried to do has been craft. I've had the greatest respect for people who are able to, oh, create a cabinet or a table, or to build a house, or to set a window into a wall. A plumber or an automobile mechanic are wonderful; they're craftsmen. And as a painter, I have tried to have that respect for the tools of my trade and that knowledge that will allow me to use them well.

I don't even know if painting is a profession or if writing is a profession. I think it's something like preachers call[ing] themselves professionals. In a sense maybe, painters and writers are a type of preacher preaching about the structure and beauty, or ugliness, of the world. To me, painting and writing are all of one piece. I don't know many painters that were first-class writers, and I don't know first-class writers ever being very good painters. A completely uneducated and untraditional man named Charlie Russell, the so-called cowboy artist, came pretty close to being able to express his life in drawing and prose in those stories in *Trails Ploughed Under*. Those are absolute gems of prose. They represent accurately the life he led and the life he loved, just as much as his paintings did. Frederic Remington tried to write some fiction, and it was terrible. This is not to berate his great ability as a painter. I think he was quite a painter, but Charlie Russell, born in Missouri, was really a piece of Montana by the time he died and that's his significance. He not only loved the land; he was able to tell people why they loved it. And, of course, that would be the greatest thing in the world if I tell people why they loved this country around here.

What makes a painter different from anybody else is a desire to record. When you have described something well, it gives you kind of a jolt of happiness and then a jolt of inadequacy. At least it's that way for me. You know, "Gosh, I got it! No, you didn't get it." You know? I don't know. The main thing is you want to do it. People that want to be writers, I tell them, "Forget it!" "Have you got anything to write about? Is something eating on you? Have you got to write about this subject or not?" It's the same with pictures. "I want to be a painter, so I buy a paint box". "Well, what do you want to paint?" "I don't know; I want to learn to paint." Yes, they want to learn to do it, but they don't know

138

why they are learning or what they want to say after they've learned. Take, for example, Charlie Russell who started out with a thing he wanted to talk about and he taught himself on it. Gee, those early things of his are pretty bad, you know. He was learning because he wanted to talk about men and horses and the beautiful big rocky buttes of Montana, and because he wanted to do it was the reason he became a painter.

I have tried to work in different media. You know, I'd do an oil painting, maybe two oil paintings, and then I'd think, "Geez, I haven't done a watercolor in a long time." And pastel has always interested me because it's a kind of drawing. And, of course, I don't think I'm really a painter; I think I'm a draftsman. I don't know how much color has contributed to my work, but I know damn well that form is the thing that has absolutely always enchanted me rather than color. Just sheer drawing has always been the thing that I loved and that I still love.

I've never exhibited many of my drawings except at Fort Worth. The drawing of the mural in the library on brown paper and some full-size figures from the *Pass of the North* mural down in the courthouse were shown, and some people bought those. I don't know who they were, and I don't remember what I asked for them, but I wondered what in the hell they're going to do with these great big drawings on brown paper. But they were good drawings. I've saved some drawings. They're only preliminaries of paintings [but] some of them are just as strongly developed as the final painting. Often I've said everything that I should have said in brown and black and white. Color can bother me.

Some people think of oil painting as a symphony and watercolor as nice chamber music, but some of my best color work has been little watercolor studies. I think one of the very best watercolors I ever made in my life was up in Monticello. It was during the time I was making studies for the St. Louis mural competition. The Sangamon River – that was old Abe Lincoln's river, you know – runs right through Monticello, which is Sarah's little hometown. We spent a summer up there and one day I went out there alone with my watercolor box to a sort of a bosque, an Illinois bosque, you know, a thick timber around the riverside. And this little study I did on the Sangamon I saved, and I think it's one of the few times that my work has been truly integrated color. I think it's called *Sangamon River Bottom*. It was exhibited one time. During that summer I did a bunch of little watercolors and we have some of them framed in our bedroom. I did one of Sarah's grandparents' farm, one of these huge elm trees in the front yard of Sarah's house there, and I made one of the huge rolling Illinois prairie that Carl Sandberg [wrote] so wonderfully about.

Some paintings have been more fun than others. When a painter suffers with [a painting], why, he naturally feels like he's brought a sick child back to

139

life, and he's not happy with the memory of how he produced it, [but] he values this painting that he's suffered with just as much as the one that he enjoyed [painting]. There is a unity to whatever [has been created] out of his labor. It's the progression of the man as he goes through the years with this intense desire to do better.

In looking at my pictures, they all seem like some kind of stepping stones to me. Sometimes my step falters, and when it advances, I like it. All of my paintings that I saved, that didn't go to the garbage can, are something that I thought were worthwhile and that I liked, but I can look at some paintings that sort of carried me forward, at least in my opinion. I think of the painting I did for Maury Kemp down in Sinaloa in Mexico, of the knocked-down and sorrowful-looking adobe with this beautiful bougainvillea growing by its side [*Grace Note In A Hard World*]. And I did a painting which I call *Socios*, which means partners. It's a man and his horse, and it's very, very loosely painted, but I think very sound in its structure. That was a step forward.

There's a recurring theme in most of my paintings: a horseman riding alone. I don't know why that is, but that's the way the land is connected to the human being. There was a school – I think it was late Sung, Chinese – where there was the sky and the earth and man. And there had to be evidence of man in order to give sky and earth its essential meaning. They didn't even have to have a man; they could just have a little path with a little bamboo shack or a little boat of some kind on the river, but some evidence of man was always present in that school of painting. Not a bad idea. And the idea of not having a person, where you have to make your own connection with these forms, that's fun too. That's what I'm doing [now] and that's what I did in the public library mural, where there were no evidences of man. The paintings that I've done recently have mainly been concerned with the sky. Light from the sky is the creator of landscape, and any good observer of landscape is most concerned with the wonderful, ever changing light on the structure of the world.

In closing, I'd like to say that in a long life, I've been blessed with great good fortune. In mind and heart, I've had high adventure. In work, I have found quietly abiding happiness as well as never-ending challenge. Throughout the years, I have never relinquished the hope that I may learn to make tomorrow's work better than today's.

# Color Plates

1. *Hokyanya*,1930
Lead Pencil, India ink, watercolor, and varnish, 10 3/4 x 6 1/2
(Collection of Mr. and Mrs. John Alexander, San Antonio)

2. *Snake Dancers*, 1933
Oil on canvas, 61 x 41
(Collection of the Fine Arts Museum of New Mexico, Santa Fe)

3. *Lonely Town*, 1937
Oil on canvas, 24 x 34
(Collection of the artist)

4. *Design for the Western Frontier: First Phase, 1830-1860*, 1935
Casein tempera, 13 1/2 x 27 3/4
(Collection of Mr. Mack Colley, Corpus Christi)

5. *Design for the Western Frontier: Second Phase, 1860-1890*, 1935
Casein tempera, 14 1/4 x 28 1/8
(Collection of Mr. Mack Colley, Corpus Christi )

6. *Pass of the North*, 1938
Oil on canvas, 11 x 54 feet
(Mural, United States Courthouse, El Paso)

7. *Portrait of Sarah*, 1939
Oil on panel, 34 x 26 1/4
(Collection of the El Paso Museum of Art, El Paso)

8. *Sangamon River Bottom,* 1938
Watercolor, 7 x 10
(Collection of the artist)

9.*The Price,*1944
Oil on canvas, 36 x 28
(Collection of the U.S. Army Center for Military History, Washington, D.C.)

10. *Death of the Wasp*, 1942
Oil on canvas, 25 x 42
(Collection of Dr. and Mrs. James D. Lea, Houston)

11. *Generalissimo Chiang Kai-shek*, 1943
Watercolor and black ink, 29 x 23 1/2
(Collection of Harry Ransom Humanities Research Center, The University of Texas at Austin, on permanent loan to The University of Texas at El Paso)

12. *Madame Chiang Kai-shek*, 1943
Watercolor and black ink, 29 x 23 1/2
(Collection of Harry Ransom Humanities Research Center, The University of Texas at Austin, on permanent loan to The University of Texas at El Paso)

13. *William Chickering*, 1945
Oil on canvas, 20 x 16 1/4
(Collection of Harry Ransom Humanities Research Center, The University of Texas at Austin, on permanent loan to The University of Texas at El Paso)

14. *Elliot Stevens*, 1939
Oil on canvas, 30 1/2 x 26 1/2
(Collection of Harry Ransom Humanities Research Center, The University of Texas at Austin, on permanent loan to The University of Texas at El Paso)

15. *Sarah in the Summertime*, 1947
Oil on canvas, 69 x 28
(Collection of the artist)

16. *The Shining Plain*, 1947
Oil on canvas, 27 x 30
(Collection of Mr. and Mrs. Florian Hofer, Warrenton, Virginia)

17. *Hacienda Del Sauz and Don Julián Llaguno*, 1946
Watercolor, 17 x 28 1/2
(Collection of Mr. Henry Taylor, El Paso)

18. *Manolete Awaiting a Quité*, 1947
Oil on canvas, 42 1/2 x 14
(Private collection)

19. *Everybody's Gone to the Wedding*, 1960
Oil on canvas, 22 x 30
(Collection of Kemp, Smith, Duncan and Hammond, El Paso)

20. *Southwest*,1956
Oil on canvas, 5 1/2 x 20 feet
(Mural, El Paso Public Library, El Paso)

21. *Baldy, Seen From Bud's Lake, Wyoming*, 1950
Watercolor, 10 x 7
(Collection of Mr. and Mrs. Leonard A. Goodman, Jr., El Paso)

22. *Sam Rayburn*, 1966
Oil on canvas, 60 x 40
(Collection of U.S. House of Representatives, Washington, D.C., courtesy the Architect of the Capitol)

23. *Wild Bull By a Boab Tree, Mount House Station, Western Austrialia*, 1973
Oil on canvas, 24 x 20
(Collection of King Ranch, Kingsville)

24. *Unto the Hills*, 1970
Oil on canvas, 32 x 54
(Collection of Mr. and Mrs. Charles H. Leavell, El Paso)

25. *Socios*, 1971
Oil on canvas, 24 x 18
(Collection of Mrs. George Hervey, El Paso)

26. *Grace Note In a Hard World*, 1978
Oil on canvas, 22 x 34
(Private collection)

27. *Summer's Green Arcanum*, 1975
Oil on canvas mounted on masonite, 36 x 58
(Collection of Sunwest Bank, El Paso)

28. *Lone and Wide*, 1987
Oil on canvas, 43 x 55
(Collection of Mr. and Mrs. W.H. Hunt, Dallas)

29. *Invocation*, 1987
Oil on canvas, 43 x 55
(Collection of BDM International, McLean, Virginia)

30. *Southwestern Landscape*, 1993
Pastel, 19 1/2 x 25 1/4
(Collection of Mr. and Mrs. John Knight, San Francisco)

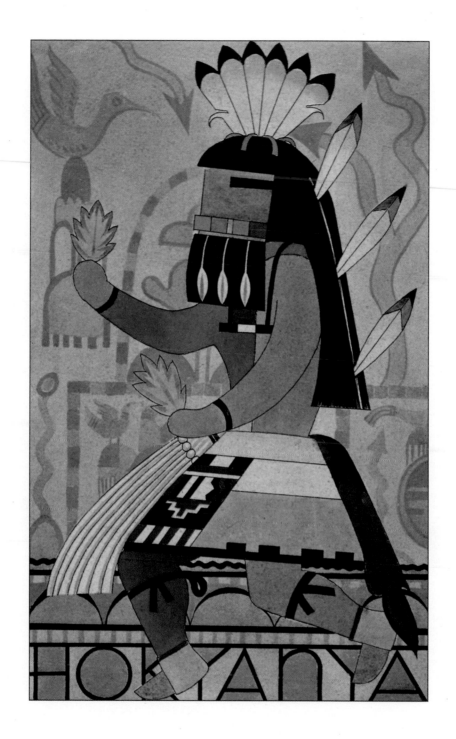

Plate 1

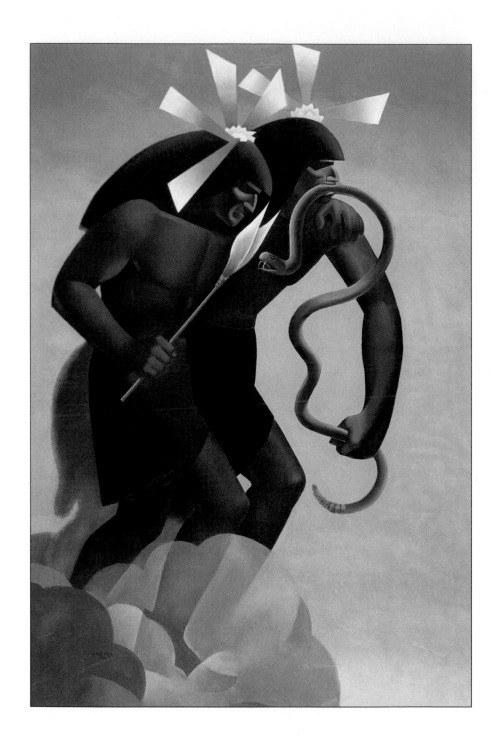

Plate 2

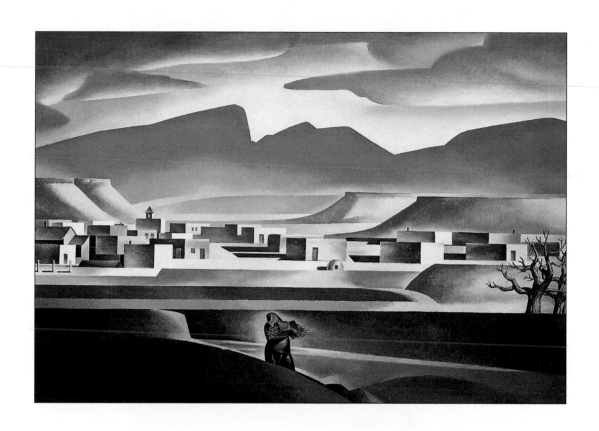

Plate 3

Plate 4

Plate 5

Plate 6

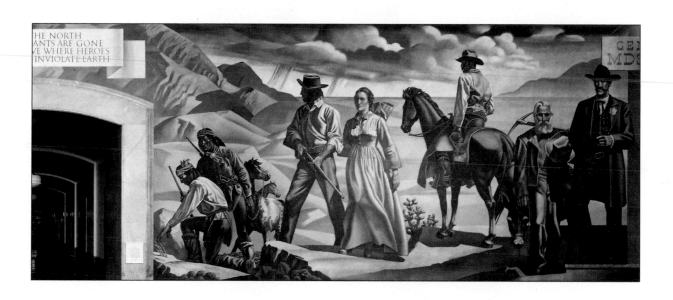

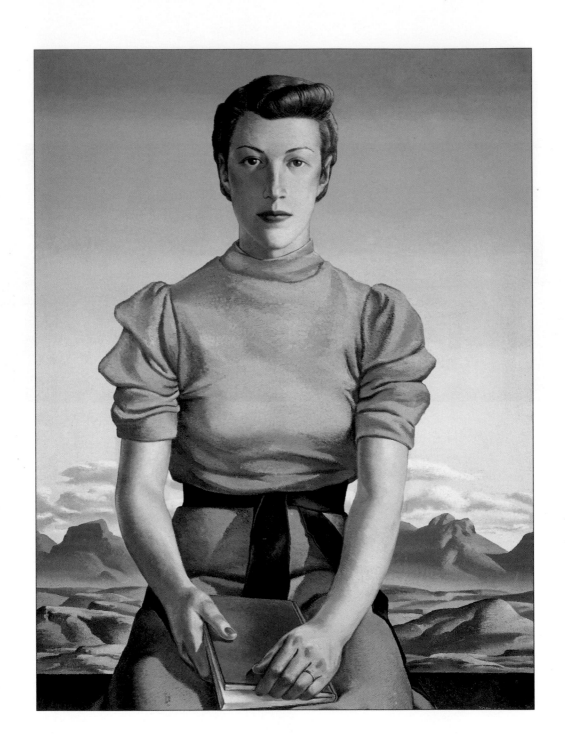

Plate 7

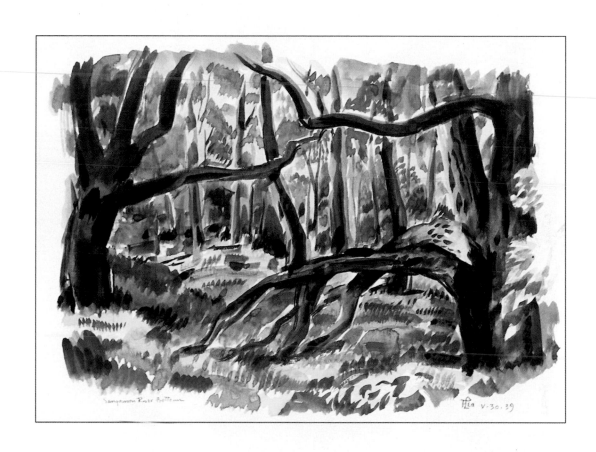

Sangamon River Bottoms                                        Lea V-30-39

Plate 8

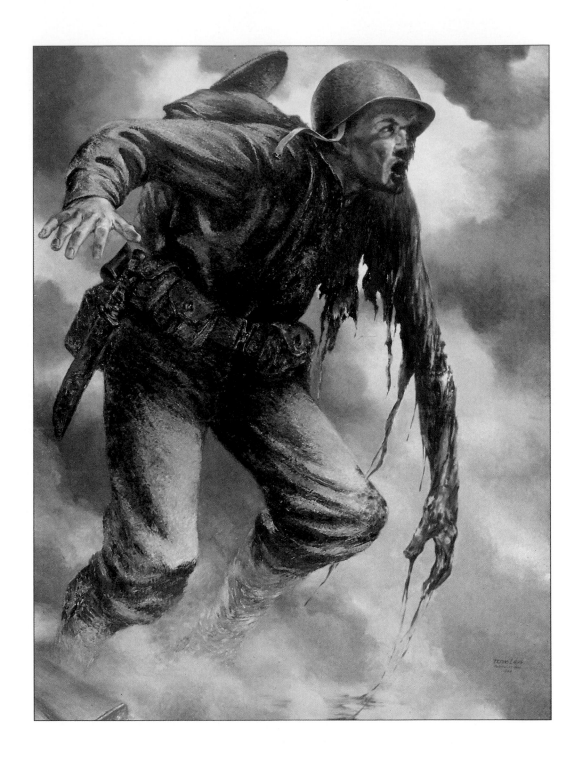

Plate 9

Plate 10

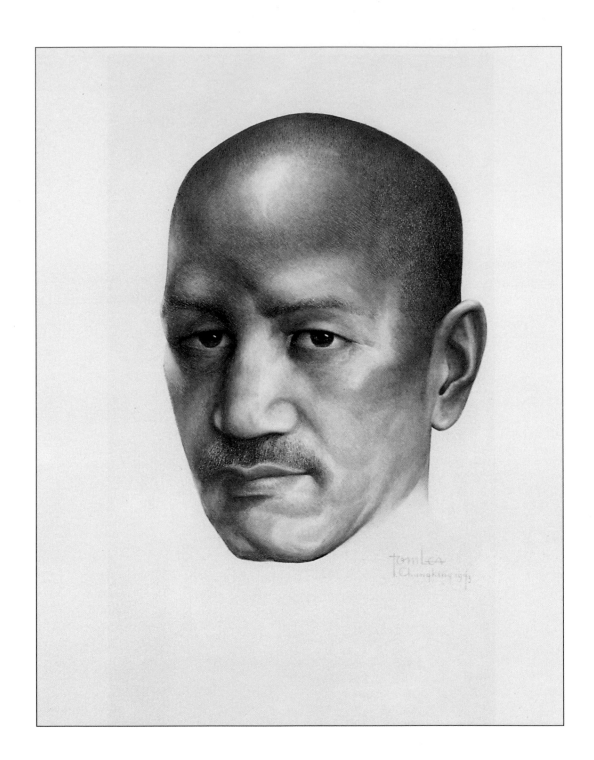

Plate 11

Plate 12

Plate 13

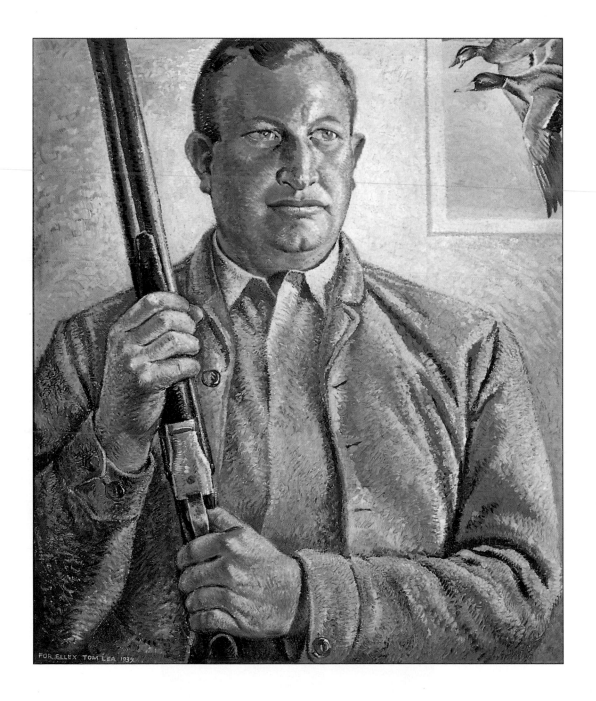

Plate 14

Plate 15

Plate 16

Plate 17

Plate 18

Plate 19

Plate 20

Baldy, seen from Bud's Lake
Wyoming 1950

Plate 21

Plate 22

Plate 23

Plate 24

Plate 25

Plate 26

Plate 27

Plate 28

Plate 29

Plate 30

# Selected Bibliography

## Written and Illustrated by Lea

*Randado.* El Paso: Carl Hertzog, 1941.

*A Grizzly from the Coral Sea.* El Paso: Carl Hertzog, 1944.

*Peleliu Landing.* El Paso: Carl Hertzog, 1945.

*Calendar of the Twelve Travelers through the Pass of the North.* El Paso: Carl Hertzog, 1946.

*The Brave Bulls.* Boston: Little, Brown and Co., 1949.
> Foreign editions/translations
> Norwegian: *Tyrefekten fra Guerreras.* Oslo: Dreyer, 1949.
> British: *The Brave Bulls.* London: William Heinemann, 1950.
> Hebrew: *Blood and Sand.* Jaffa, Israel: Carmi, 1950.
> German: *Der Torero.* Stuttgart: Hans E. Gunther Verlag, 1951.
> Mexican: *Toros Bravos.* Mexico: Editorial Costancia, S.A., 1951.
> French: *Corrida de la Puer.* Paris: Les Editions du Scorpion, 1952.
> Italian: *I Tori.* Milan: Garzanti, 1952.
> Spanish: *Toros Bravos.* Barcelona: Luis de Caralt, 1952.
> Dutch: *Een Man vecht Veer Zickzelf.* 's-Gravenhage, Nederland: Unicum-reeks, 1953.
> Australian: *The Brave Bulls.* Sydney, Australia: Horwitz Publications, 1960.

*Bullfight Manual for Spectators.* El Paso: Carl Hertzog, 1949.

*The Wonderful Country.* Boston: Little, Brown and Co., 1952.
> Foreign editions/translations
> Dutch: *Martin Brady van Vogelvrije tot Texas Ranger.* 's-Gravenhage, Nederland: Heinemann, 1954.
> Spanish: *La Frontera.* Barcelona: Luis de Caralt, 1955.
> British: *The Wonderful Country.* London: William Heinemann, 1955.

*Tom Lea: A Portfolio of Six Paintings.* Austin: The University of Texas Press, 1953.

*The King Ranch.* 2 vols. Boston: Little, Brown and Co., 1957.

*The Primal Yoke.* Boston: Little, Brown and Co., 1960.

*The Hands of Cantú.* Boston: Little, Brown and Co., 1964.

*Western Reef Cattle: A Series of Eleven Paintings by Tom Lea.* Austin: Encino Press, 1967.

*A Picture Gallery: Paintings and Drawings by Tom Lea.* Boston: Little, Brown and Co., 1968.

*In the Crucible of the Sun.* Kingsville: King Ranch, Inc., 1974.

*Battle Stations: A Grizzly from the Coral Sea and Peleliu Landing*. Dallas: Still Point Press, 1988.

*The Southwest: It's Where I Live*. Dallas: DeGolyer Library, Southern Methodist University, 1992.

## Books With Illustrations by Lea

Dobie, J. Frank. *Apache Gold and Yaqui Silver*. Boston: Little, Brown and Co., 1939.

_____. *John C. Duval: First Texas Man of Letters*. 1st. ed. Dallas: Southwest Review, 1939. 2nd ed. Dallas: Southern Methodist University Press, 1965.

_____. *The Longhorns*. Boston: Little, Brown and Co., 1941.

Gambrell, Herbert and Virginia Gambrell. *A Pictorial History of Texas*. New York: Dutton, 1960.

Grey, Katharine. *Hills of Gold*. Boston: Little, Brown and Co., 1941.

Hail, Marshall. *Knight in the Sun: Harper B. Lee, First Yankee Matador*. Boston: Little, Brown and Co., 1962.

Jackson, Joseph Henry. *The Christmas Flower*. New York: Harcourt, Brace and Co., 1951.

Kennedy, John F. *Sam Houston and the Senate*. Austin: Pemberton Press, 1970.

McCauley, James Emmit. *A Stove-Up Cowboy's Story*. 1st ed. Austin: Texas Folklore Society and the University Press in Dallas, 1943. 2d ed. Dallas: Southern Methodist University Press, 1965.

Mera, H.P. *The "Rain Bird;" A Study in Pueblo Design*. Santa Fe: Laboratory of Anthropology, 1937.

Mills, W.W. *Forty Years at El Paso, 1858-1898*. El Paso: Carl Hertzog, 1962.

Powell, Lawrence Clark. *A Southwestern Century: A Bibliography of One Hundred Books of Non Fiction About the Southwest*. Van Nuys, Calif.: J.E. Reynolds, 1958.

Saber, Cliff. *Desert Rat Sketchbook*. New York: Sketchbook Press, 1959.

Schwettman, Martin W. *Santa Rita, The University of Texas Oil Discovery*. Austin: Texas State Historical Association, 1943.

Siringo, Charles A. *A Texas Cowboy; Or Fifteen Years on the Hurricane Deck of a Spanish Pony, Taken from Real Life*. New York: William Sloane Associates, 1950.

Smith, Rex, ed. *Biography of the Bulls*. New York: Rinehart and Company, 1957.

Stinson, C.L. *Honor Your Pardner; Ten Square Dance Calls With Explanations*. El Paso: Carl Hertzog, 1938.

## Articles With Illustrations by Lea

Barker, S. Omar. "Mister Mountaineer," Pt. I, *New Mexico Magazine* 12, no. 6 (June 1934): 7-9, 48; Pt. II, 12, no. 7 (July 1934): 14-16, 41.

_____. "Ol' Belly —Stuck: A Typical Cowboy 'Big Windy.'" *New Mexico Magazine*, 12, no. 1 (January 1934): 8-10, 44.

Benet, Stephen Vincent. "Henry and the Golden Mine." *Saturday Evening Post* 212, no. 13 (September 23, 1939): 18-19.

Calkins, Gene. "Recompense." *New Mexico Magazine* 12, no. 3 (March 1934): 16-18, 35.

"China's War Anniversary." *Life* 17, no. 2 (July 10,1944): 62-65.

Davis, H.L. "A Sorrel Horse Don't Have White Hoofs." *Saturday Evening Post* 214, no. 26 (December 27,1941): 14-15, 60-62.

_____. "World of Little Doves." *Saturday Evening Post* 213, no. 43 (April 26,1941): 12-13, 90, 92, 95, 97-98.

DeHuff, Elizabeth Willis. "Basilisa's Novena." *New Mexico Magazine* 12, no. 4 (April 1934): 21-22.

Hersey, John. "Three Airmen." *Life* 16, no. 22 (May 29,1944): 67-73.

"*Hornet's* Last Day. Tom Lea Paints Death of a Great Carrier." *Life* 15, no. 5 (August 2,1943): 42-49.

Kirk, Ruth Falkenburg. "Wool Weights." *New Mexico Magazine* 12, no. 6 (June 1934): 17-18.

"*Life's* Artists Record a World at War." *Life* 18, no. 18 (April 30,1945): 42-67.

Marmer, Jacland. "Dutch Treat." *Saturday Evening Post* 215, no. 9 (August 29, 1942): 18-19, 90, 92, 96.

"Peleliu: Tom Lea Paints Island Invasion." *Life* 18, no. 24, (June 11, 1945): 61-67.

"Sinking of the *Wasp*." *Life* 14, no. 14 (April 15, 1943): 48-49.

"Soldiers at Work: Tom Lea Catches Their Absorbed Expressions." *Life* 12, no. 17 (April 27, 1942): 44.

"Tom Lea Aboard the *U.S.S. Hornet*." *Life* 14, no. 12 (March 22, 1943): 49-58.

"Tom Lea Paints the North Atlantic Patrol." *Life* 12, no. 21 (May 25, 1942): 53-61.

"Top Sergeant: Bruce Bieber Makes Soldiers Out of Citizens." *Life* 11, no. 1 (July 7, 1941): 64-71.

Whitehouse, Arch. "Fighter Convoy." *Saturday Evening Post* 214, no. 50 (June 13, 1942): 20-21.

Williams, J. Henryette. "Bah-Tah-Ko, An Indian Legend." *New Mexico Magazine* 11, no. 11 (October 1933): 15-17.

## Exhibit Catalogs

*Pictures by Tom Lea*. Villita Gallery, San Antonio, January 1-31, 1948.
*Tom Lea*. Fort Worth Art Center, January 12 - February 5, 1961.
*One Hundred Paintings and Drawings by Tom Lea*. El Paso Museum of Art, May and June, 1963.
*Tom Lea: A Selection of Paintings and Drawings from the Nineteen-Sixties*. The University of Texas Institute of Texan Cultures at San Antonio, December 6,1969 - January 17,1970.
*87 Paintings and Drawings by Tom Lea*. El Paso Museum of Art, November 5-28, 1971.
*A Bibliography of Writings and Illustrations by Tom Lea*. El Paso Public Library, December, 1971 - January, 1972.
*Tom Lea: Master Draftsman*. Adair Margo Gallery, El Paso, February 17- May 13, 1994.

## Publications About Lea

Antone, Evan Haywood. *Tom Lea, His Life and Works*. El Paso: Texas Western Press, 1988.
Bennett, Patrick. *Talking With Texas Writers: Twelve Interviews*. College Station: Texas A&M University Press, 1980.
Brady, Haldeen. "Artist Illustrators of the Southwest: H.D. Bugbee, Tom Lea, and José Cisneros." *Western Review*. 1, no. 2 (Fall, 1964): 37-41.
Cheeseman, Bruce S., and Al Lowman. *"The Book of All Christendom:" Tom Lea, Carl Hertzog, and the Making of "The King Ranch."* Kingsville: King Ranch, Inc., 1992.
Dingus, Anne. "War Paint." *Texas Monthly* 22, no. 8 (August, 1994): 88-93.
Dobie, J. Frank. *Out of the Old Rock*. Boston: Little, Brown and Co., 1972.
Dykes, Jeff C. *High Spots of Western Illustrating*. Kansas City: The Westerners, Kansas City Posse, 1964.
Farah, Cynthia. *Literature and Landscape: Writers of the Southwest*. El Paso: Texas Western Press, 1988.
Glasscock, James W. "Tom Lea of Texas." *Texas Parade* 12, no. 1 (June, 1951), 17-19.
Greeley, Lt. Col. Brendan. "Pasó Por Aquí." *Naval History* 9, no. 2 (March/April, 1995): 8-17.
Hertzog, Carl. *Two Artists in Two Mediums*. Dallas: Southwest Review, 1949.

180

Hjerter, Kathleen, comp. *The Art of Tom Lea*. College Station: Texas A&M University Press, 1988.

Morris, Willie. "El Paso's Tom Lea: A Desert and Ranch Man." *Texas Observer* 53, no. 41 (January 13,1962): 1, 6.

Past, Raymond Edgar. "'Illustrated by the Author': A Study of Six Western-American Writer-Artists." MA thesis, University of Texas at Austin, 1950.

Pinkard, Tommie. "Tom Lea: The Man and His Work." *Texas Highways* 26, no. 2 (February, 1979): 16-23.

Powell, Lawrence Clark. *Great Constellations*. El Paso: El Paso Public Library Association, 1977.

Short, Clarice. "Tom Lea's Symbolism." *Western Humanities Review* 8, no. 1 (Winter, 1954): 57-60.

West, John O. *Tom Lea: Artist in Two Mediums*. Austin: Steck-Vaughn Co., 1967.

## Films Produced From Lea's Books

*The Brave Bulls*. Columbia Pictures, 1951. Starred Mel Ferrer and Miroslava.

*The Wonderful Country*. United Artists, 1959. Starred Robert Mitchum and Julie London. Lea appeared as Peebles, the barber.

# Index

183

185

Texas Western Press
appreciates the assistance of
William Kiely
and the
Robert J. Kleberg, Jr. and Helen C. Kleberg Foundation
in the publication of this book.